Daily Life in Art

The author would like to thank the following for their help and advice: Martyne Perrot, Christine Ripert, Karl Schütz, and Daniel Wolfromm.

She would also like to thank the editorial and production teams of the French edition of this book, including Carole Daprey (editor), Laure Tattevin (assistant editor), Khadiga Aglan (iconographer), Line Martin (graphic designer), and Colette Malandain (proofreader).

Daily Life in Art

Béatrice Fontanel

Translated from the French by Liz Nash

Abrams, New York

Contents

Louis-Paul Dessar

Clotilde, ca. 1893

Musée de la Coopération,
Blérancourt, France

Preface

"Here I am on my staircase, in an old town house in the Massif Central. The winter has made it damp and icy cold; spiders and mice go freely about their business, and with four flights of stairs to go up every day I am constantly reminded of my age. And yet I feel good here; the steps yield gently under the weight of my feet, every room that opens off the staircase harbors a familiar smell, the decoration on the walls is the work of my own family, and from the windows I can see my garden. Even the cold (which the porous stones will hold until summer) is not disagreeable to me; it too plays its part, in a stern but well-meaning way, in the domestic bliss that I call my 'well-being.'. . .

"Here I am, still on my staircase. I did not design it or build it; its construction comes directly from the manuals, traditions, and hands of the artisans of my region. In that same anonymity it presented itself to my great-great-grandfather, just after it was built. Gradually it has taken on meaning, but it retains a 'vacancy' that makes it dear to me, because as I follow in my family's footsteps up its fifty or so stairs, breathing in the ancient smells of the rooms where they lived and looking out of the windows at the garden of my childhood, I can remodel it every day according to my mood as householder. Its banister slips smoothly along under my hand, and its steps wait quietly for my tread; but its physical discomfort—which accompanies all its joys and makes it superficially hostile to me—has likewise outlasted the generations.

"It is precisely that which so richly reveals my past. The form of construction that embodies all its imperfections shows my own civilization's efforts to house me, and also shows my present. And I cannot go up or down this staircase without feeling the desire (forever unsatisfied) to lessen its constraints, which necessarily turns me toward the future. Thus this sense of restriction shows me the double face of my well-being—discomfort and elation, subservience and euphoria—and its true origin: in the past and the duration of a society. My discomfort is my culture."

This 2002 piece by sociologist Jacques Pezeu-Massabuau, published in the magazine *Communication* under the title "Manières d'habiter" (Ways of living), might well serve as a kind of filter for this book. It should be kept in mind while visiting all the houses from the past that are represented in the paintings here. With its sense of style and subtlety, it will keep the reader from being too quick to feel pity for "our poor ancestors" and the discomfort of their homes. Rather than projecting on to these old interiors our own inevitably anachronistic judgments, Pezeu-Massabuau sheds new light on ways of living. His sensitive, literary description of his old family house will strike a chord with all readers . . . even those who don't own one themselves.

The Middle Ages

In the Ladies' Chamber

In medieval times, the chamber was not just a room reserved for sleeping, as we think of bedrooms today. For a very long time it was a room with multiple functions, and it was generally the most comfortable and best-heated place in the house, where close friends and relations were entertained. Although the bed took pride of place here, a table was often set up for a meal, or a tub was brought in for a bath, since baths were taken more frequently in the Middle Ages than in the centuries that immediately followed. Finally, it was the room where people were born, and where they died.

Announcement to Joachim. Birth of the Virgin. Symbols: The Hearth and the Bed with a Young Mother and Her Newborn Child

Miniature from *Fleur des histoires*, Jean Mansel, 15th century

BIBLIOTHÈQUE NATIONALE DE FRANCE, PARIS | FRANÇAIS 297, FOLIO 1

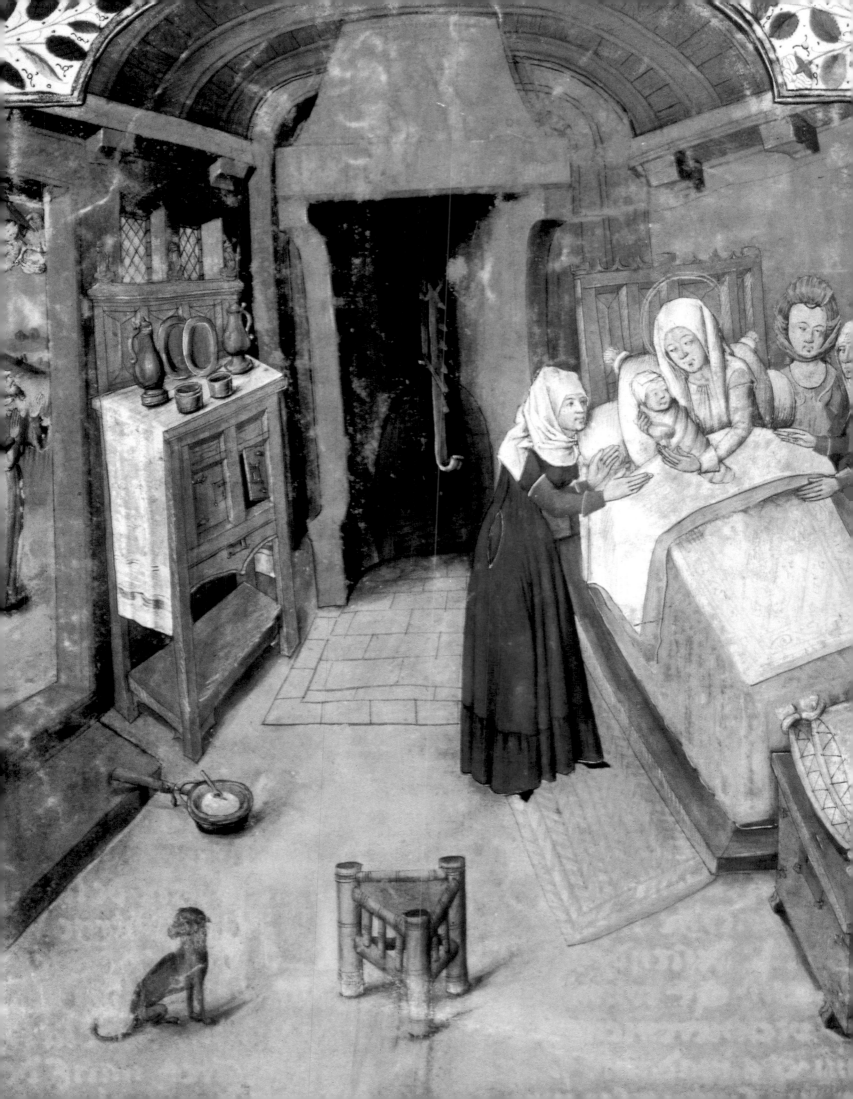

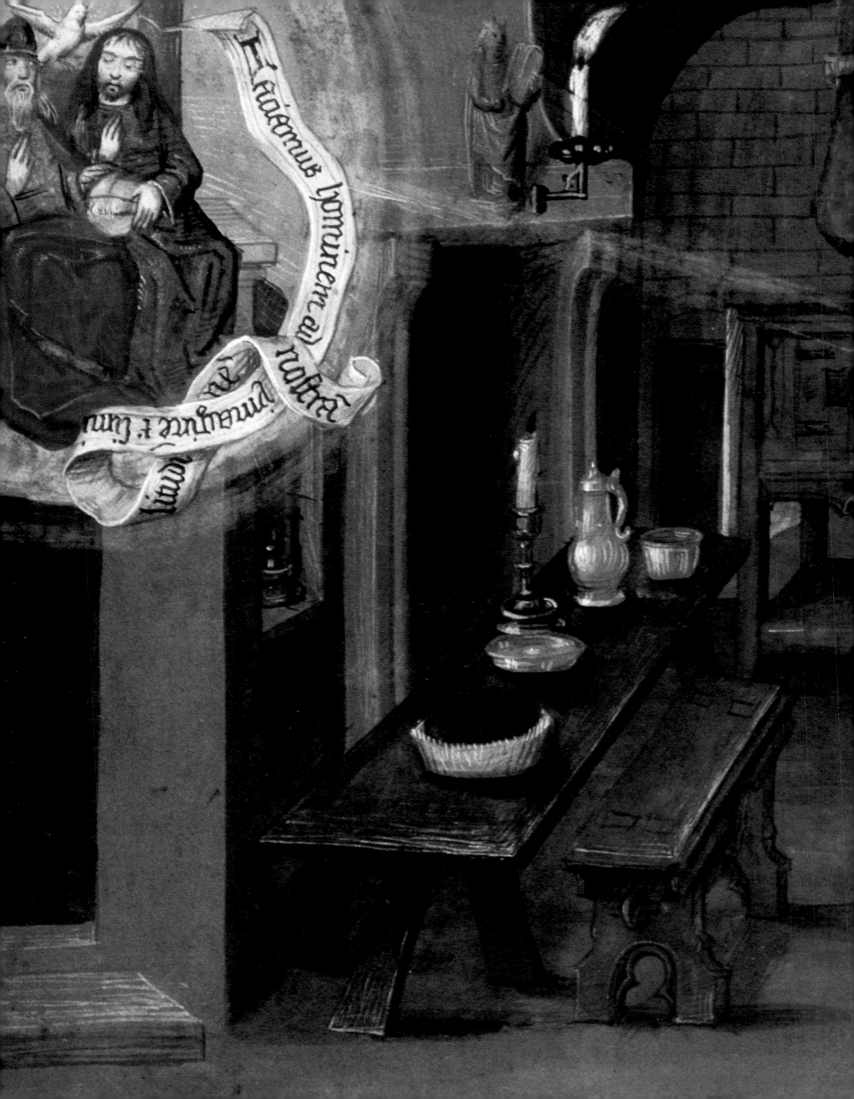

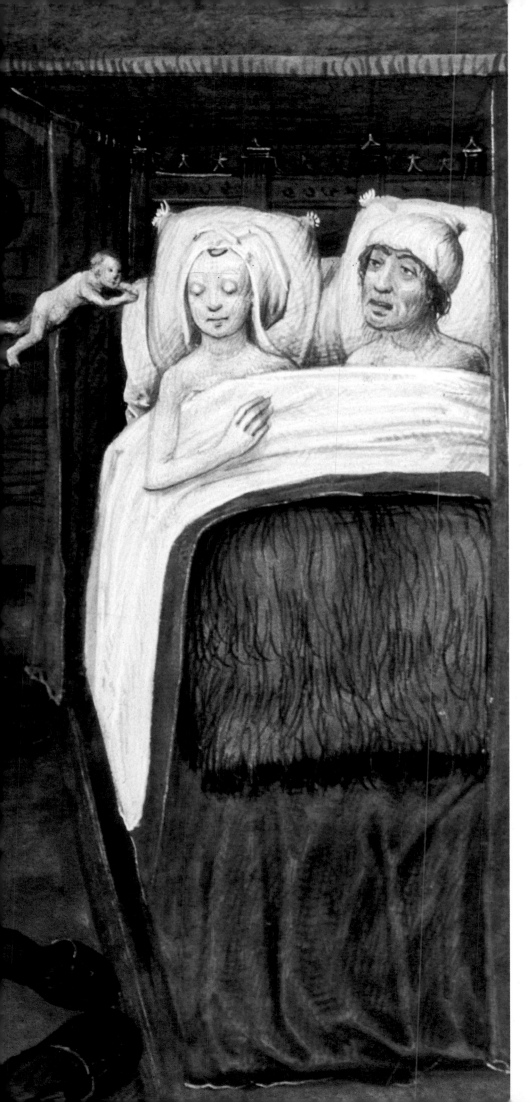

The Medieval Bed as a Refuge

A couple receives a child from the Holy Trinity. Apart from the vision of the frail homunculus flying through space toward his future parents, the illumination shows a bedroom with a couple lying naked between the sheets, as was customary in the Middle Ages. Their heads, however, are covered: a head scarf for the wife, a nightcap for the husband. At this time people were fearful of catching cold through their exposed heads, since the room temperature fell quickly once the fire extinguished in the fireplace. The nightcap would be worn until the nineteenth century, and generations of caricatures would show sleepers looking slightly ridiculous in their long nightshirts and long, pointed nightcaps.

The bed here has a thick fur cover. The bed-curtains are open and one of them, as in many miniatures, is rolled up and fastened at the top, offering a view of the activity. There is very little furniture in the room: a small sideboard covered with a cloth, a table—just a plank set on trestles—a bench, and two candlesticks that can be carried from one room to another. Another candle, placed in a wall fixture above the fireplace, is still lit. Lighting was a luxury right up to the nineteenth century.

Thus, this one simple image provides a good sense of an important part of daily life during the European Middle Ages. If people had finished their day's activities and were no longer bustling about to keep warm, the cold would quickly take a grip, so it was essential to beat a retreat and get to bed as soon as possible. Night has only just fallen, and already the couple has slipped under the warm bedclothes, leaving their slippers by the bed. In a moment they will close the curtains so as not to risk the slightest loss of body heat.

Couple Receiving a Child from the Holy Trinity

Miniature from *Le Livre lequel entre aultres matières traitte de la nativité Nostre Seigneur Jhesu Crist, de sa vye, de sa passion . . .* [*The Book Which Among Other Matters Deals with the Birth of Our Lord Jesus Christ, His Life, His Passion . . .*], vol. II, 15th century

Bibliothèque Nationale de France, Paris

Sleeping Naked

Two slender figures are undressing to go to bed. Still wearing a tiny cache-sexe, the impatient young man is helping his companion take off her chemise. Her dress has been thrown on a piece of furniture beside the bed. Even outside love relationships, nakedness was considered perfectly natural in the Middle Ages. Without the slightest embarrassment, people—sometimes several at a time—would get into bed together entirely naked. Nightshirts did not yet exist, nor did undergarments. The couple's bed stands on a wooden platform that protects their feet from the ice-cold floor. The bed itself reveals its owners' social status: It has a beautiful blue bedcover, a voluminous bolster, colored pillows, and curiously crumpled sheets that hang down to the wooden platform. The custom of tucking sheets and blankets under the mattress did not come until later. The rumpled bed may reveal the ardent nature of the two lovers' relationship, or it might just show that at this time beds were not made every day. In any case, everything in this room of love is charming: the table with the fringed cloth, candlestick, goblet, and jug of wine arrayed on top, the gently squashed cushion on a chest, the flowering plant, and the walls decorated with paintings or damask coverings.

Even well-to-do medieval homes did not have much by way of furniture or paintings. An interest in decoration was expressed mainly by the beauty of the fabrics and wall coverings and by the comfort of the bedding. In Chrétien de Troyes's twelfth-century Arthurian romance, the Knight of the Cart sleeps under "a yellow satin sheet studded with gold. . . . The lining was not of threadbare squirrel fur, but of sable." People slipped little scented sachets filled with musk, amber, or saffron under their bedspreads. Wall hangings had several advantages; they absorbed the room's humidity, gave it a warmer atmosphere, and could easily be taken down and transported elsewhere, at a time when the baronial lifestyle still involved continual moves from place to place. Soon the lovers will go to bed, having slipped their chemises under their pillows to keep them warm until they need them again at dawn. If they need to get up during winter nights to answer the call of nature, they will put on thick, fur-lined housecoats to go and pee in a pot—or in the fireplace.

Martinus Opifex

Jason and Medea Retire to Bed

Miniature from *The Trojan War*, Guido de Columnis, 15th century

Österreichische Nationalbibliothek, Vienna | cod. 2773

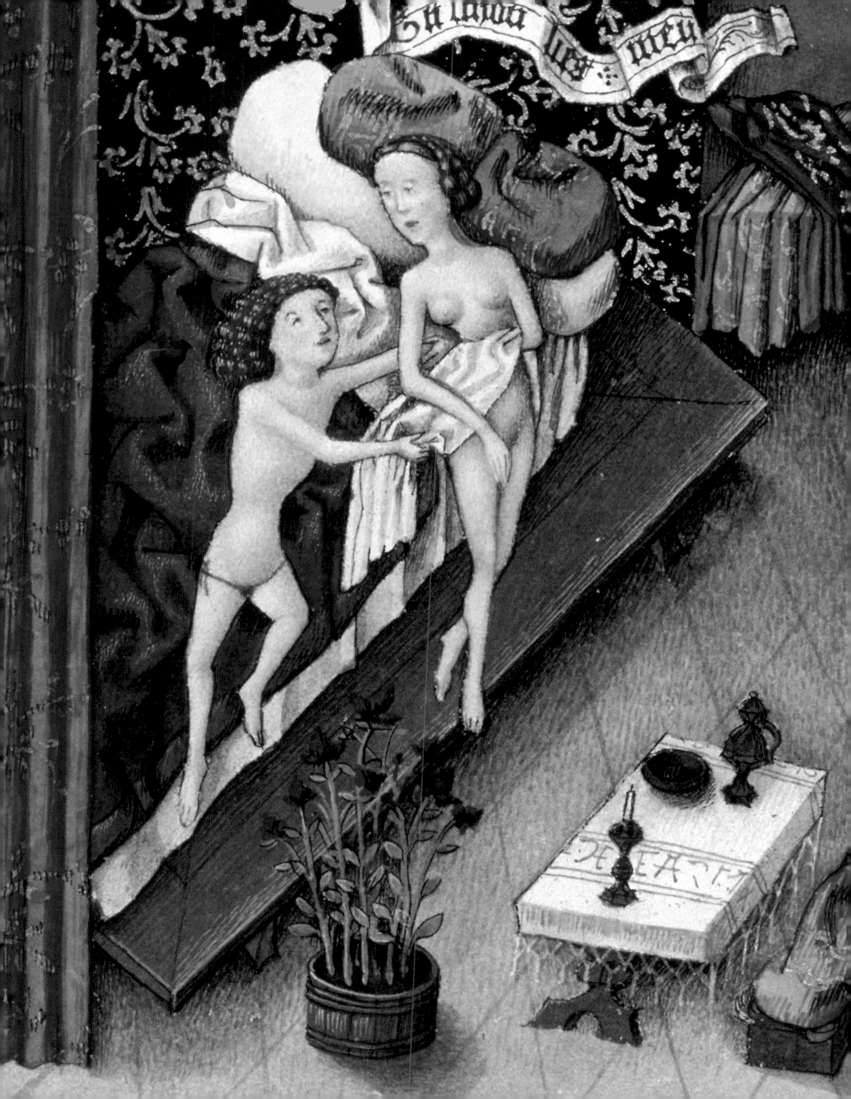

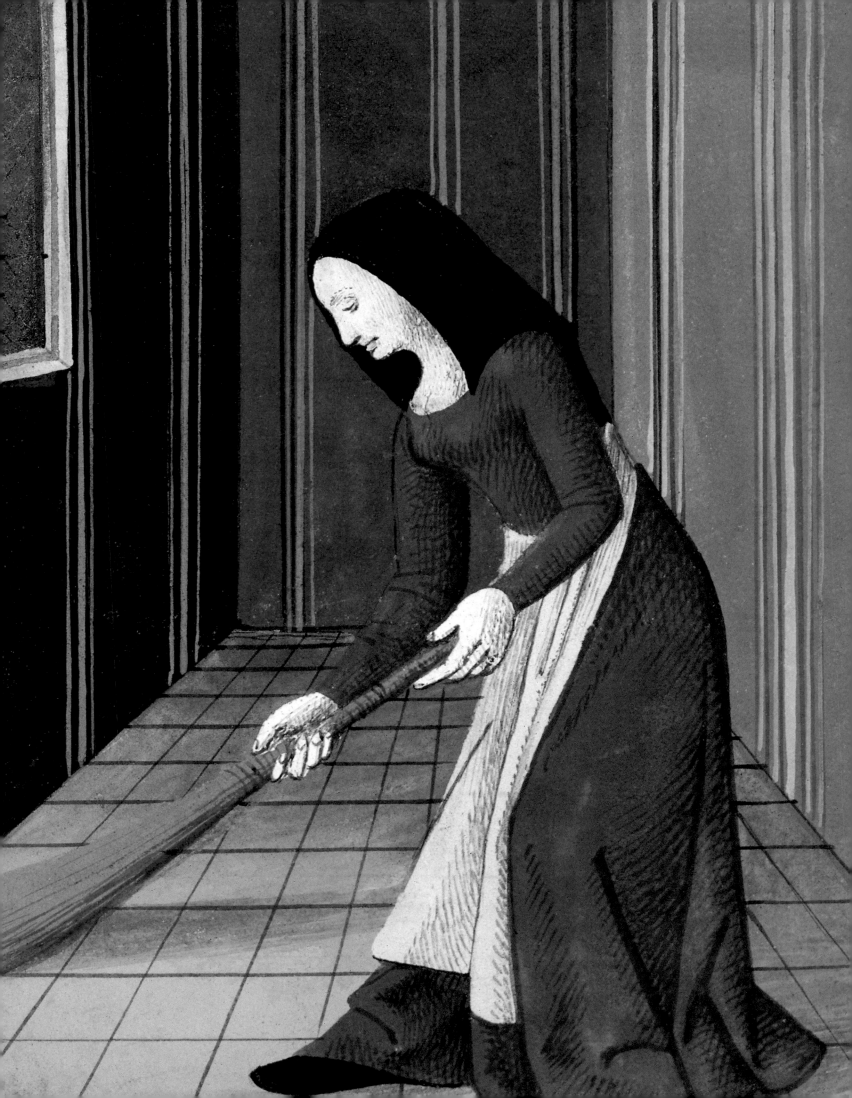

Cleaning the Floor and Using the Broom

A medieval housewife, wearing a head covering and apron, conscientiously sweeps the floor of her house with the same type of broom that will be seen for centuries to come. These brooms were made of birch twigs tied together at one end. A sturdy ash branch bound into one end of the twig bundle formed the handle.

One does wonder, however, how women maintained their floors. Was a broom enough to keep them clean? And what could they do to make them more pleasant and comfortable? A high-speed history of flooring leads amusingly from plain packed earth, with hens running freely inside the farmhouse, to a waxed parquet floor, gleaming like an ice rink and guarded by the mistress of the house, who like a domestic Cerberus ensures that all who walk upon it wear felt slippers. Packed earth, stone, brick, floor tiles, mosaic, floorboards, rugs, linoleum, wall-to-wall carpeting—the evolution of flooring materials and types has changed the way people think about the floor in their homes, as well as their judgments of what is clean or dirty.

For a long time the most economical solution for the vast majority of those living in peasant homes was packed earth. It was sometimes mixed with lime or clay, then packed down to create a smooth surface that became as hard as cement. The only disadvantage was that the floor could not be washed with water, since doing so would turn it into mud. On the other hand, if the floor was swept regularly, the house was hardly as uninhabitable as we might imagine. In the Middle Ages the custom in the wealthiest homes and in castles was to spread rushes, grasses, and fragrant plants over the cold, hard floors. When they were replaced, the wilted, soiled grasses were taken to the stables and pigpens and used as fodder for the animals. "Rush strewer" was even an official post in the courts of France's first three Capetian kings (987–1060), and a demanding job it was.

Table manners had not yet been established, and diners had no qualms about scraping their leftovers on to the floor. People also used the layer of rushes to remove the mud from their shoes when coming in from outside. Scraps and dirt were covered over as often as possible, and the rush was changed when it started to smell too strongly. The practice of covering bare floors with straw in winter and with fresh grass and flowers in summer began to disappear in Europe about the thirteenth century.

Sawdust was also used as a floor covering, a custom that has continued to the present day in some butcher shops. Sand often covered kitchen floors. This was the age of the sandman, whom we now know only through children's stories without ever recalling that his was a real job or imagining its function. The sandmen and their donkeys went from street to street, selling sand to housewives for their floors. The evolution of ideas about hygiene and the ever more distinct separation between the interior and the exterior of the house profoundly altered domestic practices such as that one.

But if the medieval mistress of the house cleaned her floor less often than we do, it was also because she respected beliefs that have since disappeared. On All Souls' Day, for instance, she avoided any excessive sweeping so as not to disturb the souls of the dead returning to visit their homes.

Servant

Miniature from *The Book of the Properties of Things*, Bartholomaeus Anglicus, 1480

Bibliothèque Nationale de France, Paris | Français 9140, folio 107

Making the Bed

Two maidservants (or menservants?) are making up the bed with embroidered sheets and a striped bedcover. What is most striking here is the tool one of the figures is holding: a bed-making stick, which no longer exists. In the Middle Ages beds were so wide that a utensil of this type was needed to stretch the sheets from one end of the mattress to the other, especially since it was sometimes difficult to move around the bed, which might be wedged into a corner of the room and was often surrounded by chests and curtains. Several cedar bed-making sticks appear in the French King Charles V's inventory of furniture, some of them decorated in gold "with two round knobs at the top, one with the arms of France, and the other with the arms of Monseigneur le Dauphin." The use of these sticks continued long after beds had become narrower; they can still be seen in seventeenth-century engravings by Abraham Bosse. The surprising longevity of this piece of household equipment might well be because the heavy hemp material used for bedclothes at the time was difficult to handle; by contrast, our light cotton sheets tend to fly up in the air as we throw them across the mattress, like a seasoned fisherman casting his net.

In the bedroom of this noble residence, the walls are decorated with painted motifs (wallpaper, which originally came from China, was not produced in Europe until the end of the eighteenth century) and the floor is covered with a woven mat. Sturdy straw or rush floor coverings were used in the homes of northern Europe until the sixteenth century. They were thick and insulating, and helped keep out drafts from under the doors. Sometimes they were sewn together to cover the whole surface of a room, like wall-to-wall carpeting. Their disadvantage, however, was that they gathered dust and wore out within a few years. Europeans also imported finer mats from North Africa, but they gradually fell out of use about the middle of the seventeenth century, no doubt because floors became more attractive and because a fashion for rugs, which were richer and softer, caught on.

Chastity and Poverty Preparing a Bed

Miniature from *The Pilgrimage of Human Life*, Guillaume de Digulleville, 14th century

Bibliothèque Sainte-Geneviève, Paris | MS BSG 1130, folio 83

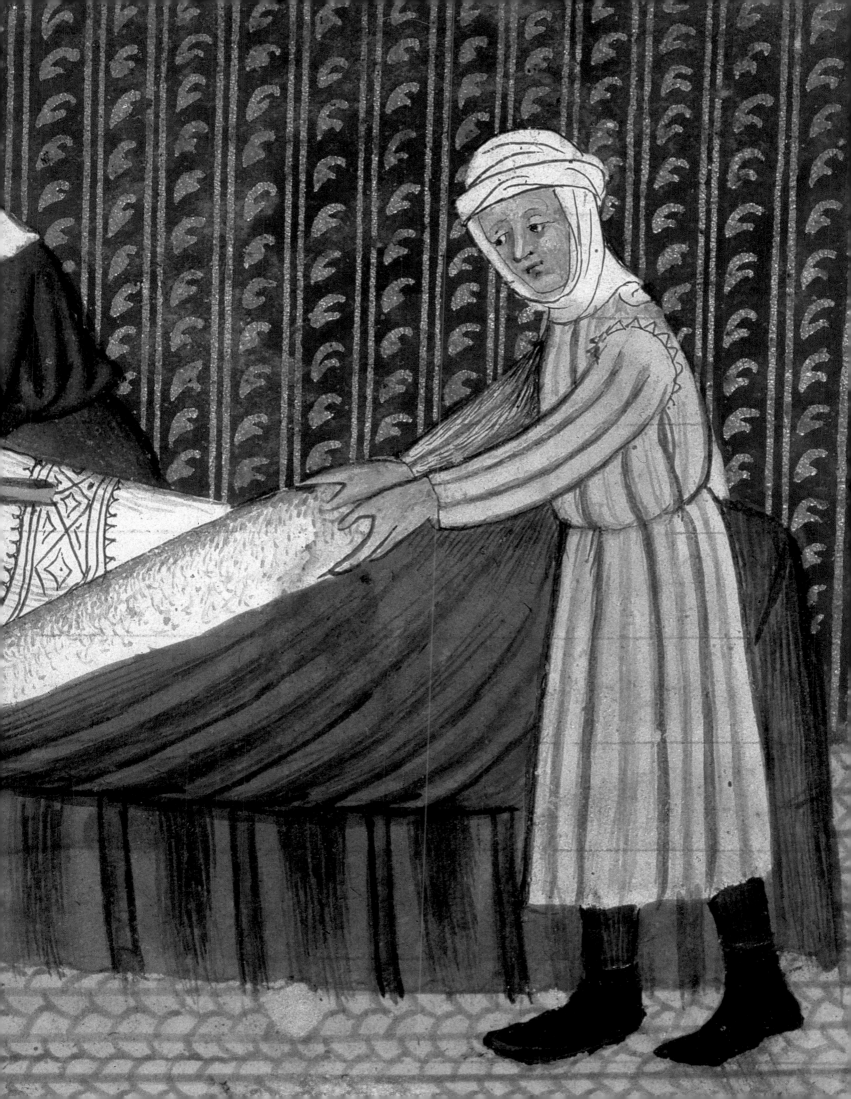

Bath Time

The heavy wooden bathtub has been rolled into the room and positioned near the bed beside a large fire blazing in the fireplace, where numerous cauldrons of water have been heated—a tedious job. A slim young man is relaxing in his bath, with a pleasant snack and a glass of wine set out on a plank within easy reach; he does not appear to be the least embarrassed by the presence of the fully dressed noblewoman, who is watching him and with whom he seems to be chatting. For greater hygiene, and to prevent him from being hurt by splinters, a large sheet has been placed in the tub. Through most of the Middle Ages the idea of complete immersion in water, which would later inspire great fear, was quite popular. People took baths to wash, to relax, and to warm themselves in the depths of winter.

In the homes of the nobility it was customary to honor distinguished visitors who had traveled a long way by offering them a hot bath. After bathing, they would lie down and rest for a while on their bed. These hygienic practices were to a considerable degree influenced by those of ancient Rome, as well as by the steam room traditions the crusaders brought back from the Orient.

Tristan's Bath

Miniature from *Tristan, Knight of the Round Table*, ca. 1494

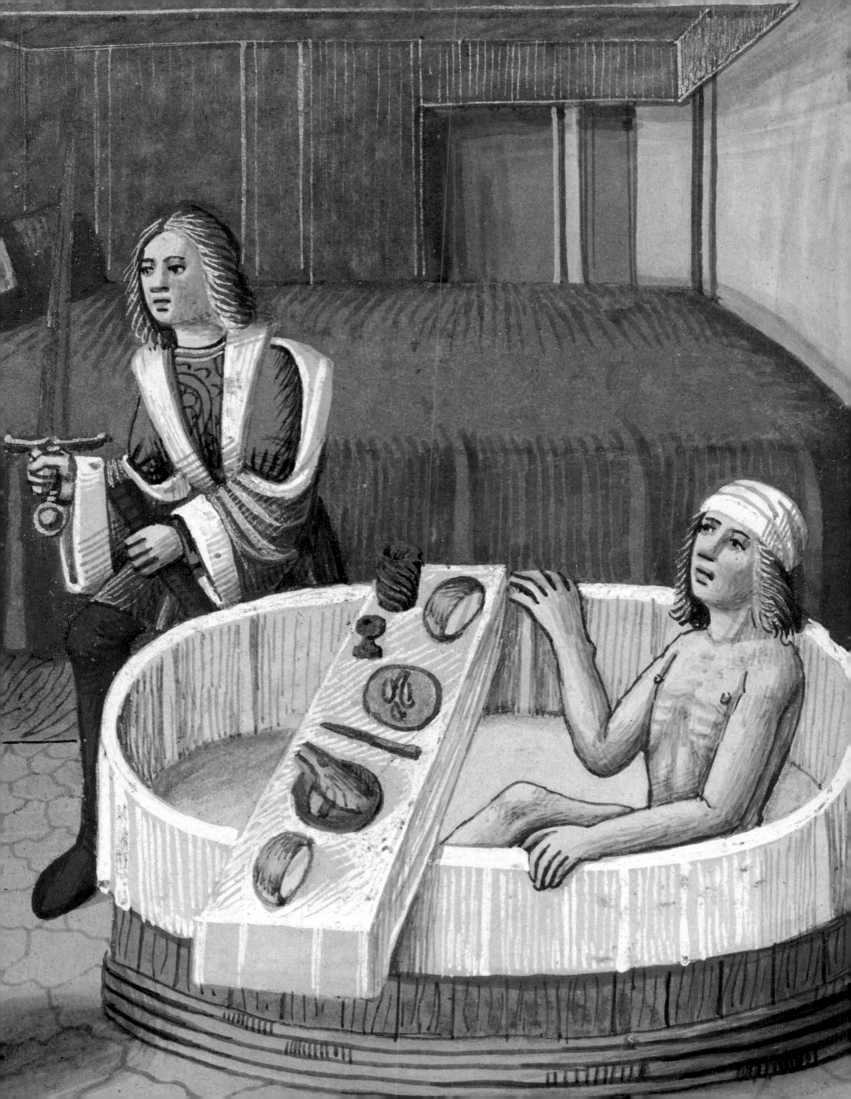

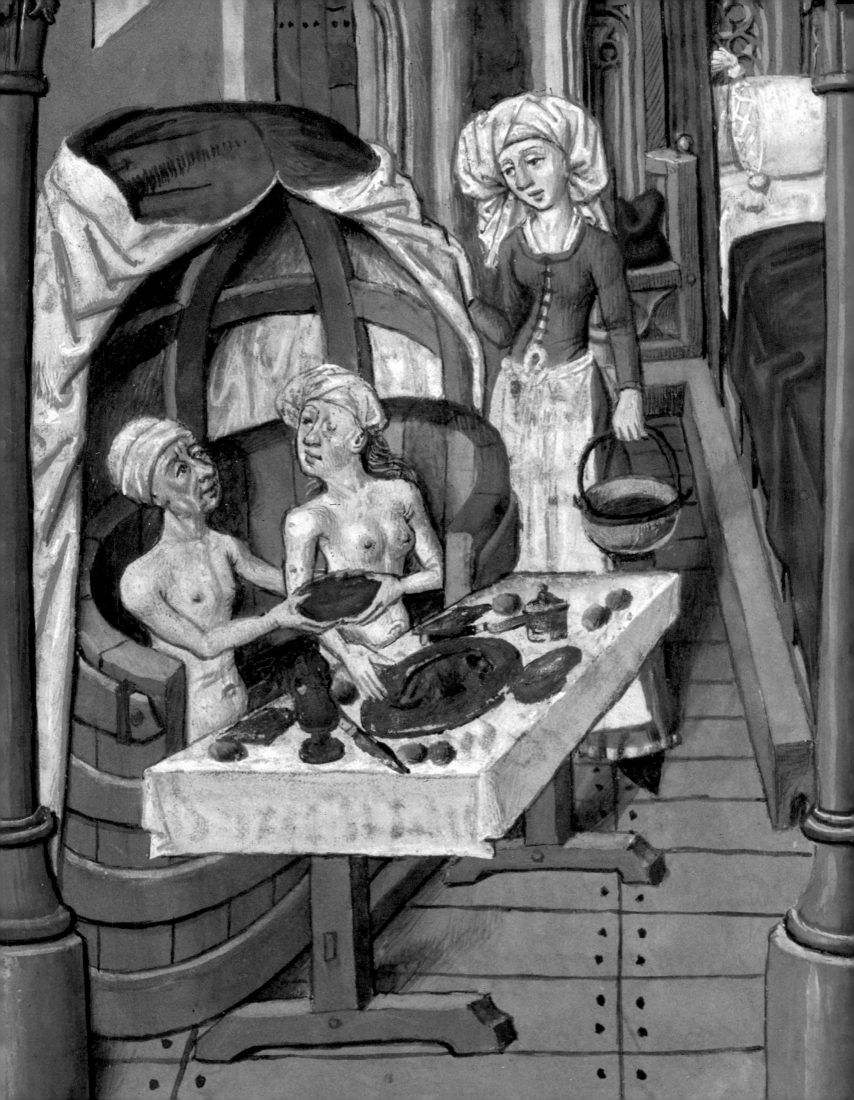

Bathtime Feasts

The large wooden bath is topped by a lined canopy, which retains the water's heat; closing the curtains creates a steam bath effect. A servant brings in a pot of hot water to keep the bath at an agreeable temperature. When her masters have finished bathing, she will have to empty the water very carefully, a long, laborious task. The bathtub, made by a skilled cooper, is designed so that one can climb into it easily from one side. Its shape also makes it possible to draw up a table alongside it, allowing the bathers to enjoy a meal comfortably. A bath was often the occasion for a meal shared in good company.

In medieval Europe well-to-do people with servants took their baths in the chamber, which was often the best-heated and most comfortable room in the home. Towns also had numerous public steam rooms, carrying on the tradition of the Roman thermal baths. However, when the great epidemics came along—the plague, cholera, venereal diseases—the baths were accused of being dens of iniquity and were strongly criticized by the Church. (Many wood engravings from the period show adulterous women meeting their lovers at the baths and being confronted by an enraged husband, armed with an ax.) As a result, by the end of the Middle Ages water no longer represented purification and became highly suspect. Hot water, which dilated the pores and enabled miasmas to infiltrate, seemed most pernicious.

Despite its potent beneficial powers (some springs were said to cure diseases or sterility), this questionable element came to be used by commoners with great caution and only at key moments of existence. Bathing was increasingly regarded as an occasion poised at the intersection of life and death, and it became rare. It was virtually impossible to take more than two or three baths throughout a lifetime: at birth, on the eve of one's marriage, and at death, before burial. Smelling rather strongly was considered a sign of good health and sexual vigor. For centuries grime even was thought to be protective.

Sergius Orata in His Bath

Miniature from *Memorable Deeds and Sayings*, Valère Maxime, 15th century

The Attraction of the Fire

A man wearing a fur-lined coat and a fur hat stretches out his hands and legs toward the warmth of the fire. He has just taken off the wooden clogs he was wearing to protect his shoes from the icy mud on the streets. His seat has a high, curved back that protects him from drafts and holds in the heat of the flames, like a hood. A woman is serving the meal.

A single candle burns on the table next to the fireplace. The chandelier hanging from the ceiling holds no candles; it is used only for special occasions. For lighting, people mostly made do with a fire's high flames, which threw their dancing display of light and shadow out into the room. Here the wooden shutters inside the lower part of the window are closed. In winter they would be kept closed even during the day, insulating the room from the extreme cold outside, with the meager daylight coming in through the upper part of the window.

The fire was a constant attraction. People, domestic animals, and furniture were positioned as close to it as possible, so that moustaches were singed and accidents were not uncommon. No one moved away from it, except to go out or go to bed. When eating at table, the master always had the best seat, closest to the fire—even if, as Rabelais put it with his inimitable turn of phrase, "the man sitting in front of the fireplace freezes his backside and roasts his chestnuts."

In "Sensibility and History" the great twentieth-century historian Lucien Febvre wondered whether true winter still exists for Europeans. "Anyone going into a middle-class home today, in a city, in the middle of winter, will immediately feel the warmth from the radiators in his face and take off his heavy clothes. In the sixteenth century, when a man entered his house in January, he felt the cold falling on his shoulders: the still, silent, dark cold of a home without a fire. He shivered, as he had just been shivering in church. As people shivered in the king's palaces, despite the tall fireplaces there that consumed whole trees. And the first thing a man did on coming home was not to take off his overcoat. It was to put on a greatcoat that was warmer than the overcoat he wore outside, and a fur hat that was thicker than the one he wore in the street."

The sixteenth-century French philosopher Michel de Montaigne was astounded to discover, on his travels through the Germanic countries, the use of the stove, which spread heat effectively and evenly around the room. When the people there go home in the middle of winter, he remarked, they do something unheard of: They take off their clothes. "Whereas when we go into our homes we put on our warm, furry dressing gowns, they on the contrary wear a doublet and stand by the stove with their heads uncovered, and dress warmly to go back out into the open air." The very simple, natural act of taking off one's coat on returning home was long unknown to many Europeans, who did the reverse. In fact, it was so cold in their houses that they never stayed there long; they were constantly out and about, staying on the move.

Simon Bening

January

Miniature from the *Da Costa Book of Hours*, ca. 1515

PIERPONT MORGAN LIBRARY, NEW YORK | MS 399, FOLIO 2V

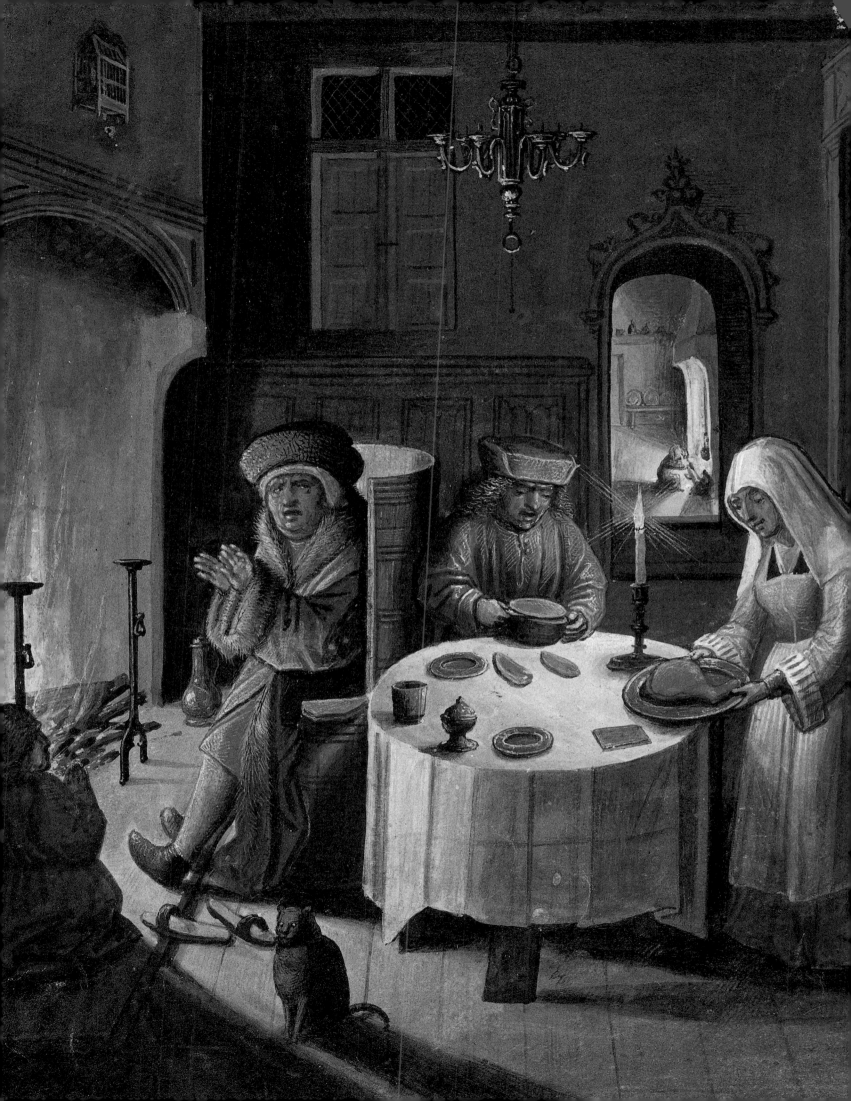

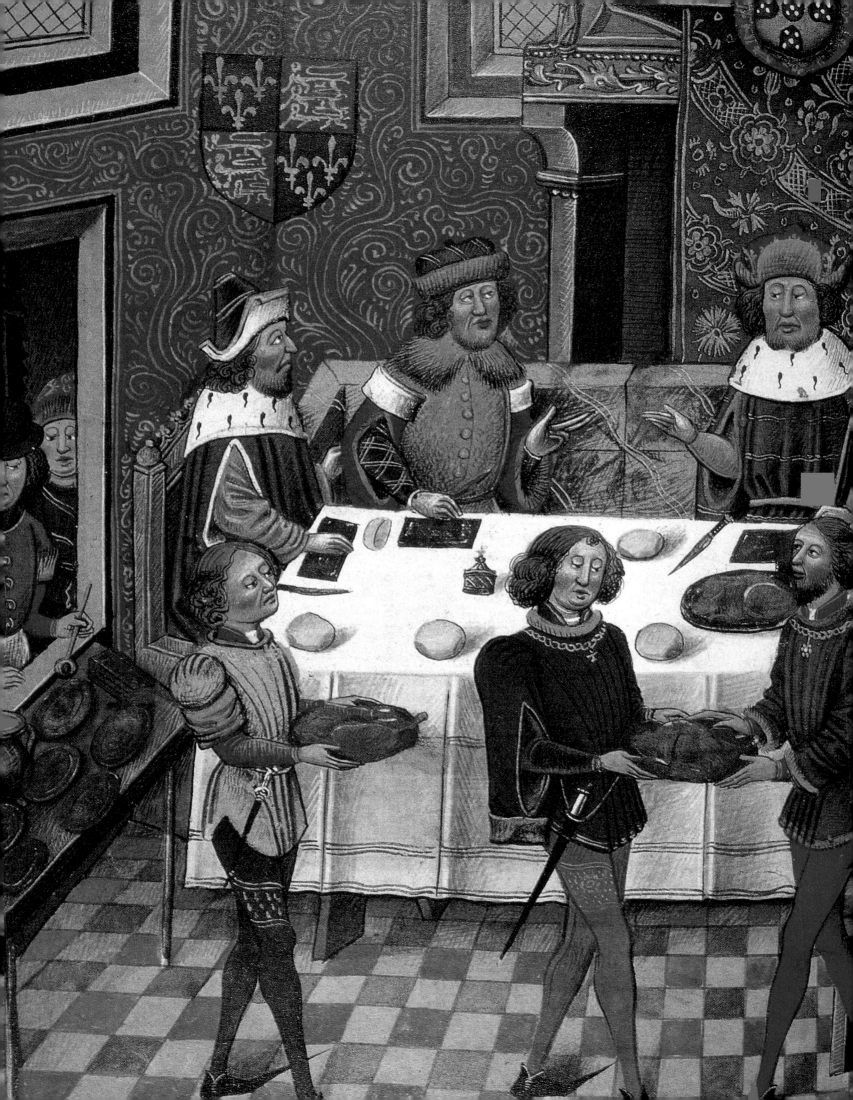

Victuals but No Place Settings

Everything in this banquet scene radiates gaiety and splendor. The red, green, blue, and gold of the decoration accentuate the snowy white of the tablecloth. The table as a piece of furniture did not yet exist in the Middle Ages, so a surface had to be set up specially for dining. Planks were placed on trestles and covered with tablecloths that hung to the floor. The guests sat on one side of the table only, so that they all could follow the procession of dishes and see the entertainment—poets, musicians, acrobats, or highly skilled animal trainers—that passed the time between courses.

Nimble young pages with shapely thighs arrive with legs of lamb and fowl, while a kitchen boy behind a serving hatch ladles sauce over some meat. The fleet of menservants moves briskly along to ensure that the food is still warm when it arrives at table; the kitchens were often quite a distance from the banqueting hall, sometimes even in a separate building, since for a long time fires were among the disasters that people feared most. For these baronial banquets the dishes were as numerous as they were extravagant They might include beef, mutton, swan, or peacock (the last two redecorated with their feathers before serving). Ducks, pheasants, and chickens were stuffed with egg yolks, berries, nutmeg, cloves, and cinnamon. Smaller game birds were stewed in a rich, spicy sauce. Savory pastries were prepared in molds with stylized animal shapes. Sometimes small live birds were baked into the pies, flying out when they were sliced, to the wonderment of everyone present.

Although the number of dishes was staggering, on the table itself was nothing, or almost nothing: no plates, no silverware, and no glasses—just wooden platters and knives. Sometimes the food was not even eaten off individual wooden boards but from a large slice of bread that could serve two guests at once. This sort of edible plate became saturated with meat juices; at the end of the meal it was thrown to the dogs or the poor. When a guest was thirsty, he signaled to a servant who came running over with a full glass or pewter goblet that the guest was invited to consume in one go. It was not until the eighteenth century that every diner had his own glass.

In peasant homes people poured drink straight down their throats; they ate soup made of turnips, cabbages, and herbs, with a small piece of bacon for added flavor and plenty of bread to thicken it. Often everyone ate from the same container, using wooden spoons. Some paintings by Bruegel show peasants with this small utensil curiously wedged into a hole in their hats. Forks, with two prongs at first, were widely used in Italy by the sixteenth century but did not commonly appear on tables elsewhere in Europe until the seventeenth century.

Without plates, forks, napkins, or any of the codes of good manners that developed later, the tablecloth often ended up looking like a blood-spattered linen from an operating room. As etiquette evolved there was less and less tolerance for slatternly behavior; in the sixteenth century the Italian writer Giovanni della Casa censured those who in the process of eating reduced their napkins to such a state that "the rags in the latrines are cleaner."

Princely Banquet
Miniature, 15th century
BIBLIOTHÈQUE NATIONALE
DE FRANCE, PARIS

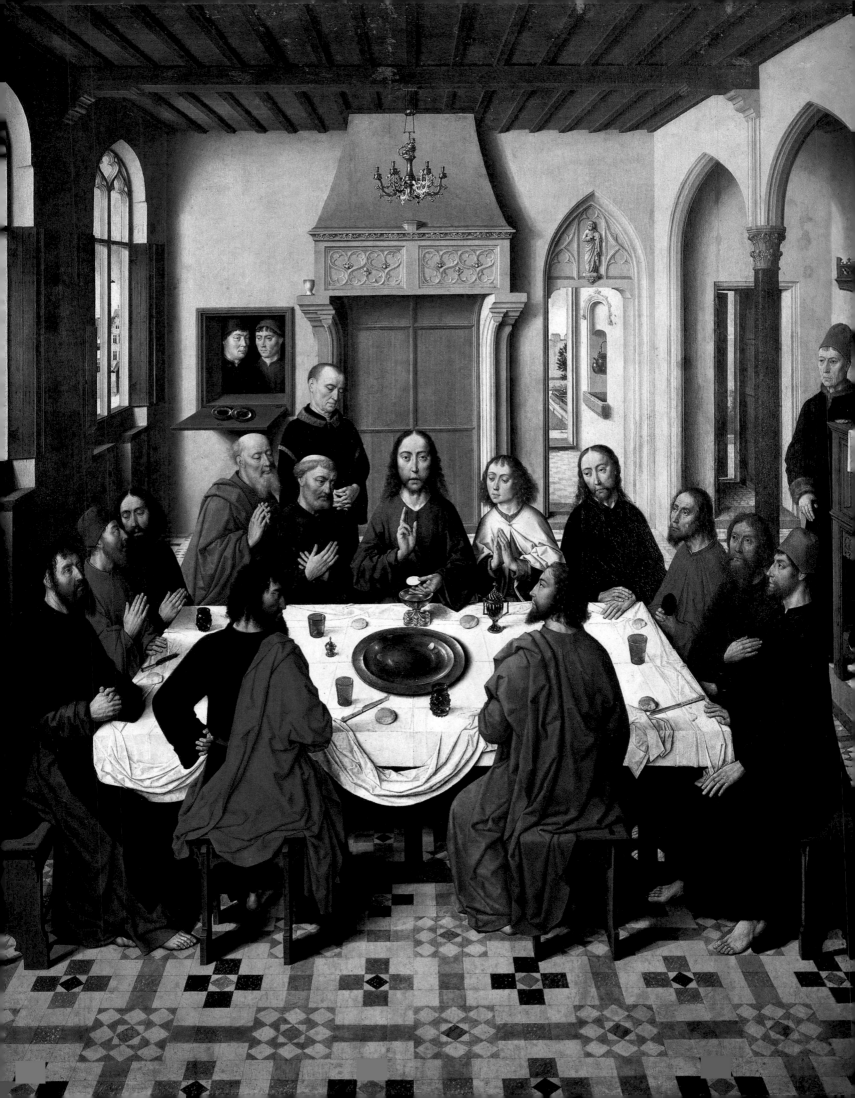

Guests and Table Manners

In a sumptuous fifteenth-century Flemish interior, Christ blesses the host at the Last Supper. Two servants, who seem to have understood the gravity of the situation, are watching the gathering through a narrow serving hatch. Laid out on the tablecloth, which has been so carefully ironed that the creases are still visible, are a large pewter dish, a few knives, some bread rolls, a saltcellar, and, in addition to the chalice and ciborium, various types of glasses, including some ornamented with picots, which are often seen in later Dutch still lifes. There are fewer glasses and napkins than guests, who will therefore need to share them. On a credenza to the right (not shown in full) are several precious dishes.

The apostles are sitting on benches and stools. Chairs were still rare, and high-backed seats, modeled on thrones, were reserved for the master of the house or distinguished guests. A complex protocol, then scrupulously observed but largely forgotten today, determined where one was entitled to sit and on what, according to age, sex, and social status.

Manuals of etiquette proliferated from the fifteenth century on, gradually leading to prohibitions on loose behavior, the sharing of crockery, and bodily noises. Good table manners were a way of showing one's elegance of mind. With the emergence of this new sensibility, it became considered vulgar indeed to blow one's nose into a napkin, to spit into a plate, to throw bare bones back into the serving dish of food, to talk with one's mouth full, or to make loud chewing noises. One was advised to sit up straight, not to put one's arms on the table, and above all not to pick one's teeth with knife or fingers. In these manuals, the emphasis was on the civility of one's actions and on cleanliness, but also on the courtesy that one owed one's neighbors at table. Some art historians have commented on "the congenital stiffness of Bouts's figures, and their taciturn faces." One might also interpret them as showing restraint and self-control.

Dirck Bouts

The Last Supper (central panel of the triptych), 1464–67

A Well-Ordered House

Far removed from the common conception of the Middle Ages as a time of vast, bare, drafty rooms, the miniatures of the time show little scenes whose details reveal a real concern for comfort. The artist here depicts a wealthy household, with panes of glass in the windows—a rare luxury at the time—and a large crimson bed (red was thought to be a protective color and thus particularly suitable for the mother and her newborn). The canopy is suspended by ropes from the ceiling. The curtains would be drawn at night to hold in the heat from the bodies and breath, and also to protect couples' privacy at a time when several people often slept in the same room. The curtains around the bed also meant that none had to be hung at the windows, which was useful when daily life was arranged according to the sun's rhythms.

A woman with a graceful figure is placing a cushion before sitting on a three-legged stool, which was a common object in the Middle Ages. At the center of the room stands a sort of chest or small sideboard, on which a light meal has been prepared for the mother. Arranged on a shelf above the door are some pewter and copper dishes and some candlesticks. Miniatures even of well-to-do interiors show just how few things people owned at this time. Storage pieces were rare indeed; there were no wardrobes or closets, only the occasional recess in the wall, hidden by a curtain. A few shelves would be mounted very high on the walls, perhaps to discourage theft, and also perhaps because the precious objects they held were used only on special occasions, with wooden or earthenware dishes sufficing for everyday use.

What most attracts the eye is the precision with which the artist portrays the open chest to show the meticulous arrangement of its contents. During this period and for long afterward the chest, along with the bed, was the key piece of furniture, especially prized for its mobility. The chest enabled the peasant who needed to flee from pillagers to take his few possessions with him; it allowed the lord traveling from castle to castle to transport his belongings with ease. A well-filled chest could be a young bride's dowry, to be carried in procession from her parents' house to her future husband's. The chest would be placed next to the bed so that close watch could be kept over it, even overnight.

It was a versatile piece of furniture. It could be used as a bench or as a step for climbing up into a high bed. Nothing was thrown randomly into a chest; it had lateral shelves, which meant that small objects could easily be found. Linen and baby blankets were carefully folded; boxes were stacked by size. A strap held back the lid so that one could get hold of an item without risk of pinching one's fingers.

As storage evolved from the chest to the closet, the only change in how it was used was in posture. Medieval women had to kneel to take what they needed from a chest, whereas one stands upright before a closet. Over the centuries housework slowly but increasingly was done in a standing position, but medieval housewives lived close to the ground—crouching by the chest, bending over the fire keeping an eye on food as it cooked, sitting on floor cushions because the amount of seating was limited, hunkering in huge straw baskets or on low chairs close to the fire while changing infants. It took women several centuries to stand up again.

Another striking aspect of this depiction of the birth of John the Baptist is the warm, gentle atmosphere, the concern of the women for the mother and her newborn, the presence of domestic animals that are clearly well treated, and finally the other small child who is taking his first steps.

Jan van Eyck

Birth of John the Baptist

Miniature from *The Milan-Turin Book of Hours*, 1422

Museo Civico, Turin, Italy

FOLLOWING PAGES

Master of the Life of Mary

Birth of Mary, ca. 1463

Alte Pinakothek, Munich

Anonymous (Italian school)

Birth of the Virgin (panel of a predella), Veneto, Italy, ca. 1480

Christie's, London

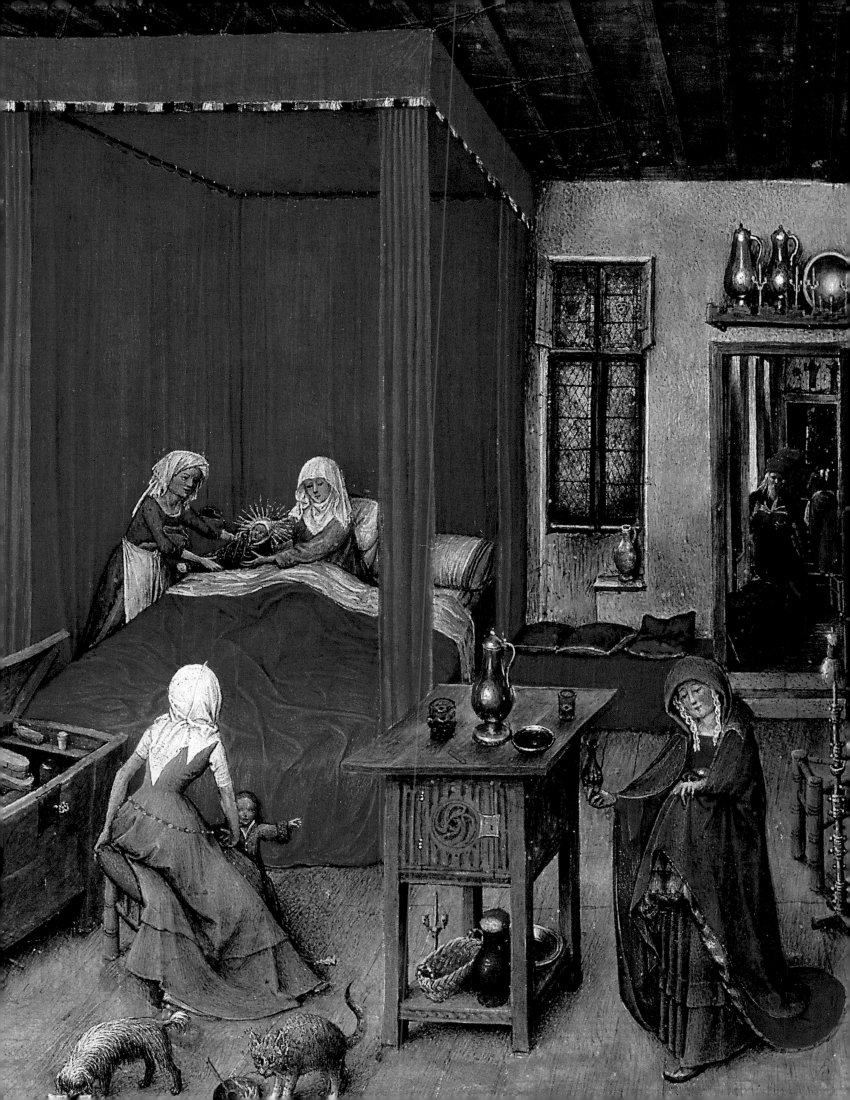

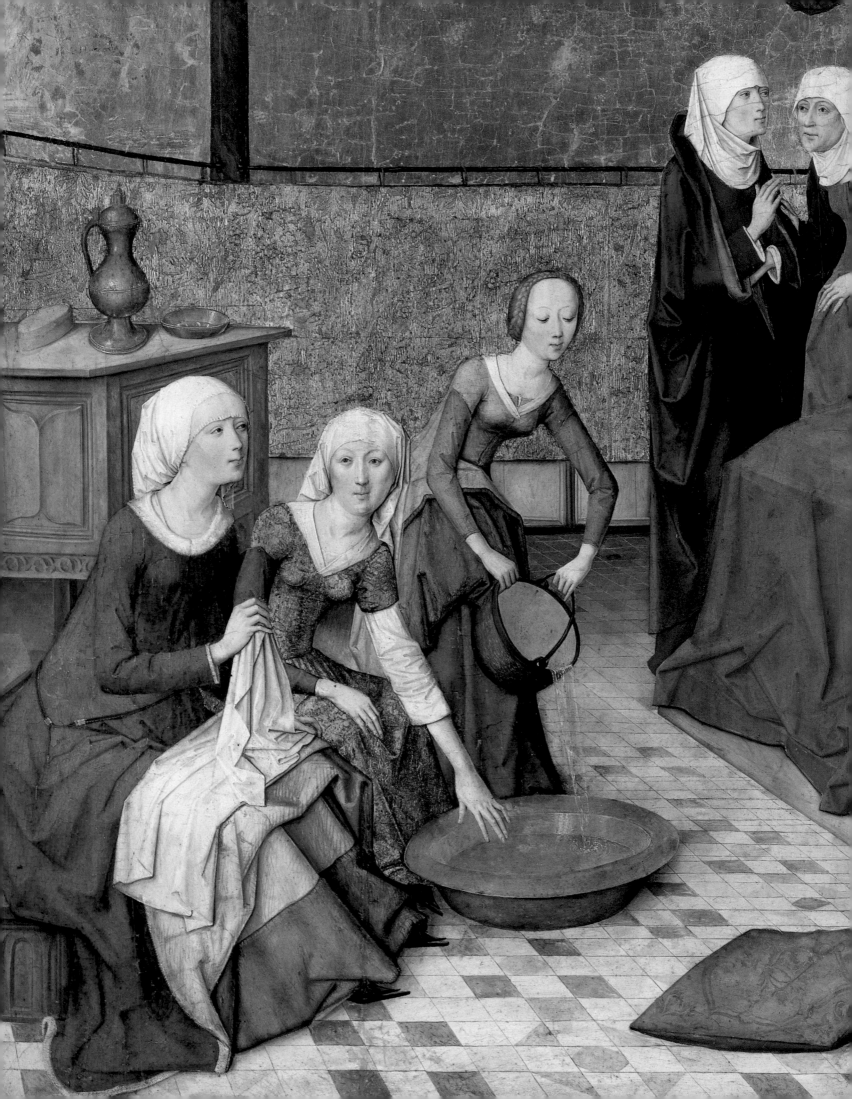

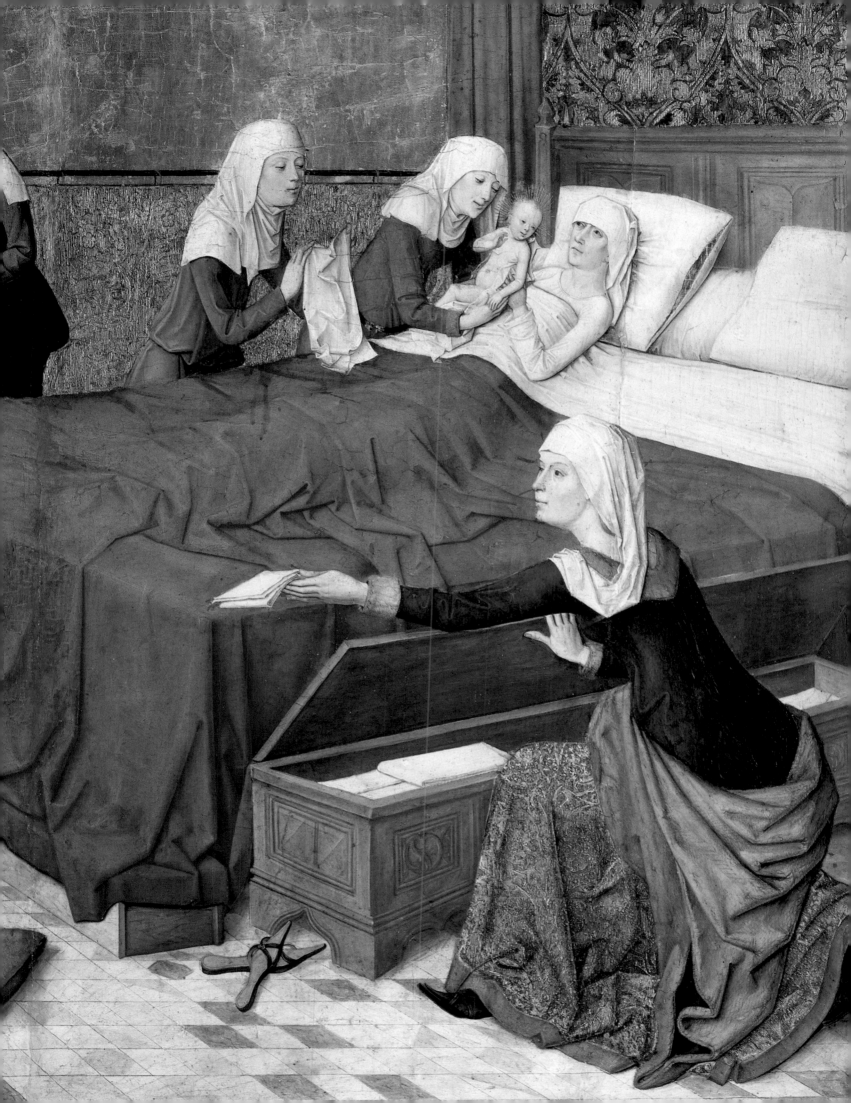

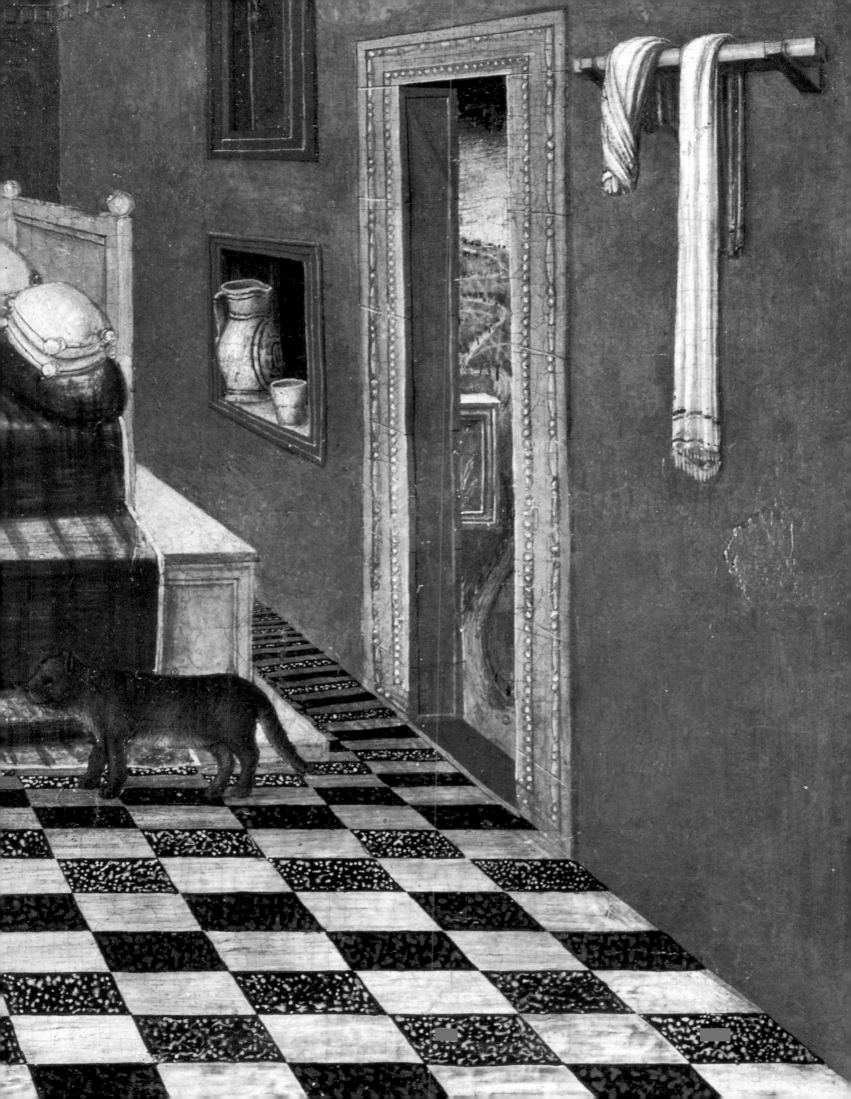

The Feminine Spirit of the Home

In this room not a square inch fails to convey a refined interest in decoration: the finely worked floor of ceramic tile; the walls covered with what is probably embossed, gilded leather; the piece of furniture (or perhaps paneling) that wraps around the room; the finely carved canopy bed, where the young mother is comfortably settled. Large pillows behind her, one of them checked, help her sit half upright. This propped-up posture is something of a precaution; it enables her to avoid lying flat as a corpse, a position thought to be especially dangerous after childbirth, when the mother and her baby are both very fragile.

A young woman kneels to prepare a long tub for the child's bath. With her free hand she tests the water's temperature. A light meal has been laid out on a table beside the bed, and another woman is bringing two eggs to the new mother to restore her strength. On the step by the bed we can just see the mother's tiny slippers; she will not use them for several days or perhaps weeks, as she will not be permitted to rise. A rather strange curtain hangs from a rail (possibly movable). It is likely there to keep out drafts—or perhaps to ward off evil spirits—especially when the baby is completely undressed for her bath, which the aproned woman bending gently forward will soon give her.

Master of the Upper Rhine

Birth of Mary (detail of a reredos in the cloister at Ottobeuren), ca. 1460–65

Württembergisches Landesmuseum, Stuttgart

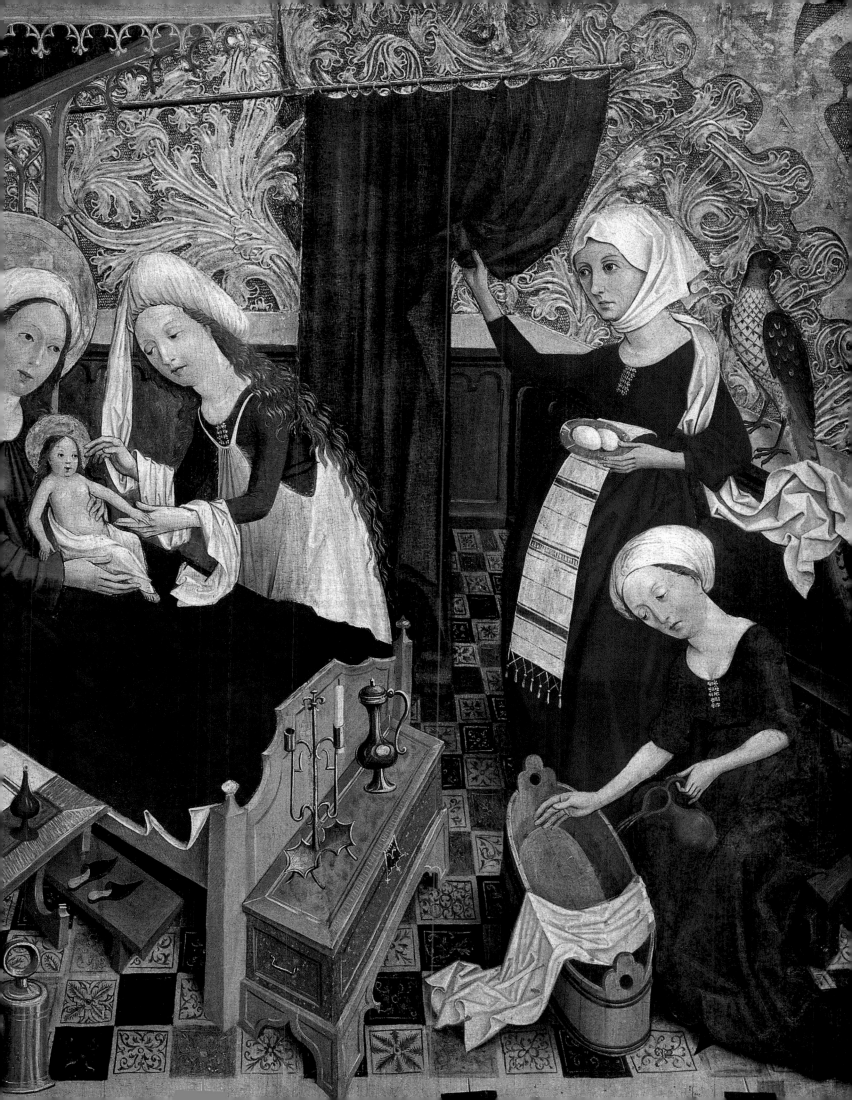

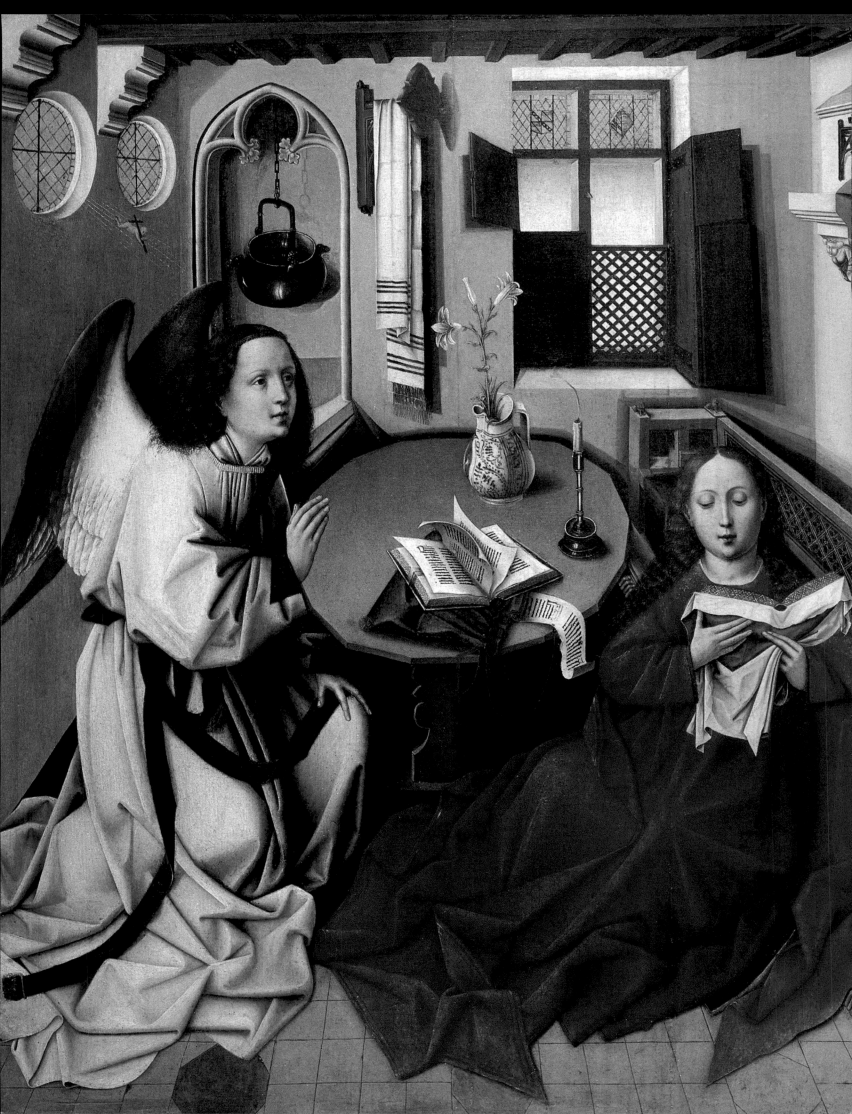

An Interior Space

Once we have absorbed the supernatural apparition of the angel announcing the miraculous news to the Virgin, the painter invites us to enter the room itself, thanks to the plunging perspective and the fascinating realism of the objects. We can see that the weather is mild. (The Feast of the Annunciation is March 25.) The window is open, and a slight trail of clouds passes in the sky. The shutters, depicted so clearly you could count the nails in them, are folded back inside the window. The upper section of the window has some diamond-shaped glass panes; the lower section has latticed panels to reduce drafts and protect the privacy of those inside.

In a gracious, contemplative pose that reflects her modesty, the Virgin is reading. She sits on the footrest of a bench whose back can be removed to allow the sitter to face the fire or turn a back to it; it's often necessary to change positions to remain comfortable in the winter. For now, the fireplace, with its fireguard and finely worked andirons, is empty, but the artist has not forgotten to show the black soot that covers it. The table base suggests that the table can be folded and moved according to need. The dining room does not yet exist; meals are eaten in different parts of the house depending on the season and the number of guests. Hanging in a niche is a cauldron filled with water. On the table is a vase of lilies—a symbol of purity—and some books, which still were so precious and rare that they were kept in cloth bags and read with a cloth in one's hand to protect the cover. Also on the table is a mysteriously smoking candle, which was probably blown out by the angel's beating wings.

Robert Campin

Annunciation (central panel),
ca. 1425

THE METROPOLITAN MUSEUM
OF ART, NEW YORK, THE
CLOISTERS COLLECTION

The Renaissance

The Drama of the Fireplace

By the end of the Middle Ages fireplaces attached to the wall were widespread in European houses, having replaced freestanding hearths in the middle of the room. The progress in their design (with a flue, a hood, and a cast-iron plate at the base) made the fireplace the focal point of the home, as it continued to be for centuries. Within its small stone temple the fire provided light, heat, and the means to cook food. It also sang and spoke: The fall of a log, a fire's inexplicable extinguishment, or its comforting crackle were all interpreted as omens and fed the dreams of those watching the flames.

Jean de Mauléon

February: Cooking and Feasting

Miniature, ca. 1525

WALTERS ART MUSEUM, BALTIMORE | MS W.449, FOLIO 3V

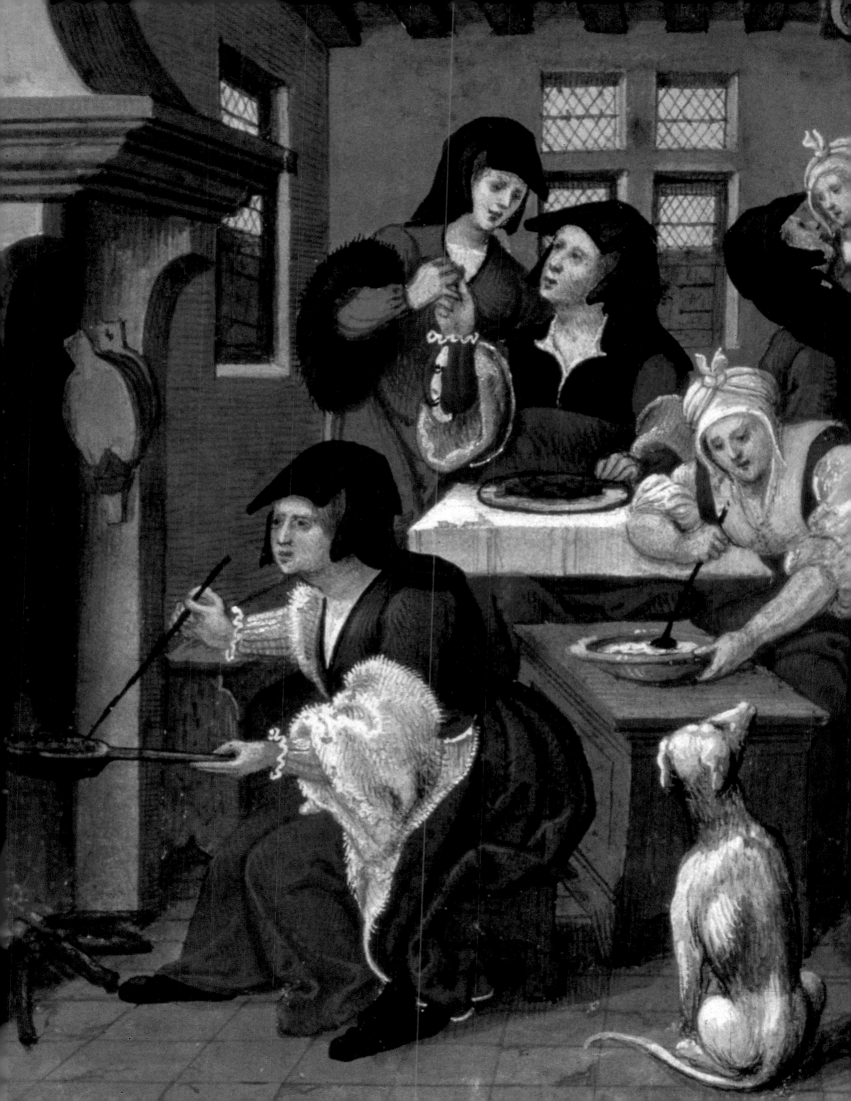

Strategies Against Winter

A man leaves a house with a pile of wood on his shoulder and a large pitcher in his hand. Is he going to deliver his logs, or some wine or water? Outside the street is covered in snow, and icicles hang from the eaves of the house opposite. Inside an older man in a fur-lined coat warms his hands over a brazier, while his grandson uses the bellows to rekindle the fire. As one might expect in winter, a woman is spinning wool, while some men in the back room seem to be playing cards. The bed is a sort of fortress, with its curtains rolled up around two of its thick posts to reveal a huge pile of mattresses, quilts, and covers almost worthy of the bed in "The Princess and the Pea."

It might seem curious that there is no fire in the fireplace on the right, but when people had things to do and could not stay by the fire, there was no point in wasting the logs. The shivering inhabitants have other ways to keep warm. The woman in the foreground slips a warmer under her garment. The wooden box on the floor behind the old man is another warmer, designed as a rest for frozen feet. Throughout the winter people used braziers of all sizes. warming pans and hot-water bottles to lessen the icy dampness of sheets, and portable warmers— even fake books made of earthenware and filled with hot water to take to mass. The struggle against the cold was a kind of incessant guerrilla warfare, with no hope of winning. At the bottom right of this painting, titled *The Month of January*, a humanoid cat with a nasty stare seems to reproach us across the years for our well-heated homes.

Cristoforo Rustici

The Month of January,
16th century
PALAZZO PUBBLICO, SIENA,
ITALY

FOLLOWING PAGES

Flemish School

Kitchen Interior, Supper at Emmaus, 16th century
MUSÉE DES BEAUX-ARTS,
LILLE, FRANCE

Vincenzo Campi

The Kitchen, 16th century
PINACOTECA DI BRERA, MILAN

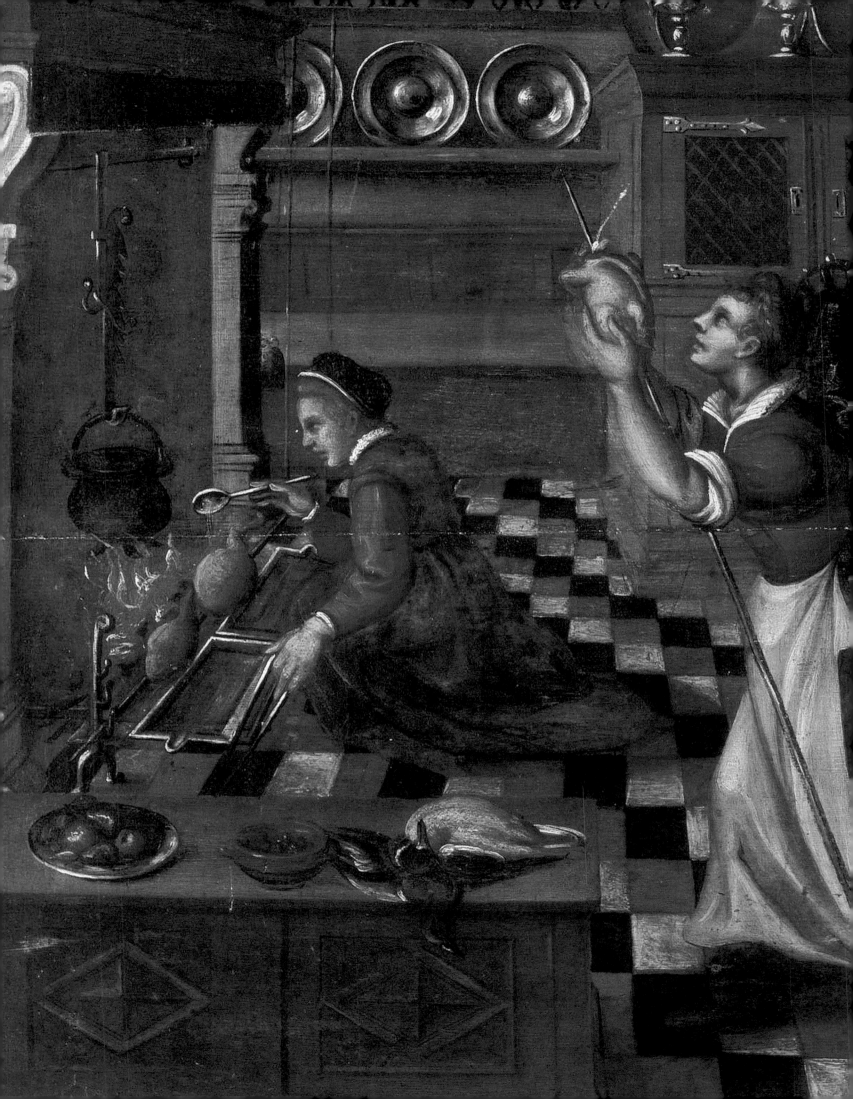

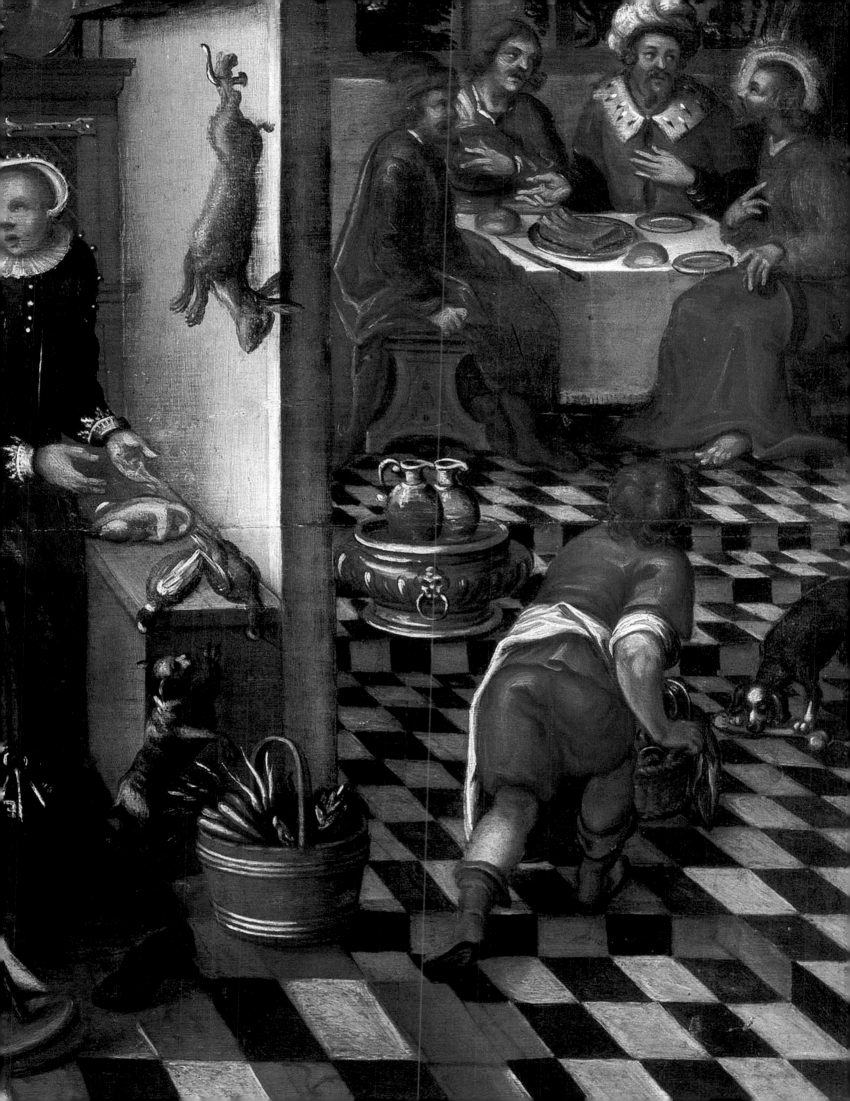

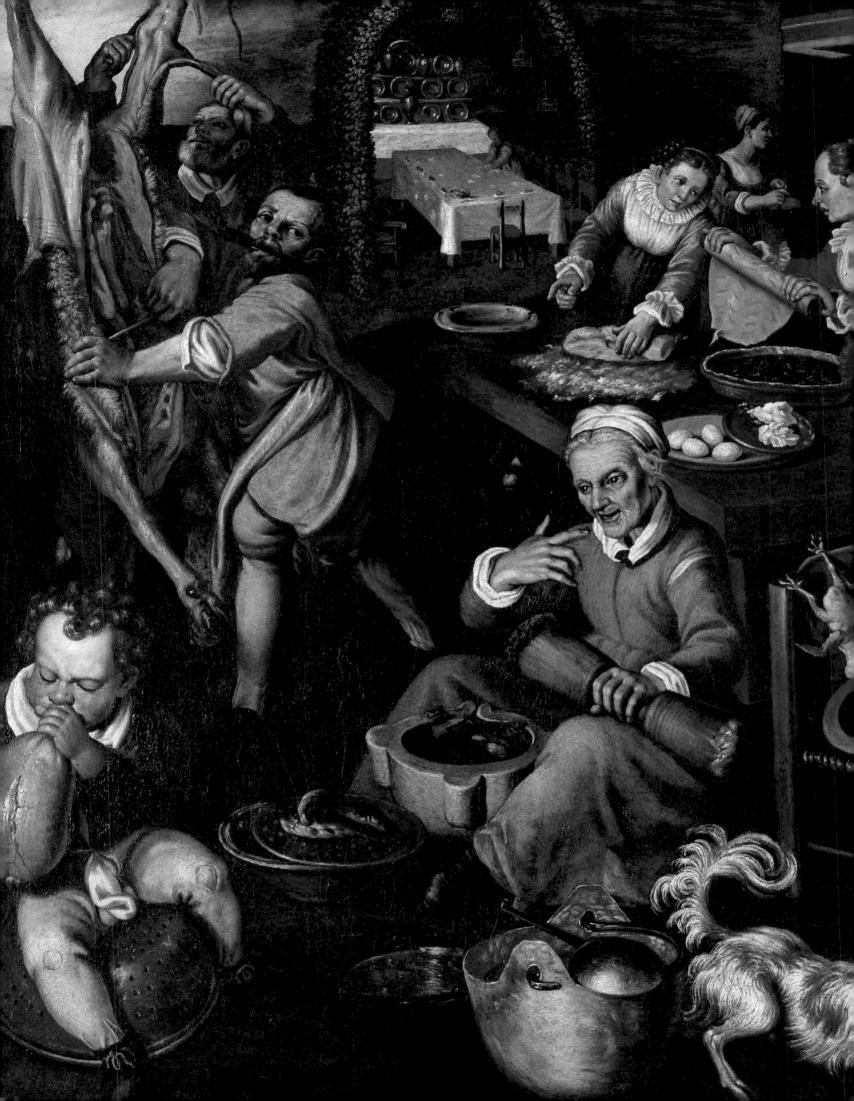

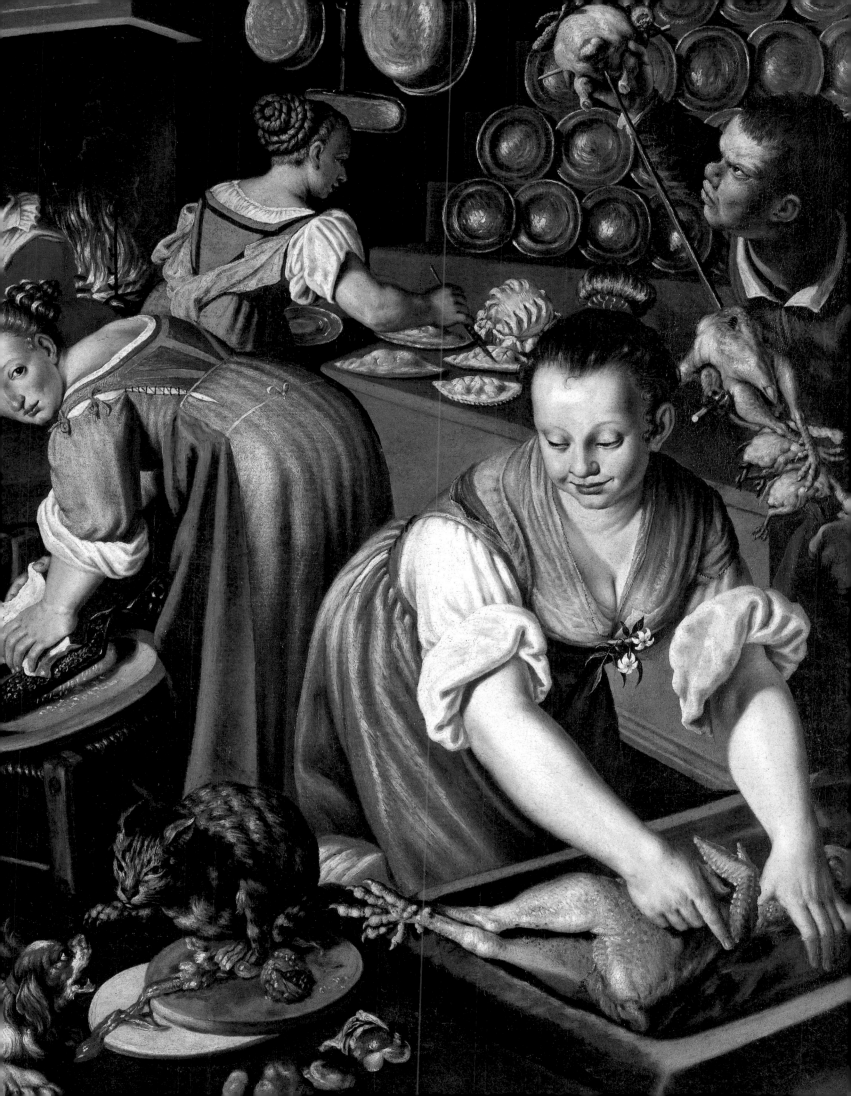

Fire in the Home

It is so cold out! From inside the house the child unashamedly pees out onto the snow, enjoying the picture he makes with his jet, as boys have done throughout the ages. His mother is spinning wool, with a distaff in her hand and a smile on her lips. Her husband has lifted his tunic up over his thighs to make the most of the heat from a fire burning at ground level. At this time having a proper fireplace was the sign of a certain prosperity; it indicated that the home-owner had at least one wall made of nonflammable material—stone or brick—and that the wall was thick enough to accommodate a flue. That is not the case in this house, where the cob is flaking off in places and exposing the wattle, the lattice of interwoven branches that forms the framework of this modest cottage. The fire's smoke can escape through a skylight with a valve. Even so, with no chimney and no hood, the smoke was bound to spread throughout the room. This was not a problem, however, since soot, ashes, and smoke were regarded as beneficial. The ashes fertilized the soil and were used to make a kind of soap, while the smoke kept out insects and evil spirits, drove away the vermin that gnawed the thatch roof, and was used to preserve hams. Its reassuring smell was among the house's essential features. In fact, the opening in the roof was sometimes placed away from the fire, instead of directly above it, to conserve more of the beneficial smoke. The emotive and symbolic power of the fire was such that in the sixteenth century the French word *foyer* came to mean not just *hearth* but also *home*.

When children today are asked to draw a house, they never forget the chimney and its plume of smoke. But it was not until the end of the fifteenth century, when the peasants' standard of living and the construction of their houses improved, that chimney stacks began to appear on roofs and become a permanent feature of our landscapes.

February: Peasant Life

Miniature from *Breviarium Grimani*, 16th century

BIBLIOTECA MARCIANA, VENICE | FOLIO 2V

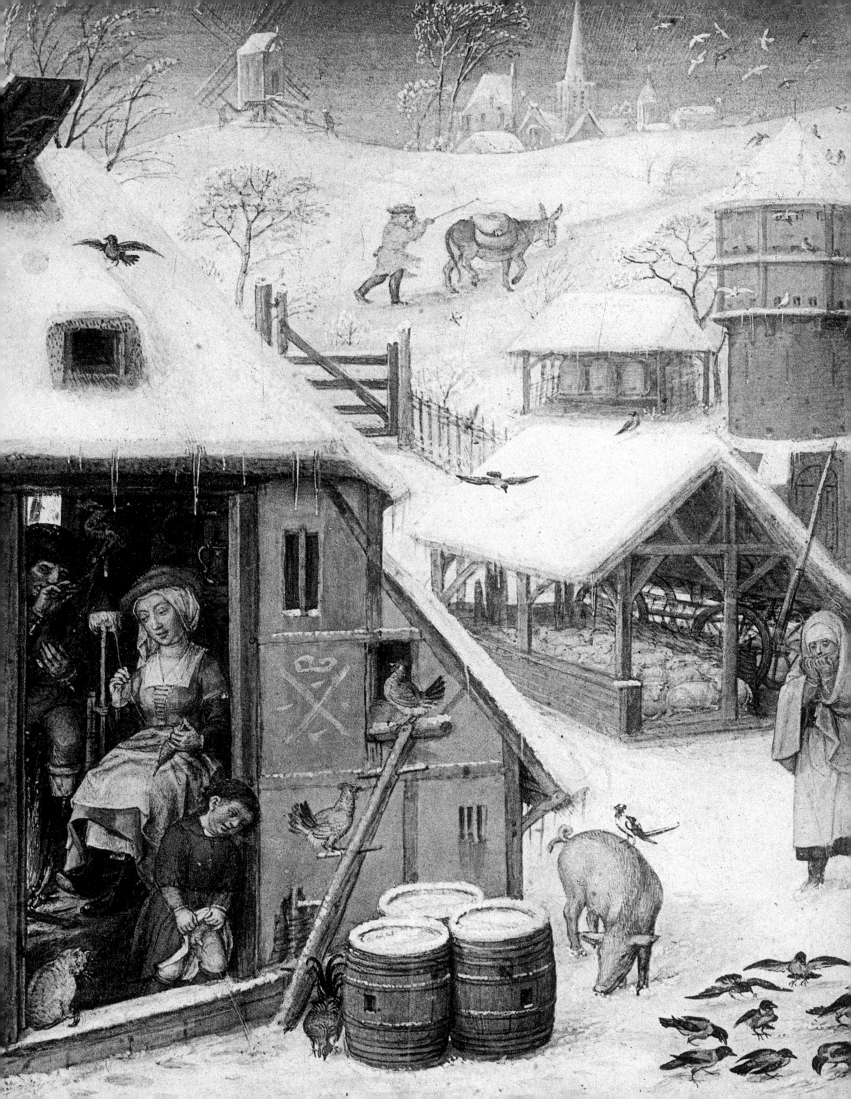

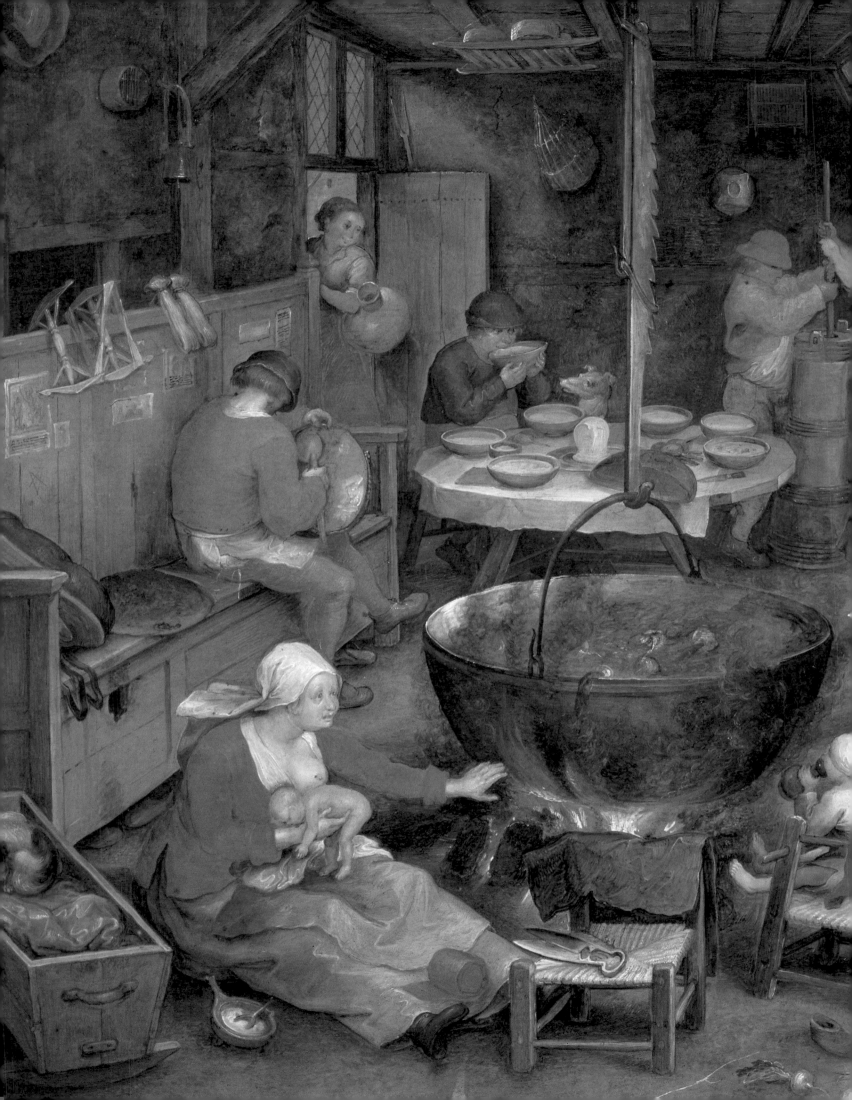

The Warmth of Overcrowding

One could spend hours examining the details of this work by Bruegel the Elder. What is immediately striking is the central fire on which an enormous pot of beer, hanging from a trammel of equally impressive proportions, boils away. Sitting on the ground by it is a mother who has just fed her baby and is now drying its bottom by the heat of the fire. On the floor beside her some baby food is cooling; the child is already being weaned. A dog rolled into a ball is asleep in the cradle. Ignoring all the rules of hygiene, the mother does not chase it away. Between her legs is a roll of red cloth she will use to wrap up the baby. Another child sits in a low chair that has a wooden bar to prevent its young occupant from falling forward. Lost in his own daydreams, he watches the fire as he drinks his bottle. A third child, barefoot and looking rather vacant, is staring at the charitable lady who is about to give him a penny, while his father, standing just behind, thanks the man who is offering him a loaf of sugar. Farther back, a couple incessantly churns butter; they cannot break off from their task despite the masters' visit. On the left, a man sitting on a chest scours a cooking pot, while the ravenous man at the table drinks his soup straight from the bowl, ignoring the large wooden spoons lying on the tablecloth. A woman with pink cheeks and a pitcher on her arm is going out to fetch water.

Hanging on the wall are the family's meager possessions: a birdcage, a bell, a hat, some cheese molds, a poultry basket. The bareness of the house's decor is in inverse proportion to the density of its population. The room teems with the human presence of the generations mingled together. The lack of privacy may seem unbearable to us, but not to people of the time. It had not yet occurred to anyone apart from madmen and eccentrics that it might be possible or desirable to live in isolation.

**Jan Bruegel the Elder,
known as "Velvet Bruegel"**

Visit to the Farm or *Visit to
the Wet Nurse*, ca. 1597

Kunsthistorisches
Museum, Vienna

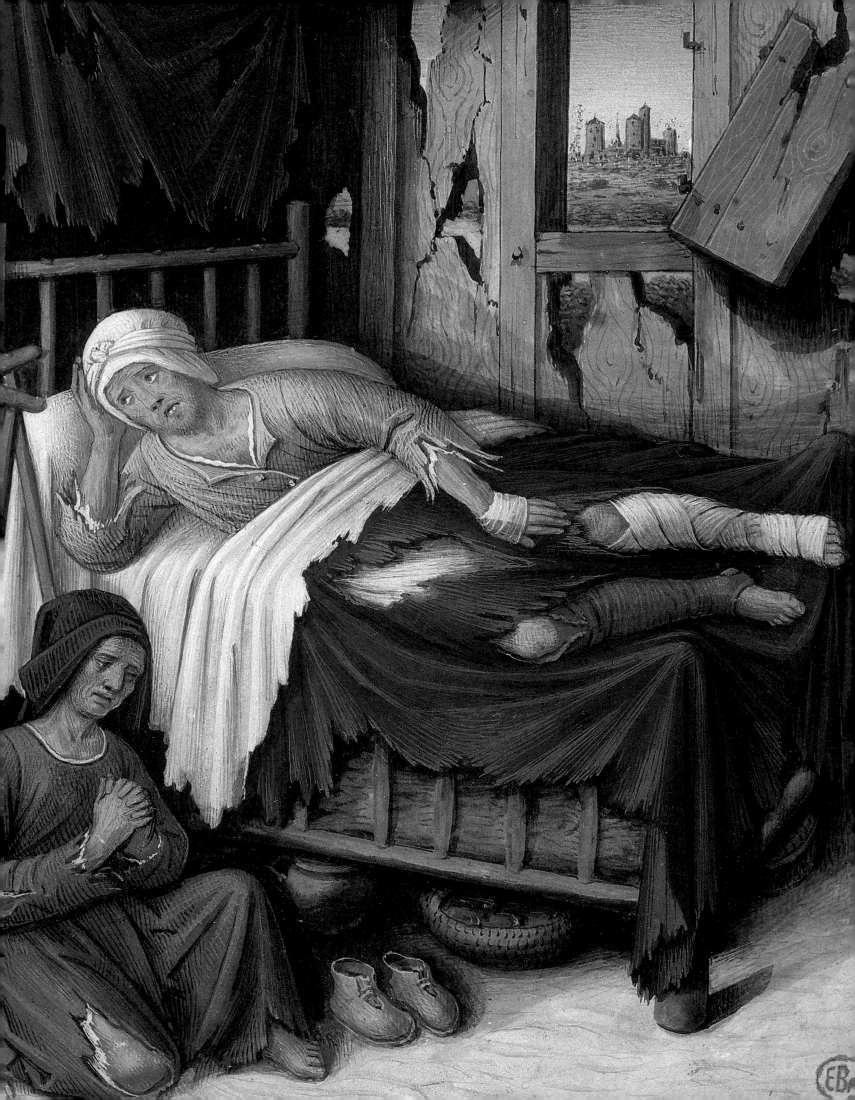

The Poor Man's Bed

Grinding poverty, chronic malnutrition, and disease were the lot of the poorest peasants. In a ruined house, open to the four winds, with holes in the roof, crumbling walls, and a tattered drape, a sick man lies on his bed. The peasant house—with its simple wooden framework, cob walls, and thatch roof—was made entirely of materials that rapidly deteriorated if not maintained, almost as if the cottage were trying to return to the landscape from which it had come. If the owner were struck down by illness or infirmity, his house quickly revealed the marks of his destitution.

The man lies on the bed holding his head, his legs poking through the torn sheets and bedcover. Bandages cover the sores on his hand and calf. A pair of crutches leans against his pillow. A woman sits below him praying for his recovery, with no hope of help other than that which might come from heaven.

This painting by Jean Bourdichon demonstrates the extent to which bedding reflected a home's prosperity. Low beds or, worse still, straw mattresses laid on the ground were evidence of the most extreme poverty. At this time getting into a proper bed meant climbing up over the chests around it, the wooden platform on which the bedstead stood, and a heap of eiderdowns and bedspreads. The bed's seemingly inconvenient height was deliberate, to keep its occupants far from the floor, which was always cold and not always clean. The higher the bed, the greater the display of its owners' wealth. For the more humble, the cost of this essential piece of furniture and its paraphernalia often represented several years' wages.

The affluent used linen or hemp sheets, woolen blankets, sometimes lined with fur, pillows and comforters stuffed with feathers or, even better, with down, and wool or cotton mattresses. Poorer people generally had to make do with coarse cloth sheets, worn, patched blankets, and simple straw or heather mattresses. When the straw fell to dust they could replace it for next to nothing. In 1517 the servant of the cardinal of Aragon complained that, while making a journey, he and his master had had to sleep "on small straw beds, with no sheets, and coarse sheepskins for blankets." Given the conditions, one can understand why, despite the vermin and parasites, peasants preferred to sleep with their animals, whose large bodies provided a kind of natural central heating.

Who today can remember how fragrant and rustling mattresses used to be? The book L'Ostal en Margeride included this 1910 account by A. Prugne: "On a dry day in November, when the leaves in our mattresses are worn out, my father borrows a horse and cart, and with half a dozen empty sacks and two rakes we go off to the great beech forest. We arrive at the spot. Under the bare trees lie the beautiful red or coppery leaves, tinted by the autumn and recently fallen, covering the ground with a sumptuous carpet. They are perfectly dry, and with the help of our rakes we gather them up in heaps under each tree and fill our sacks with them. Once the sacks are well filled and loaded on to the cart, we start back on the way home. . . . In the evening, our mattresses stuffed with new leaves are voluminous, and rustle as we move about on them."

Jean Bourdichon

The Four Conditions of Human Life: The Poor Man, ca. 1505–10

École Nationale Supérieure des Beaux-Arts, Paris

The Chamber of Dreams

Although she appears to be sleeping peacefully, with her cheek resting on her hand, the princess who would become Saint Ursula is in fact having a terrible dream: An angel has come to announce her imminent death. In this famous painting Carpaccio captures Ursula's wonderfully refined room momentarily suspended between silence and grace. It is illuminated both by the angel and through a door on the left that opens to an adjoining room. In front of the wicker-screened windows are tall plants one can imagine swaying gently in the breeze, one of which bends under the weight of the chaffinch perched upon it. From the small desk, pen, writing case, and shelves lined with precious books we can tell the resident is a cultured woman. Above a finely carved armchair is a reliquary in which a pious image is lit by a candle, with a small container of holy water and a sprinkler. At a time when people were born and died at home, it was essential to be able to baptize a newborn child quickly if it looked too weak to survive, or to bless the mother if she developed puerperal fever. The sprinkling of holy water was regarded as a protective measure for any illness.

This room seems to be a place of contemplation and introspection. It gradually reveals the occupant's desire to withdraw to pray, as well as to dream and to think. Saint Ursula's bed has an elegant fringed canopy supported by slender turned-wood columns. According to the historian Peter Thornton, the canopy would usually have had curtains hanging from it; they were removed in summer and rehung as soon as the weather turned chilly. Canopies suspended from the walls by ropes, curtained wooden frames hooked to the ceiling, alcoves, and box beds: All were designed to turn the bed into a kind of tent or enclave within the house and were appropriate responses to the implacable siege the cold laid to sleepers each winter.

Vittore Carpaccio

The Dream of Saint Ursula,
1495

GALLERIA DELL'ACCADEMIA,
VENICE

The Seventeenth Century
Holland Invents the Well-Ordered Household

Women who chop onions, peel turnips, keep everything neat and tidy, fold away the linen, polish the copper, and sweep floors that are already gleaming: That was the favorite theme of painters in the Dutch Golden Age. Housewives were bestowed with a new status that reflected the nobility of their task, thankless and tedious though it was: restoring order time after time to the gathering chaos, and also enjoying the gentleness and humanity of the home.

Nicolas Maes
The Sleeping Servant, 1655
SOTHEBY'S, LONDON

The Smell of the Home

With one foot perched on a foot warmer the mother wipes her baby's bottom with a blue cloth. The other children, who were just about to eat their porridge from the communal bowl sitting on a block of wood, are vigorously protesting the smell. The father laughs at their comically outraged expressions while drying what appears to be the infant's urine-soaked blanket by the heat of a small brazier on the floor. One can well imagine that the baby's bedclothes were not washed every time he soiled himself. Parents couldn't have washed them even if they wanted to, since they had no spare linen.

Although this amusing peasant scene by Adriaen van Ostade shows children conspicuously holding their noses, it should not be forgotten that people's tolerance of odors at this time was greater than ours, living as we do in deodorized or even perfumed homes. Here, a heap of manure sits close by in the yard, and the hens leave their droppings when they waddle into the house to peck at the grains that have fallen from a sheaf hanging from the timbers. The bottom half of the Dutch door can be closed to keep the hens out, while the top half is left open to let in the light, since the poorest houses had no windows.

The distinction between inside and outside was not as clearly defined then as it is today. There was no visible demarcation at the threshold, since the packed-earth floor of the house was only slightly better than the ground outside. It was never significantly warmer inside the home than outside, so people lived mainly in the open air, moving around continually—working in the fields or the vegetable garden, fetching wood, water, or grass, going to the communal oven, and visiting their neighbors. The house was primarily where people ate and slept, and where they were born and died.

Adriaen van Ostade

The Toilette, 17th century

Musée Municipal, Laon, France

FOLLOWING PAGES

Jan Victors

Peasant Family Eating Galettes in a Rustic Interior, ca. 1650

Musée de Picardie, Amiens, France

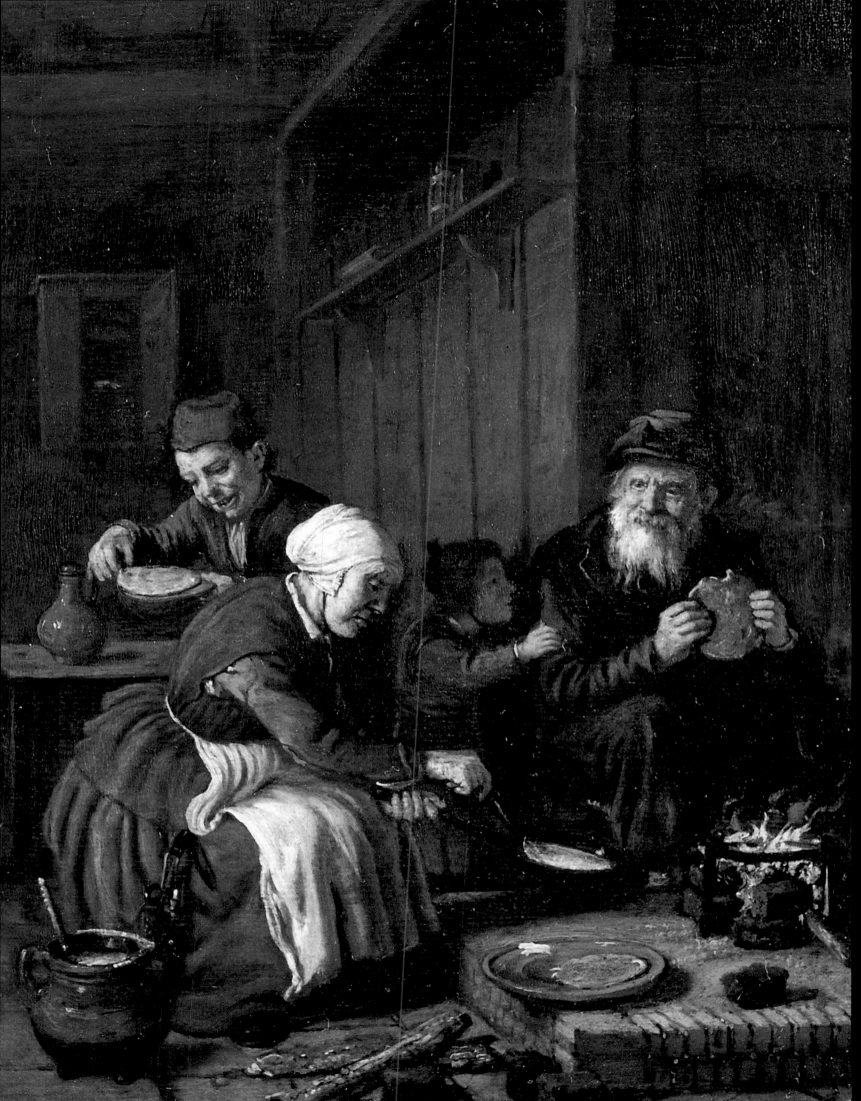

The Simple Well-Being of Peasants

The little boy who has just learned to walk would like to lean out of the window like his big brother. The window has panes of glass, which suggests that peasants in Holland had a somewhat higher standard of living than their French contemporaries.

The room is rather neglected, however, and the floor is not very clean, with a carrot, a turnip, some pieces of firewood, and broken pottery scattered here and there, despite the broom leaning against a barrel on the left. But the atmosphere is good-natured, and everyone appears to be at ease in this rustic setting. The baby, sitting placidly in his box seat, has nothing to play with but a wooden spoon. The father smokes his pipe, holding a pair of tongs in his hand so he can pick up a live ember should he need to relight it.

His wife is sitting on an upturned basin that is sometimes—but not very often—used to wash the dishes. Most of the time dishes were quickly rinsed in rainwater that had collected in a barrel standing under a gutter outside. In any case there weren't many dishes to wash: People often ate from a communal bowl, drank straight from the jug or the ladle, and had no qualms about wiping knives on their thighs. Yet they had very few clothes: two or three skirts or pairs of pants, usually black or gray, and a few shirts. The clothes were always made of hemp or linen, the thread for which was generally produced at home, as shown here by the clump of fibers and the spool of thread on the floor near the window. In his 1982 book about peasant life in the seventeenth century, the historian Pierre Goubert described what our laboring ancestors' wardrobe must have been like: "Clothes for everyday use, a coat, a smock, an apron, hanging on nails or pegs, all of them very worn, never washed, and handed down, it seems, from one generation to the next, with each woman resewing or patching them with whatever pieces of material could be found from another altered garment."

The painting does indeed show a dark-colored apron that is almost in tatters thrown over the banister. Hanging from the ceiling, right by the inside shutter, are some onions, which are held up by a rope hooked to a nail. Despite the house's simplicity there is a fair amount of furniture: a wall-mounted cabinet, a carved sideboard, a chest by the fireplace, a table, a chair, a small stool with a candle on it, a ceramic dish hanging on the wall, a halberd mounted over the stairs, a tankard. All the clothes, furniture, objects, and utensils have been well worn by time, soot, or sweat. In the past, however, signs of wear and tear on everyday items were not seen as marks of poverty; they were actually valued. We who live in a culture of disposables might find it difficult to imagine that, traditionally, the new was suspect—even to be feared. People then threw nothing away, not even pieces of broken pottery like those lying all over this room. Such items, which we would consider rubbish, were included in the inventory of possessions upon the owner's death.

Adriaen van Ostade

Peasant Family at Home, 1661

MAKINS COLLECTION,
WASHINGTON, D.C.

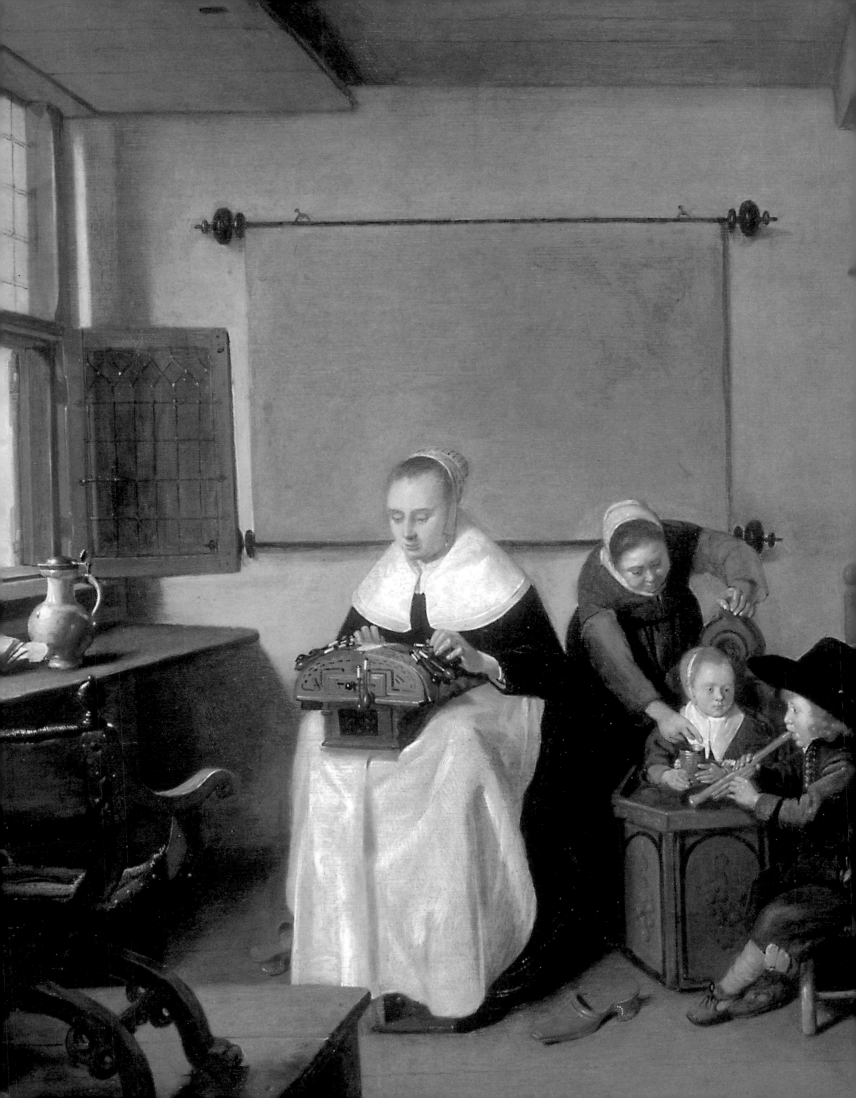

The Benefits of Half-Light

In a dimly lit interior a mother wipes her baby's chubby bottom, while a young child sitting in the doorway pulls his sock up, or perhaps scratches himself. (Painters were quite willing to show people searching themselves for fleas or lice.) Nowadays we regard a dark house as inexcusably flawed, but in the past people liked the half-light. The home's few openings, low ceiling, and walls blackened by the smoke from the fire created an atmosphere they found enveloping and protective.

To make the most of what light there is, a table—or perhaps a workbench—has been set up along the windowed wall. Up until the industrial age the home was also the workplace, and in artisans' homes the workshop and the communal room where their family lived were sometimes one and the same. As a result, work and domestic life were inextricably linked.

Once again the floor is strewn with turnips, carrots, a cabbage, crockery, and spoons. Perhaps the vegetables have just been picked from the kitchen garden and simply left on the floor, still covered with earth, before being washed in the basin on the right and made into a soup. Vegetables were used as they were harvested. At the end of the summer the fruit from the orchards was left to dry on racks in the barn. A larder (which was sometimes locked) usually held a piece of bacon and some bread—and that was about all. The ceilings were low enough to be used for storage, and all sorts of things were hung up there. Hanging from this one we can see some clothes, a copper pot, and a lantern.

Thomas Wyck

Rustic Interior, ca. 1660

Musée d'Art Thomas-
Henry, Cherbourg, France

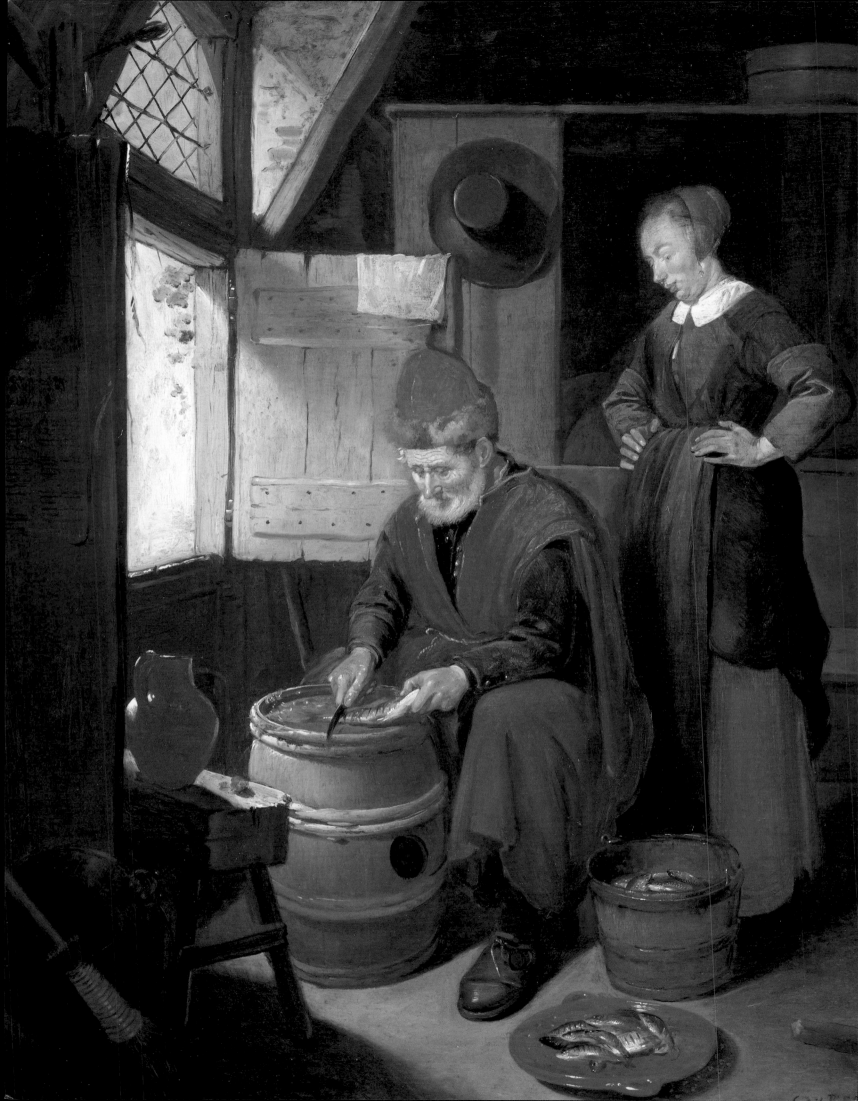

Quiringh Gerritsz. van Brekelenkam

Couple in an Interior, 1657

Johnny van Haeften
Gallery, London

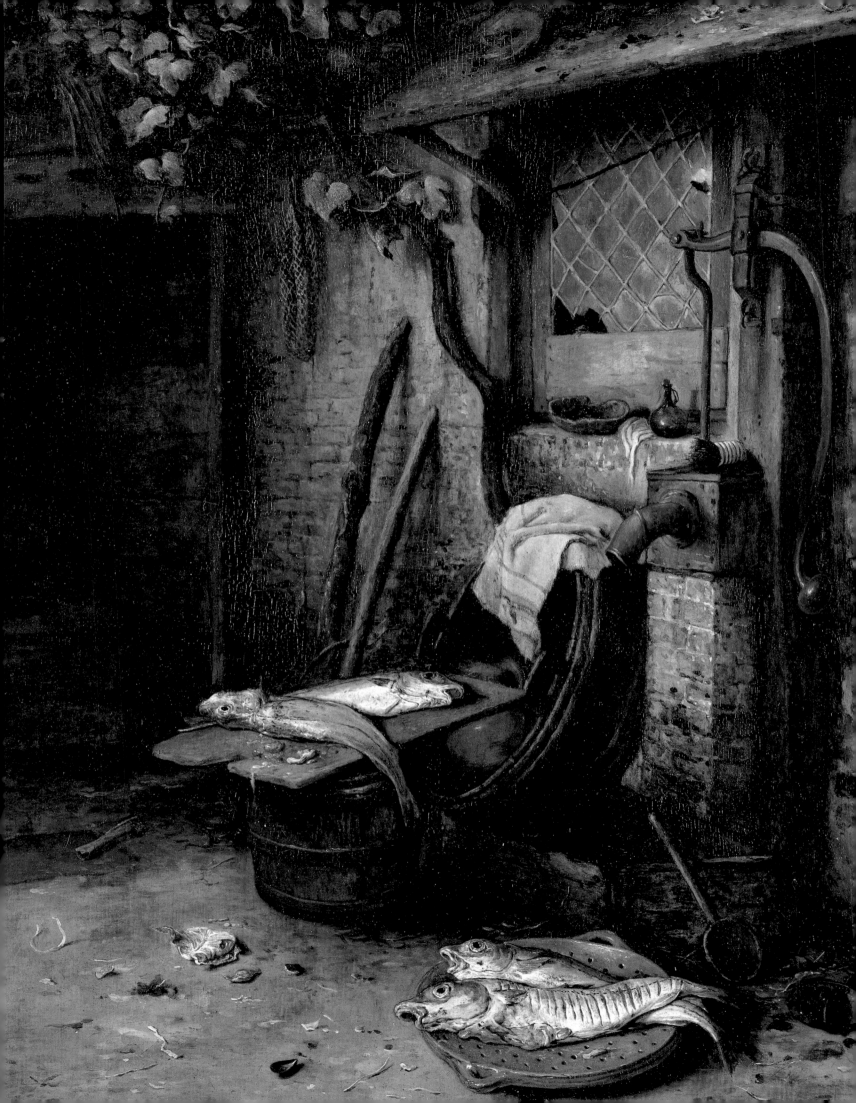

The Price of Water

Under the vine in the yard some fish have been placed on a plank that is balanced on a small barrel, where they will be gutted and scaled, then washed at the pump. Leaning against the wall beside the pump is a washtub with a pitcher set inside and a cloth thrown on top. On the pump lies a short, stout brush. The window has several panes, some of which have been repaired. Despite the rustic, almost dilapidated look of the place, it has the great advantage of access to a pump like this.

In the past providing water for the home weighed heavily—both literally and figuratively—on people's daily lives. The difficulties involved in procuring it profoundly affected both bodily habits and the belief in the value and power of water. Water weighs more than eight pounds per gallon, and transporting it was one of the unavoidable chores of country life, carried out mainly by women and children. The proximity of the water supply—a well or a pump, sometimes inside the house (the ultimate luxury) or in the farmyard; a tank for collecting rainwater; or a fountain in the village or town square—was significant in a way we can hardly imagine in the modern world, where we turn on the faucet without even thinking. Heavy wooden water buckets with iron hoops banged into the legs of those carrying them. When they had to walk a long distance, people learned to add outer hoops to keep the buckets away from the body. In towns people hired the services of water carriers, but it was best not to be too particular about the quality of the water.

In the eighteenth century Louis-Sébastien Mercier commented on these arrangements in his *Tableaux de Paris*—not with alarm, but with a kind of complaining resignation. "In Paris we buy water. Public fountains are so rare and so badly maintained that people resort to the river; not a single bourgeois home is supplied with water in sufficient abundance. From morning till evening, water carriers climb with two full buckets from the first to the seventh floor, and sometimes beyond. A standard measure of water costs six farthings or two sols. If the carrier is strong, he makes thirty journeys a day. When the river is cloudy, we drink cloudy water. We are never quite sure what we are swallowing; but we keep on drinking. The water from the Seine loosens the stomach, for anyone who is not used to it. Foreigners rarely fail to experience the inconvenience of a little attack of diarrhea." If the summer heat dried up the rivers, lakes, and ponds, the cities' populace suffered. People even died of thirst. Fighting would break out around the water supply points where a meager trickle of water was still available.

During that period, a terrible drought broke out in Saint-Cézaire, recounted Jean-Pierre Goubert in his 1986 book *The Conquest of Water*: "A small fortune was offered to 'water diviners' who discovered a new spring. On the day the fountain was blessed, tears of joy flowed on every cheek."

Adriaen van Ostade

The Water Pump, 17th century

Corporation of London,
Harold Samuel Collection

FOLLOWING PAGES

Ludger tom Ring the Younger

Kitchen in Westphalia,
ca. 1600

Westfälisches
Landesmuseum für Kunst
und Kulturgeschichte,
Münster, Germany

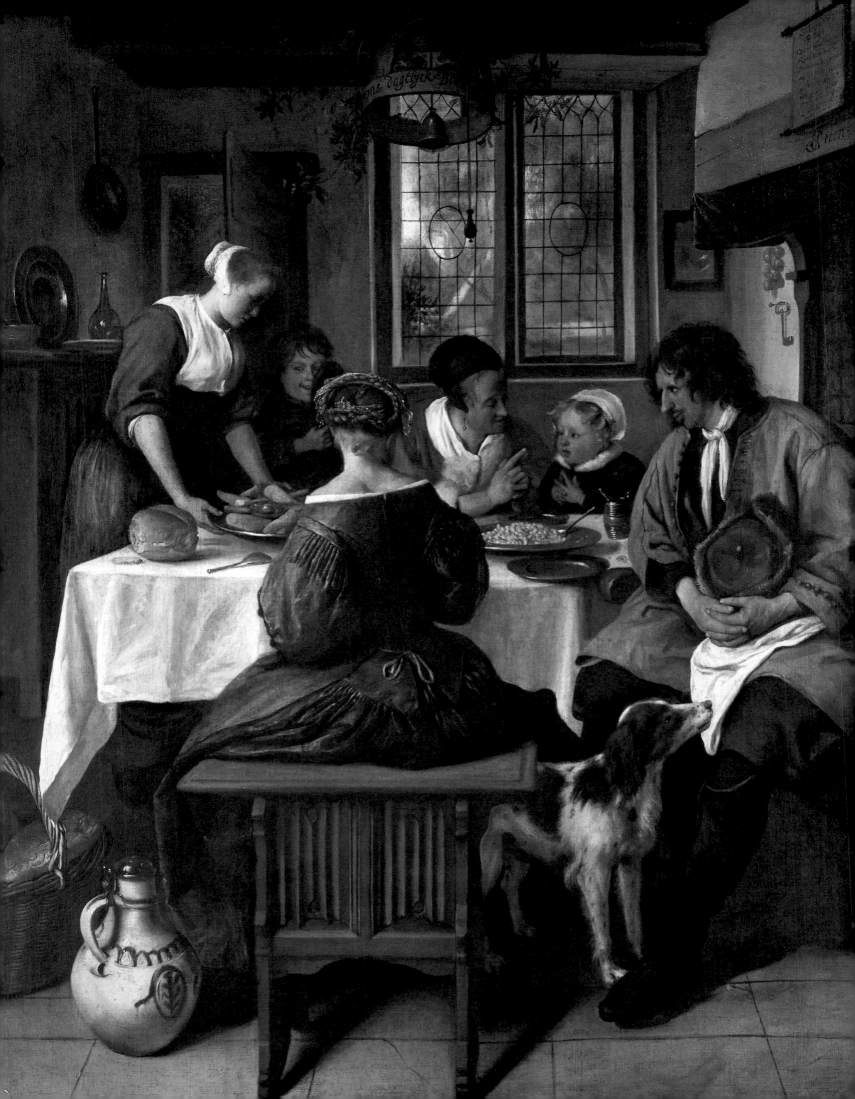

The Family Meal

Before eating the mother teaches her little daughter to join her hands to say grace. The father, who with his thick lips bears a strong resemblance to the painter, Jan Steen, seems rather to be ogling the young serving girl who is bringing a dish of carrots and parsnips to the table, while his son cannot resist chuckling behind his hat during the prayer. Sitting on a finely worked piece of furniture that is both a stool and a small sideboard, the daughter of the family has her back turned to us, so that all we can see of her is the nape of her pale neck, her bronze silk dress, and the ribbons in her tied-up hair. The white tablecloth is laid with a dish of beans and a loaf of bread. The meal is quite simple but perfectly sufficient.

From the ceiling hangs a wooden crown decorated with oak leaves, which symbolize marital fidelity. The key hanging on the wall is supposed to represent the household's decency. The half-open door and the slight view of another house through the window remind us of the link between this family and the rest of the community, while at the same time emphasizing the private nature of the meal, which is a time of devotion and intimacy. All the objects that appear in the Dutch paintings of this period had hidden meanings, many of which have been forgotten today; they frequently referred to the Bible, and the cultivated art buyers of the day were able to decode them without difficulty.

Many artists, right up to the twentieth-century American painter Norman Rockwell, depicted moving scenes of these premeal prayers, which remind those about to eat their fill that not everyone has the same good fortune. In Steen's slightly mischievous painting we also see a happy, private, and true-to-life moment in the day of a seventeenth-century Dutch family, whose postures at table indicate little respect for protocol. The boy appears to be standing up.

The father is seen in profile, sitting in the corner with his pewter plate, his dog between his legs. As often happens when the table is too small, a large jug and a basket full of round loaves are sitting on the floor. (In other works by the same artist, a barrel or a bench serves as an improvised sideboard.) In the paintings and engravings of Adriaen van Ostade, who depicts humbler families, people eat off blocks of wood or three-legged stools. The meal was not yet a sacrosanct occasion at which diners sat facing their plates, seated at regular intervals around the table. There were still no place settings to delimit the small, inviolable territory we expect today. For another century at least, eating at table would remain pleasantly informal.

Jan Steen

The Prayer Before the Meal, 1660

Belvoir Castle, Leicestershire, England

FOLLOWING PAGES

Wolfgang Heimbach

Kitchen Interior, 17th century

Germanisches Nationalmuseum, Nuremberg, Germany

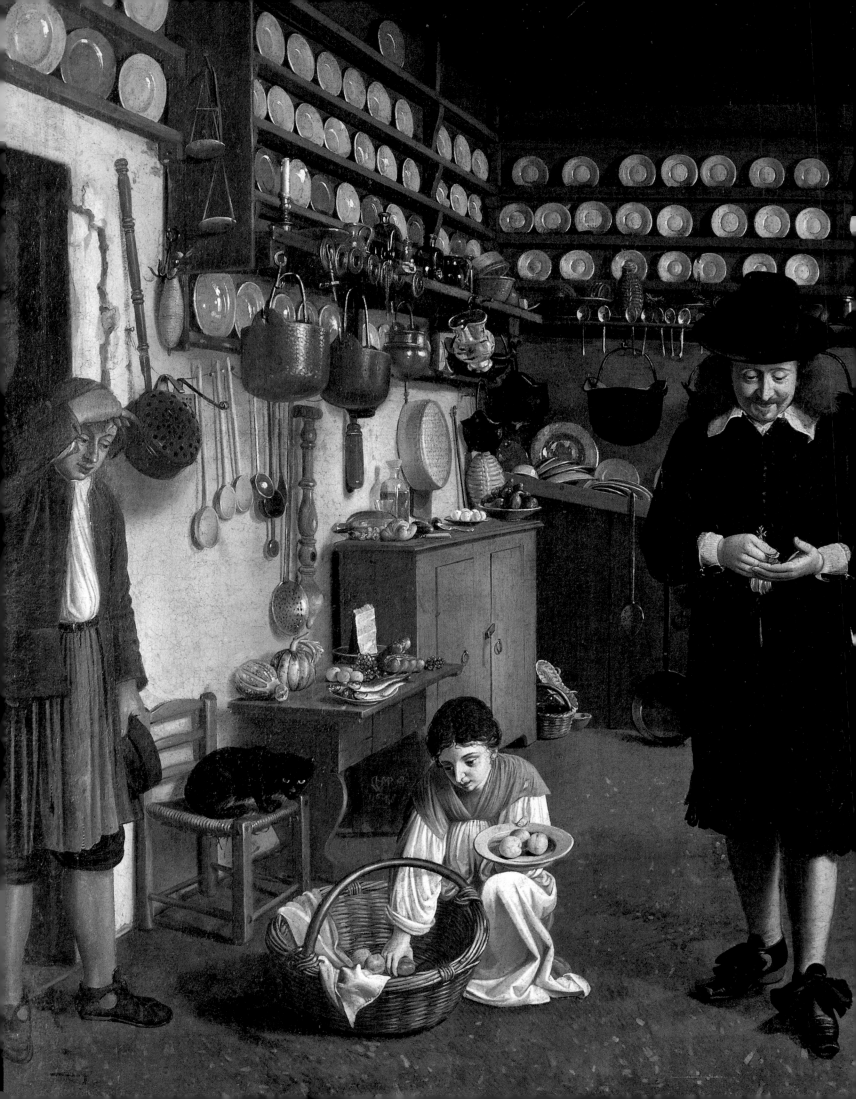

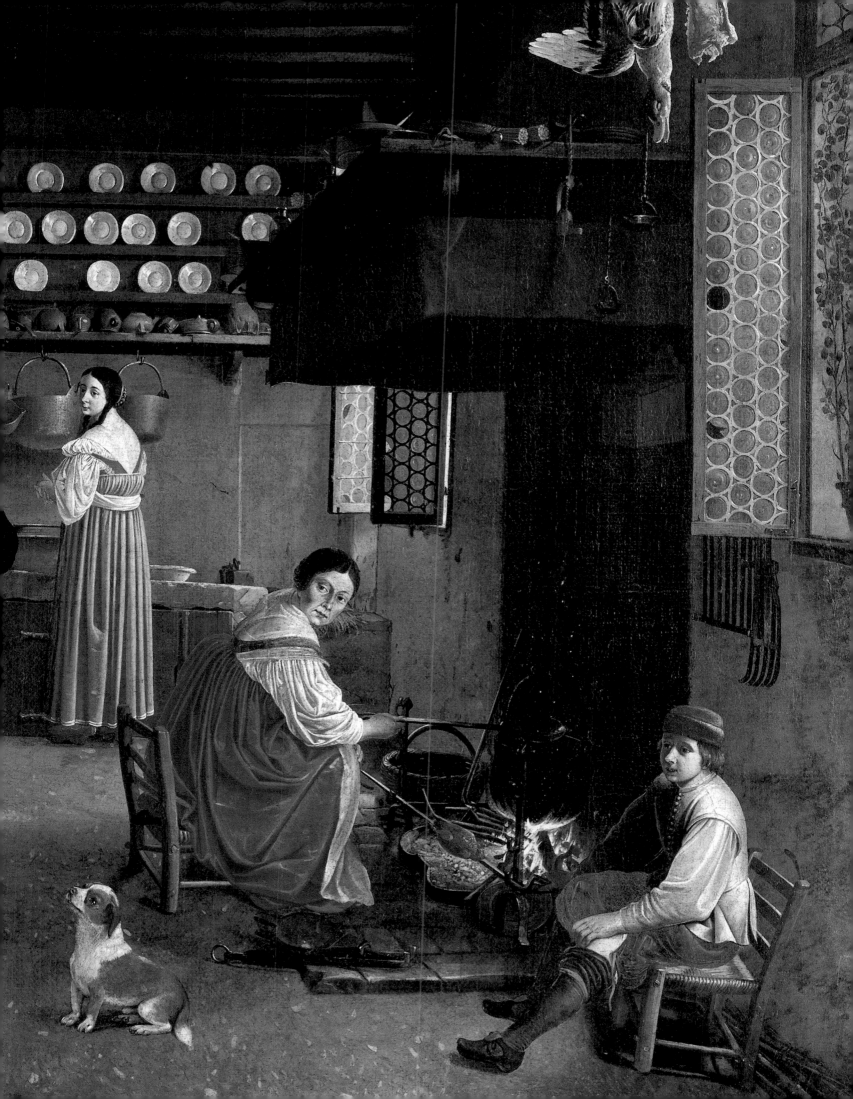

Frail, Flickering Lights

The servant, lantern in hand, has just brought in a piece of paper, but the master is not there. His meal is ready, however. On the table, next to a tall flute glass full of rosé wine, is a candle that is about to burn out. In the background, beside one of the fireplace andirons, is a soup tureen that has been pushed close to the fire to keep the meal warm. Only the faces of the two women are illuminated by the flame; the rest of the room is engulfed in darkness.

"What does the contrast between light and darkness mean to us in the twentieth century?" asked Lucien Febvre in his 1941 essay "Sensibility and History." "Nothing, or almost nothing. A flick of the switch—and electric light takes over from the light of the sun. Our mastery of night and day is virtuosic. But what about people in the Middle Ages? Or in the sixteenth century? They were not the masters of light and darkness, poor people—they did not even have an oil lamp, not even a candle to light when night fell. It was a rhythmical life, punctuated every day by the sequence of light and darkness; a life divided into two parts (of unequal length depending on the season and the geographic location): day, night; white, black; absolute silence and noisy work—can we believe that this could have engendered in these people the same mental attitudes, the same ways of thinking, feeling, desiring, acting, and reacting as our stabilized lives that run so smoothly, without contrasts and brutally defined oppositions?"

Candles, torches, or lanterns made it possible to see a bit more clearly; they also served to ward off the malevolent beings that assailed the house once night fell. A light was always kept burning next to a newborn baby, who was fragile and particularly coveted by evil spirits. A flame that flickered or, even worse, went out for no reason was a sign of bad luck. It is hard to imagine just how dark homes were at night before the advent of artificial light, and how difficult to illuminate. Good wax candles were expensive. Oil lamps and tallow candles produced foul-smelling smoke and gave a feeble light that quickly burned out.

So daily life was ruled by the sun. People woke up earlier than we do today, ate at different times (the main meal was in the middle of the afternoon), and went to bed earlier. (Not until the nineteenth century, when houses could be properly lit, did people begin eating dinner later.) The number of candles that burned in a home after dark was a conspicuous sign of the owner's prosperity. In societies where thrift was all, a generously lit room gave rise to sarcastic remarks about the waste involved in such illumination. However, over the course of the eighteenth century—the famous Age of Enlightenment—well-to-do homes saw some changes, including better-designed and taller windows, lighter interiors, and many more sources of light, such as silver candlesticks, tall candelabra, and chandeliers dripping with pendants that reflected the light beautifully. People in "enlightened" circles, who devoted much time to the life of the mind—reading, writing, studying—longed to free themselves from the rhythms imposed by the cycles of the sun. Flickering candlelight was not well suited to lengthy periods of reading. Gerrit Dou's painting, which shows a press on the left and a girl with a piece of paper, reminds us that for a very long time darkness was a serious hindrance to intellectual activity. Only in the mid-nineteenth century, with the proliferation of gaslight, did large numbers of people finally have the benefit of more intense, even light.

Gerrit Dou

Woman Arranging the Rolls for the Evening Meal,
17th century

Städelsches Kunstinstitut, Frankfurt am Main

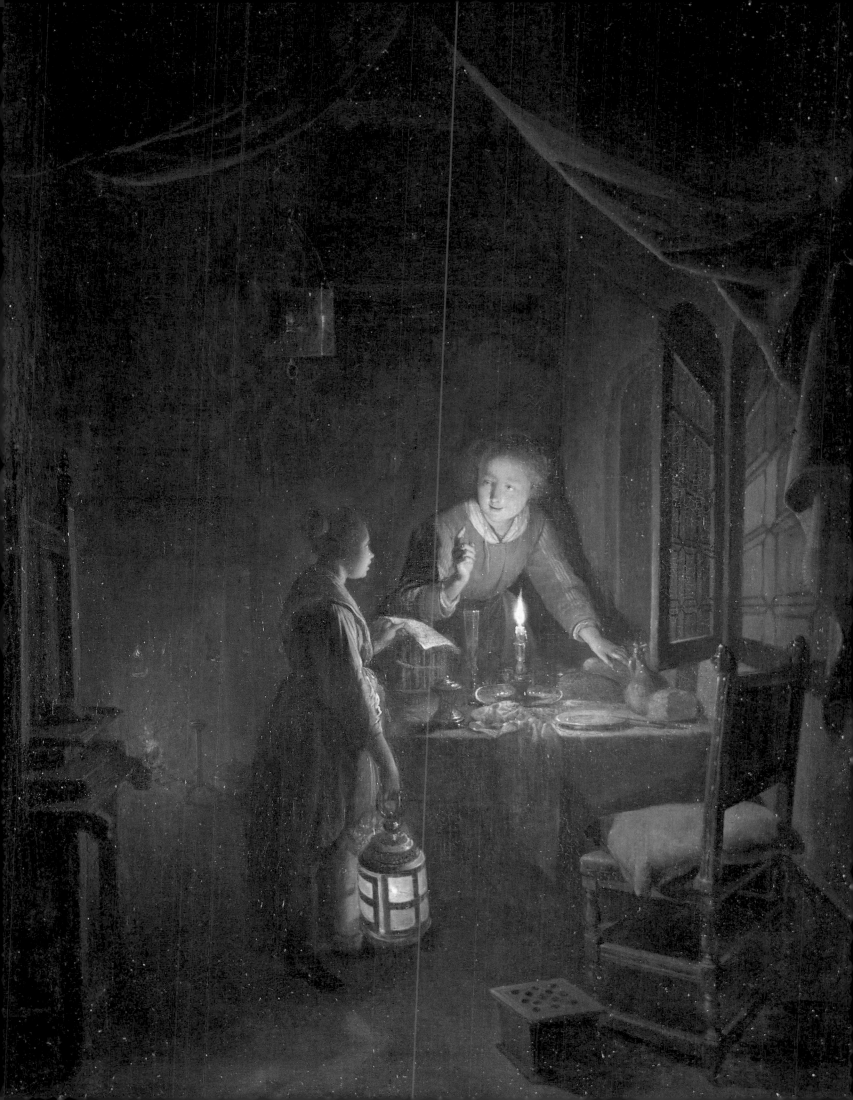

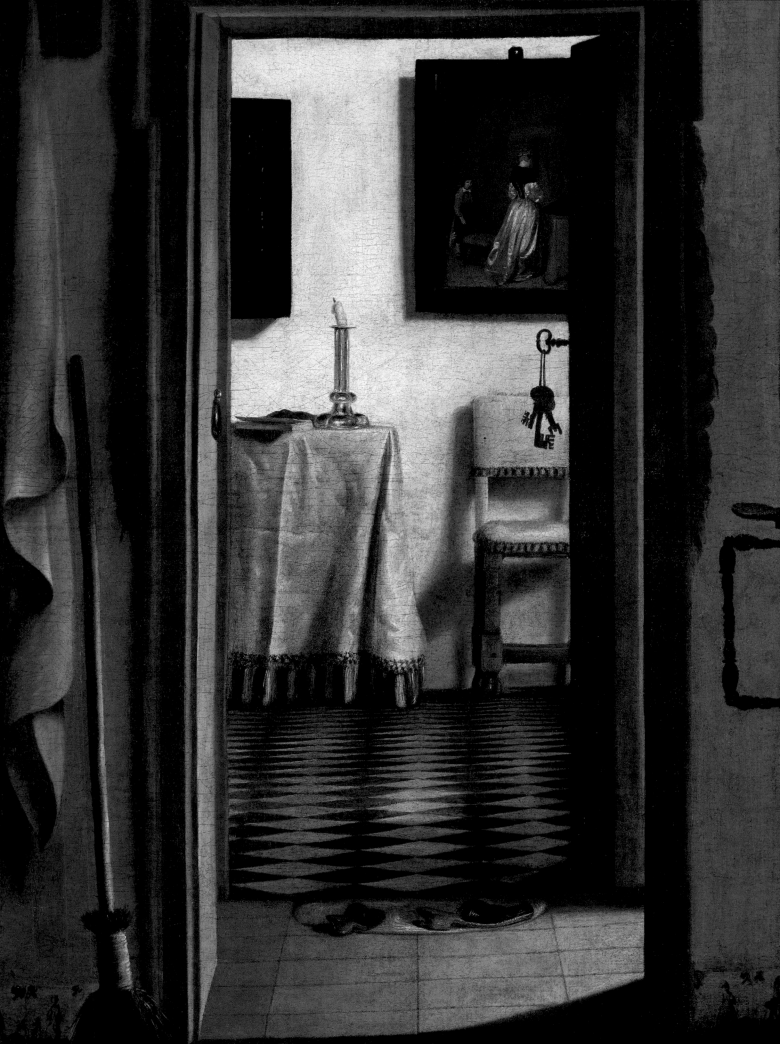

A Happy Interior

Is anyone home? Everything seems quiet. The keys are still hanging from the keyhole. A pair of slippers has been discarded on a fiber doormat. A broom leans against the wall, with a cloth hanging next to it. The delft baseboards are an elegant and clever way to protect the walls when the floors are washed—which is every week, in Holland. We see a series of rooms with a succession of checked tile floors that draws us further into the house. All the doors are open. even the one on the far right, whose metal latch we can see. Against the wall at the back are a chair and a table topped by a fringed gold tablecloth, a book, and a candlestick with a snuffed-out candle leaning to one side. The painting inside the painting shows a child and a woman, viewed from behind. standing in front of a red canopy bed. The light shining through the corridor bathes the room behind it, as is emphasized by the shadow thrown by the yellow chair. The silence that emanates from the canvas, the interplay of light, the suspension of time, the sections of interior that appear to have been set off by the doorframes as if they were picture frames— all exemplify the "celebration of the everyday" Tzvetan Todorov discussed in his 1997 book on Dutch painting. Attributed to Samuel van Hoogstraten and entitled *The Slippers*, this work appears to be a kind of hymn to domestic life, but a discreet hymn, sung almost in an undertone.

The slippers and the perfectly clean floor call to mind a famous tale recounted by the historian Simon Schama in his 1987 book *The Embarrassment of Riches*: "Sir William Temple was amused by the story of a magistrate visiting a house where the 'strapping North Holland lass . . . marking his shoes were not very clean, took him by both arms, threw him upon her back, set him down at the bottom of the stairs, pulled off his shoes, and put him on a pair of slippers that stood there, all this without saying a word.'" For foreign travelers, the Dutch housewife's love of clean floors seemed completely excessive, even causing a certain unease.

Samuel van Hoogstraten
The Slippers, ca. 1654–62
Musée du Louvre, Paris

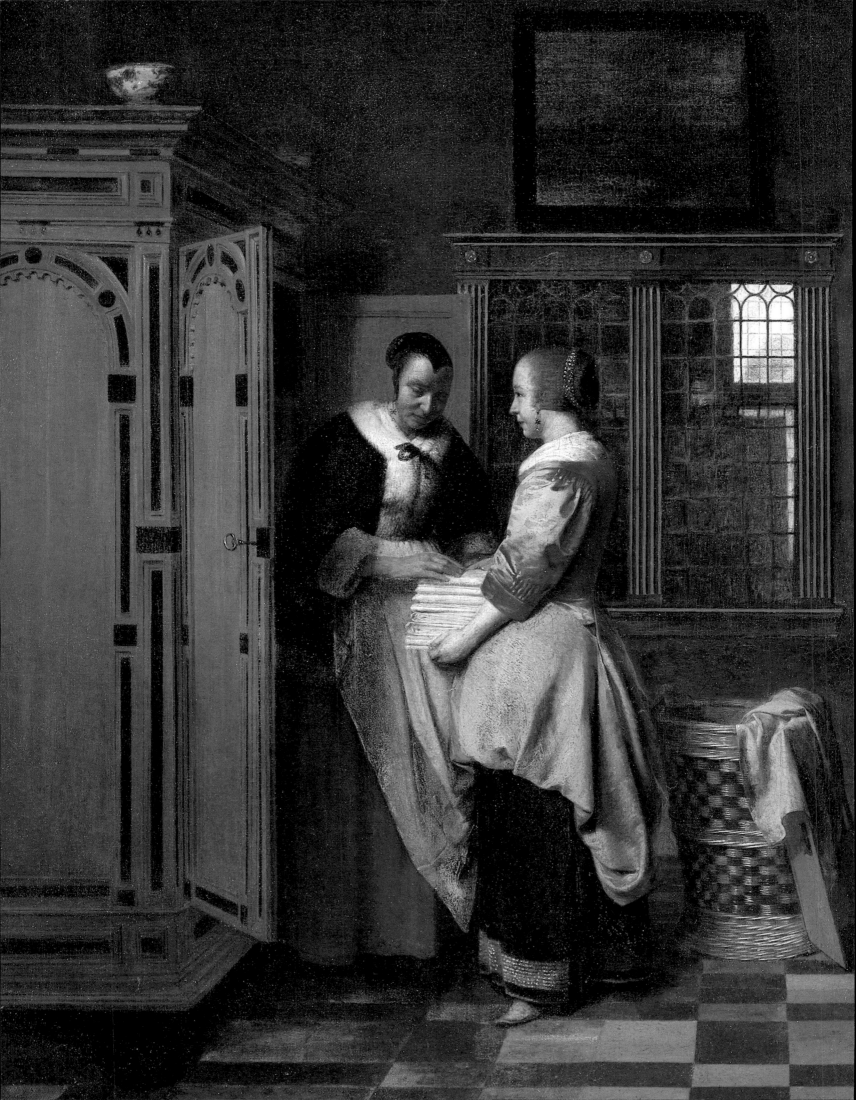

Domestic Goddesses

Helped by her daughter, who is holding a stack of sheets, the mistress of the house stores her linen in an elegant closet inlaid with ebony, while the youngest daughter plays with a kind of hockey stick. The costly furniture, the pilasters around the door and the window, the paintings on the walls, the statue of the Greek hero Perseus: Everything indicates this is the home of a wealthy bourgeois family. At the time of this painting the flourishing young republic of Holland was trading all over the world, which is clearly reflected by all the domestic objects and decoration here (the ebony, the Chinese porcelain, the ancient sculpture).

The front door is open, allowing a glimpse of the street, the water in the canal, and the houses opposite. The interiors shown in Dutch paintings often afford a view to the outside. The door may also be open because people at the time were not yet obsessed with closing their homes off from the outside world, or with jealously protecting their private lives. Right up to the eighteenth century city dwellers sometimes had to go through other people's apartments to reach their own, which nowadays we would find intrusive and terribly embarrassing.

Yet the Dutch merchant's home was a sanctuary. Every housewife was obliged to wash not only her threshold but also the sidewalks in front of the house. It was important to establish a boundary, ritually maintained by regular cleaning, that separated the external filth and chaos from the virtuous cleanliness inside. "There were moral reasons for revealing the virtue of everyday activities," wrote Tzvetan Todorov in his work on seventeenth-century Dutch painting. "The painter could achieve this magnificently. We should not underestimate the revolutionary force of this development, from the point of view of the history of images: For the first time, scraping turnips and peeling apples suddenly became an act as worthy of being a painting's focal point as the crowning of a monarch or the love affairs of a goddess. Women doing housework were put on the same pedestal as saints and ancient heroes." And indeed, these two women putting away the immaculate linen in the tabernacle of a closet could very well be goddesses disguised as mere mortals.

Pieter de Hooch

The Linen Cupboard, 1663

Rijksmuseum, Amsterdam

The Child in the Home

This interior by the Dutch painter Pieter de Hooch shows all the signs of great opulence: a sumptuous rug thrown over a table (rugs were still too precious to be laid on the floor), a large mirror with a gilded frame on the wall, a collection of delft pots on the tall mantel-piece. Yet all the richness of the decor recedes behind the sweetness of the scene set in its midst: A mother extends an apple to a small child who is learning to walk, kept safe from falling by a servant holding straps attached to a band around its head. These touching precautions show the place children occupied in Dutch society. Parents watched over their children, harnessing them to prevent injury. They paid attention to them and provided toys meant especially for them. While their contemporaries in other countries believed in corporal punishment, most Dutch parents rejected such methods. Gentleness, kisses, and patience were regarded not as signs of weakness but as the best way to ensure that their children grew up to be worthy citizens of the republic. Even affluent mothers breast-fed their children rather than use the services of wet nurses.

The books on popular medicine that were then available at low cost in Holland show how advanced the Dutch were in the field of child rearing. These manuals advised parents to bathe the baby regularly from head to foot, and then rub it with a gentle almond oil. Ivory rings and rusks were recommended to relieve the baby's teething pains. They instructed that toilet training be done in a gentle, nonthreatening way, by sitting the child on its pot with some toys, and, above all, that the child never be punished for wetting the bed—all of which suggests an approach to child care that was not very different from ours. The mother depicted here with a sweet madonna-like face exemplifies tenderness. As she offers a piece of fruit to her child, her intention is less to feed her child than to encourage it to take its first few steps.

Pieter de Hooch

Two Women Teach a Child to Walk, ca. 1668–72

Museum der Bildenden Künste, Leipzig, Germany

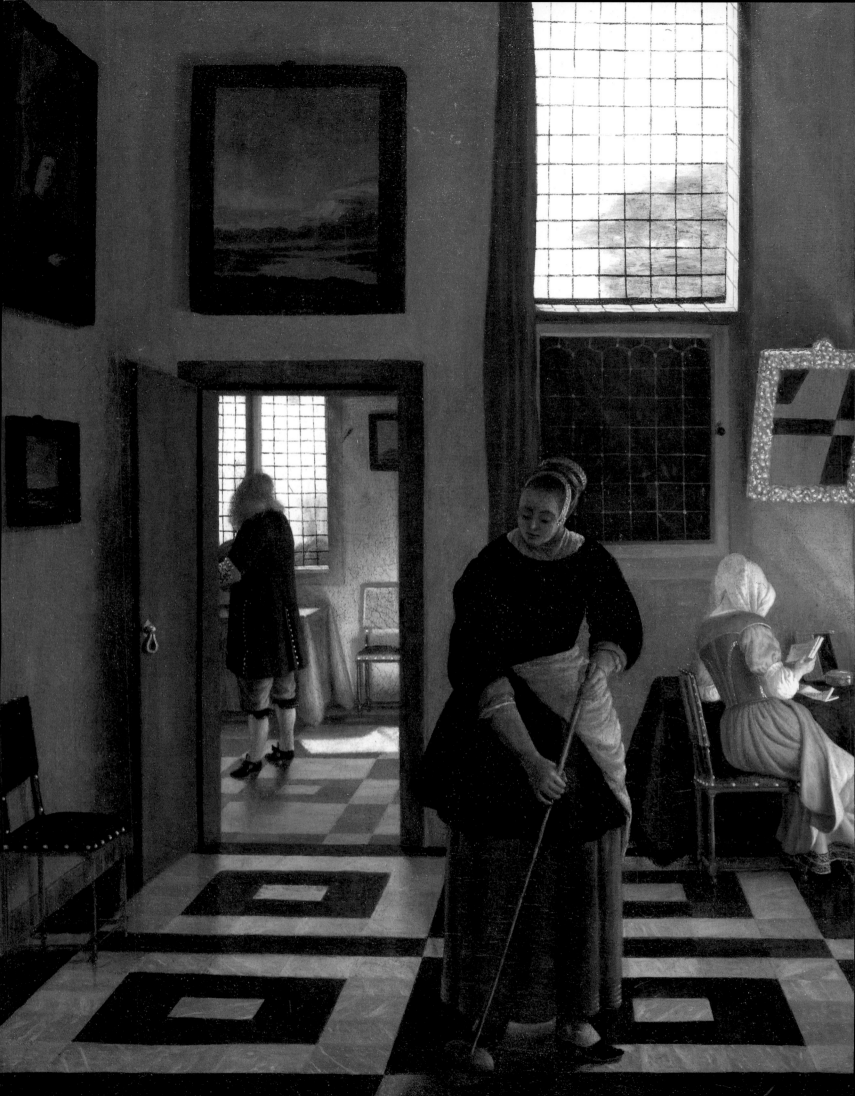

The Discipline of Housework

The servant sweeps the black-and-white floor tiles, which appear to be perfectly clean already. The mistress of the house, seen from behind, sits reading a notebook. For protection from the sun streaming into the house, the outside shutters have been half closed. From the upper windows a beam of light shines on the tiles and lights up a section of the wall. We can see some trees outside the windows. A man stands in the back room. We cannot see what he is doing.

The painting is composed like a snapshot. Everyone is going about his or her business, with the spectator relegated to the status of intruder. The painter is celebrating the moment, as well as the peace and order of this interior, where everything is in its place. The composition is also a breathtaking interplay of squares: Tiles, paintings, mirrors, and windows are organized around the central figure of the sweeping servant. For the mistress of the house, tidying and cleaning are not the banal activities they might seem. They represent the maintenance of equilibrium in a space over which one can genuinely have control.

In his 1992 book *Les Gens de peu* Pierre Sansot interpreted household chores much as the Dutch painters seemed to: "By taking care of her home, it is this fleeting happiness she is working toward. Saucepans, books, objects made by others are kept in order. It seems to me that in all humility, at a modest level, the activity of the housewife is similar to that of a demiurge or a high priest. Does not she, like them, have a vocation for moving from chaos to order? Contrary to the generally accepted idea of creation, it does not necessarily involve producing something from nothing, but rather putting order into a confused situation. It must be said that the universe has an unfortunate tendency to return to its original confusion. Housewives, like high priests—but more often than them—see it as their duty to regulate the threatening chaos."

Pieter Janssens Elinga

Interior with Painter, Woman Reading, and Servant,
17th century
STÄDELSCHES KUNSTINSTITUT,
FRANKFURT AM MAIN

FOLLOWING PAGES

Emanuel de Witte

Woman at the Harpsichord,
ca. 1665–70

MUSEUM BOIJMANS VAN
BEUNINGEN, ROTTERDAM

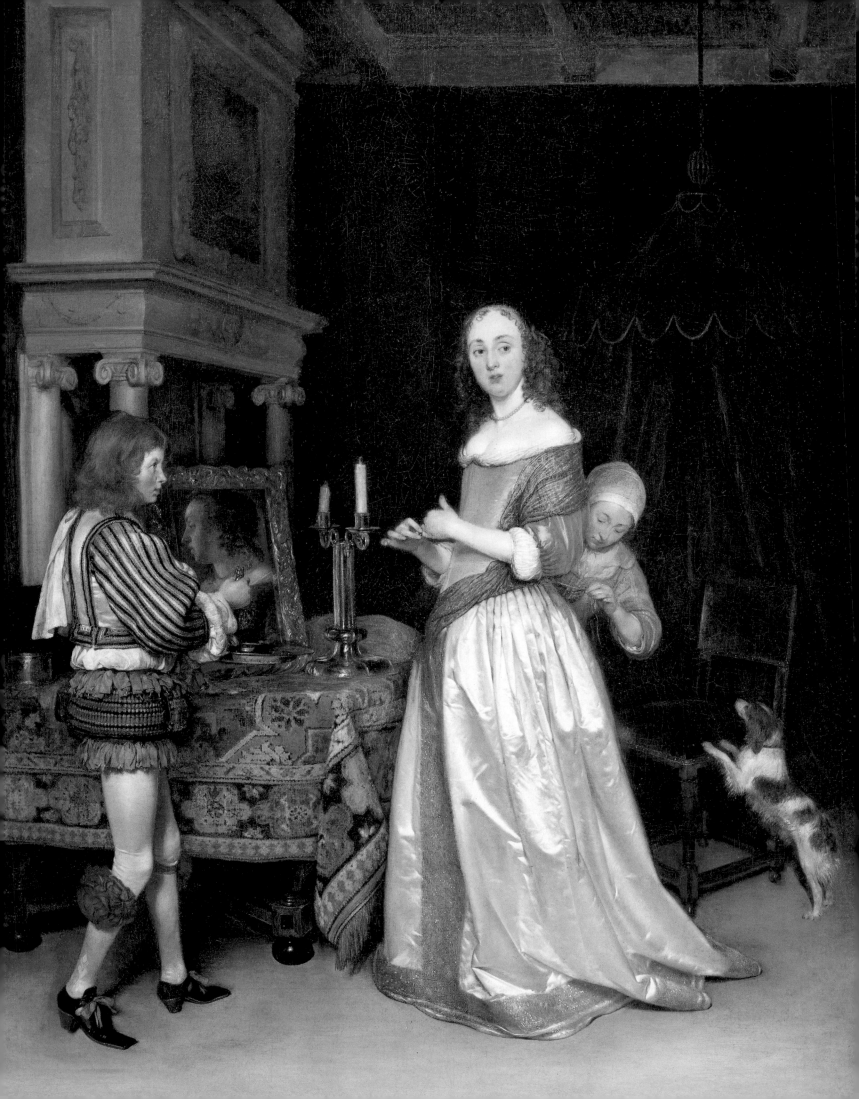

A Dry Toilette

What is she thinking about? The woman wearing an ivory satin dress has just put on her ring, with a rather absent air. The servant is taking advantage of her mistress's reverie to lace up her corset, while a young manservant with rosy cheeks awaits a signal to pour water from his ewer into a basin. The dressing table is covered with a rug, and on it is a mirror, a copper candlestick, and a silver box, perhaps containing powder. Behind the figures stands a red velvet bed whose canopy is hooked to the ceiling.

Although the title of this work by Gerard Terborch is *A Lady at Her Toilette*, it is decidedly a token toilette, rather like a cat grooming itself. In the seventeenth century dampness was regarded as harmful, and people preferred to clean themselves with as little water as possible. They concentrated on the extremities, washing only those parts of the body that were not covered by clothes: the hands, neck, and face, which could be carefully dampened with a little water and a white cloth, which was thought to be cleansing by virtue of its whiteness alone. People also believed that underwear—which was beginning to be developed during this era—absorbed sweat, and that they were clean as long as they changed their underwear.

It's worth remembering that water was difficult to transport and in short supply then, and that chilly indoor temperatures did not encourage people to strip naked during the winter. Bedrooms had small adjoining rooms that were used to store clothes and other items. The commode was housed there, along with ewers, basins for washing one's feet, and, if necessary, a bed for the maidservant. Gradually the toilette became an occasion for visiting with people and entertaining one's close friends and family. That was a toilette for show, however, where graceful beauty rituals were deployed as means of seduction. The more basic matters of bodily hygiene were dealt with in private. It was not until the latter half of the eighteenth century that the room where this took place became known as the "toilet."

Gerard Terborch

A Lady at Her Toilette,
ca. 1660

The Detroit Institute
of Arts, Michigan

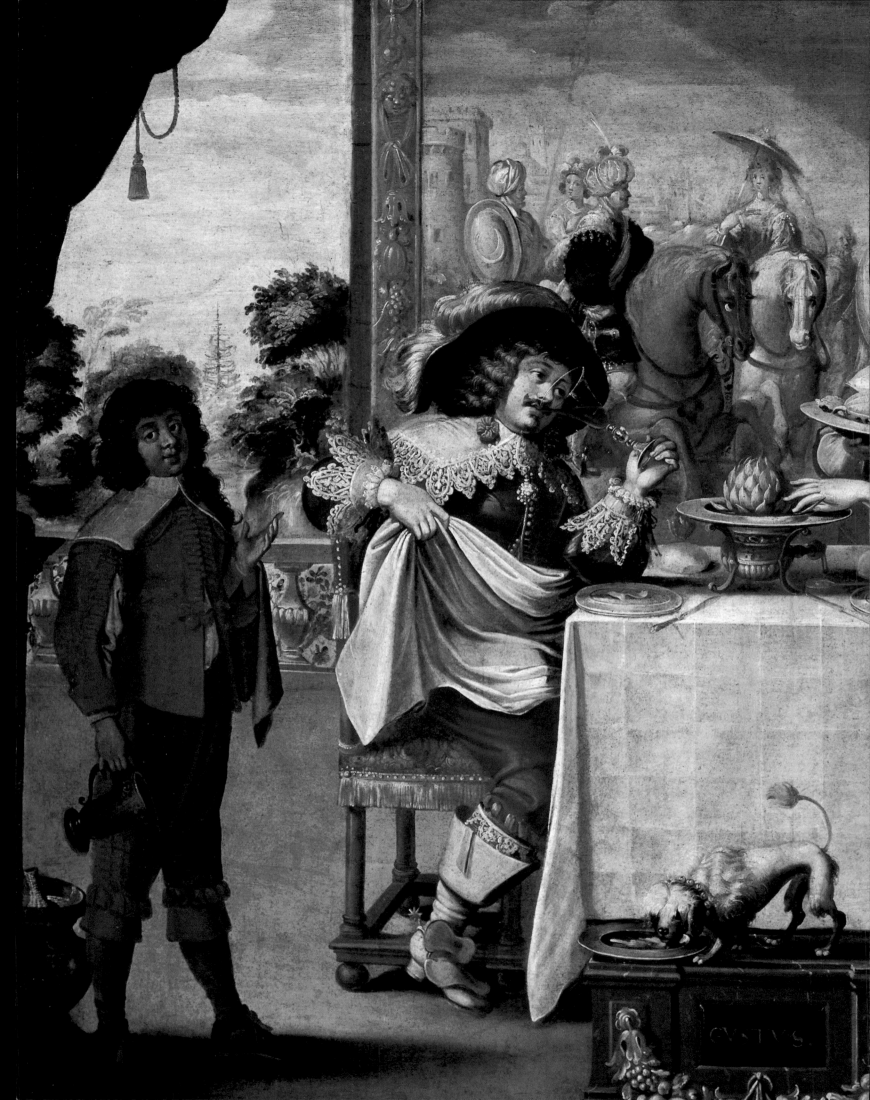

Good Table Manners

The artichoke has been a fashionable vegetable since the beginning of the sixteenth century. According to legend it was brought to France from Italy by Catherine de Medici, who one day ate so much of it that she had a terrible attack of indigestion. Here an artichoke is being enjoyed by an elegant couple lunching tête-à-tête.

The vegetable is placed over a small chafing dish heated by embers. The way the two protagonists are stripping the artichoke's leaves looks very much like a lovers' game. They each take their time. With a napkin in her hand, the lady takes hold of a leaf with an affected gesture, while the man, wearing his hat, as was the custom at the time, sips his wine. (The wine bottle is in a cooler on the floor.) A young manservant stands close by, ready to fill the glasses at a signal from his masters. There are still no forks on the table. Although by this time they had begun to appear in aristocratic homes, forks are not needed to eat artichokes. The plates are still completely flat and similar in shape to the old trenchers, without the raised rims that would be common later. But there is one innovation: On the tablecloth, with its perfect fold marks, are table knives with rounded handles, a sign of great refinement.

Another manservant brings a melon to the table. Until the end of the eighteenth century this was a rare fruit, carefully cultivated in the best corner of the kitchen garden and eaten with respect, like the artichoke and the peach. Erasmus's work *Civilities*, published in 1530 and then translated and disseminated throughout Europe, completely changed table manners, which in the 1630s veered toward affectation, as suggested by the little dog with the pompom tail who delicately eats from a pewter plate.

Abraham Bosse
The Five Senses: Taste,
17th century
Musée des Beaux-Arts,
Tours, France

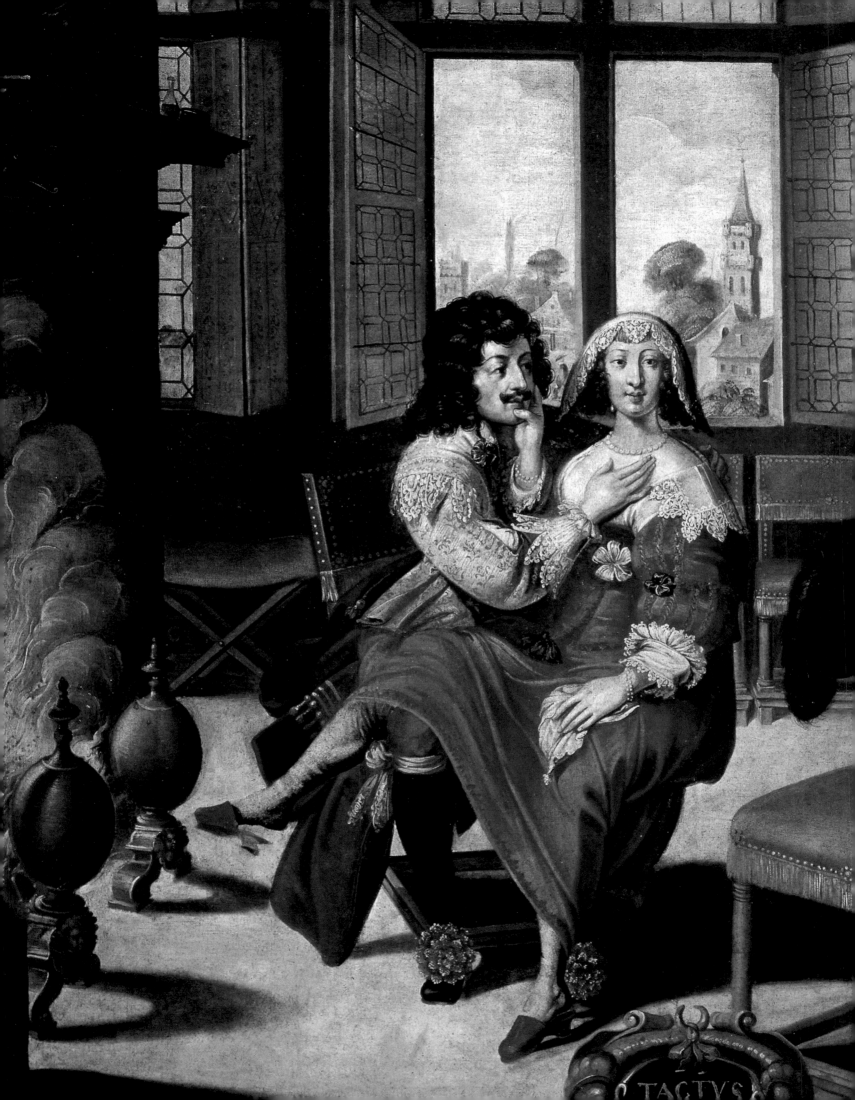

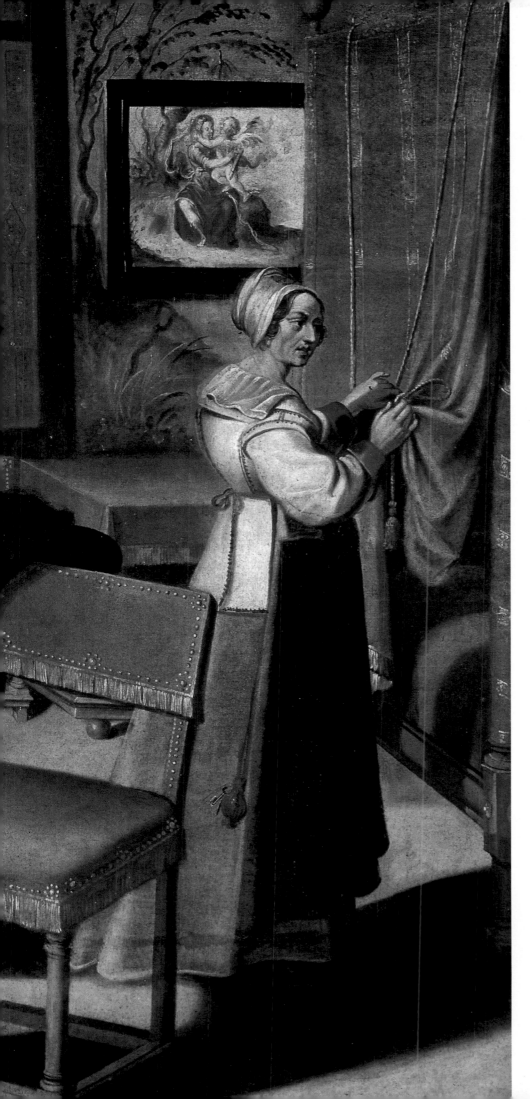

The Right-Angled Bedroom

The lady staring with slightly squinty eyes at the painter is sitting on her gentleman friend's knees, stroking his face, and outlining his fleshy mouth with her thumb while he touches her cleavage. The fire burning in the hearth is a metaphor for the arousal of the couple's senses. In a century whose mores demanded prudishness and a certain stiffness of posture and bearing, the woman with her splayed legs is a risqué image indeed. Moreover, the man is not the master of the house. His hat, which hangs from the back of a chair, reveals that he is just visiting.

It is not clear whether the servant is complicit in the affair or disapproves of it, but we know she is a trusted housekeeper from the bunch of keys attached to the small red purse hanging from her skirt. Without saying a word she is unfastening the ties that hold back the bed-curtains. The bedroom perfectly represents a well-to-do seventeenth-century interior. All the forms are square—even cubic—with straight edges. The bed and the numerous covered chairs with their fringes and decorative studs demonstrate the owners' wealth. The heavy, bulky furniture is rather unimaginatively lined up along the walls, and the palette reflects the dominant colors of the time, red and green. In the century that followed this aesthetic would change profoundly: Furniture became rounded, curved, and well-padded, dark colors and heavy fabrics were replaced by light pastel shades, and small, graceful furniture with rounded feet was placed in the middle of the room.

Abraham Bosse

The Five Senses: Touch,
17th century
MUSÉE DES BEAUX-ARTS,
TOURS, FRANCE

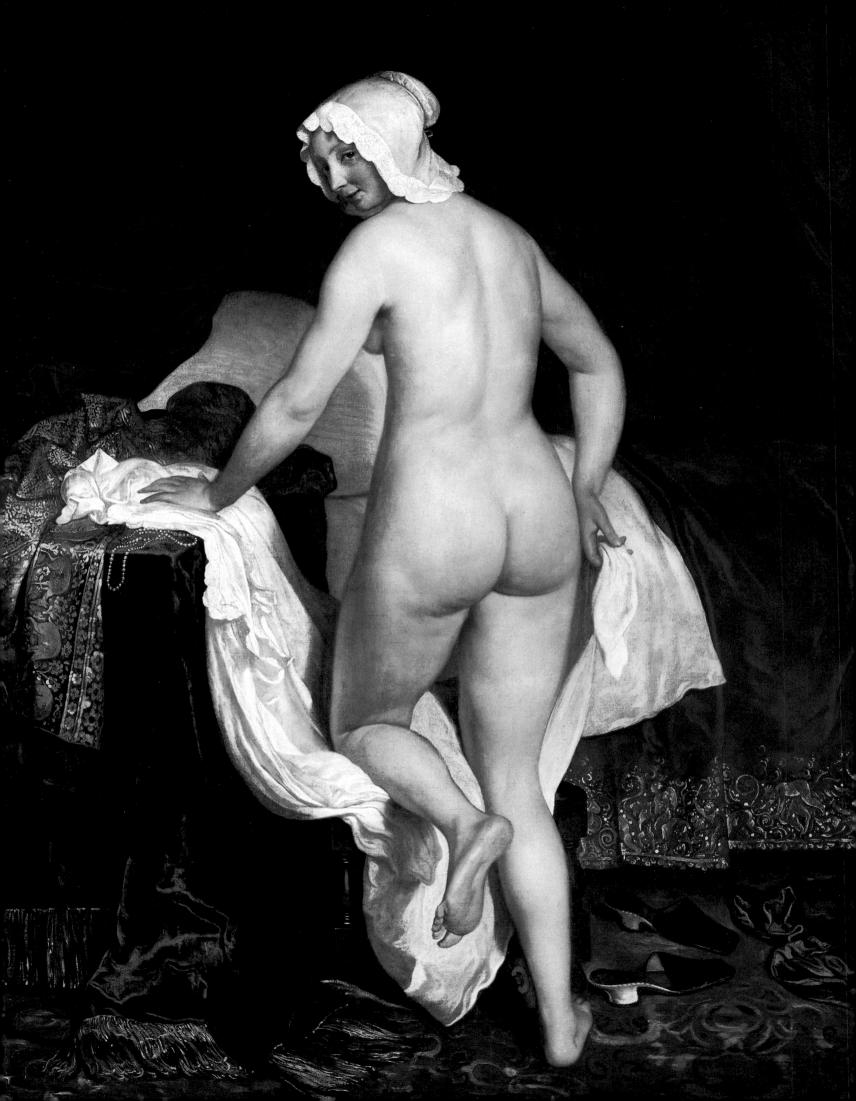

Sleeping Positions

The young woman has taken off her dressing gown, chemise, and slippers. She has placed her pearl necklace on a table covered by a green velvet cloth with yellow fringes, which suggests the advancing development of the bedside table. (For a long time people just set their candlesticks on a chair by the bed. Proper bedside tables came into being in the eighteenth century.) By now wellborn people had begun to wear nightshirts, but the creature portrayed here by Jakob Van Loo has kept on only her lace bonnet; she turns her head beguilingly, as if to invite us into her little theater of crimson velvet. Since the Middle Ages the bedroom had been a multipurpose, communal space. Little by little the room became more intimate, reserved only for one's nearest and dearest. Although social historians have explained the evolution of the bedroom and its functions, none has described the positions in which our ancestors abandoned themselves to sleep. We have no idea, for instance, whether decency permitted them to sleep flat on their stomachs, as we sometimes do; we certainly never see them doing so in paintings, where they are always shown just about to slip into bed, or getting up and putting on a stocking, or in a somewhat risqué scene involving a couple. If they are depicted lying down, they are in their death throes.

Although beds were often wide, they were not very long, precisely because it was considered undesirable to sleep lying down and fully stretched out—the position was too suggestive of death. As a result, people slept on voluminous pillows that kept them semi-upright. For deeply religious people, the only dignified way to sleep was on the back, with hands clasped on the chest. It is hard to imagine the young woman here sleeping that way. Standing barefoot on a luxurious rug, what she really shows is that, for those who could afford it, the bedroom was the supreme place to enjoy comfort and pleasure.

Jakob Van Loo

Young Woman Going to Bed, known as Retiring in the Italian Style, ca. 1650

Musée des Beaux-Arts, Lyon

Esaias Boursse

Interior with Woman Cooking,
1656

Wallace Collection,
London

The Age of Enlightenment
The Servant Girl Enters the Scene

"This little laundress, sitting on her low seat and squeezing linen between her hands, is charming, but she is a strumpet whom I would not trust. I care about my health," quipped the philosopher Denis Diderot, even while heaping praise upon this painting by Jean-Baptiste Greuze. At least since Molière's seventeenth-century comedies the servant girl had been depicted as a sometimes insolent person to be reckoned with, but nevertheless unscrupulously exploited. In the eighteenth century the bourgeoisie assumed a new social status by acquiring a retinue of servants—a silent, submissive class of people who were responsible for the many domestic chores in the home.

Jean-Baptiste Greuze
The Laundress, 1761
THE J. PAUL GETTY MUSEUM,
LOS ANGELES

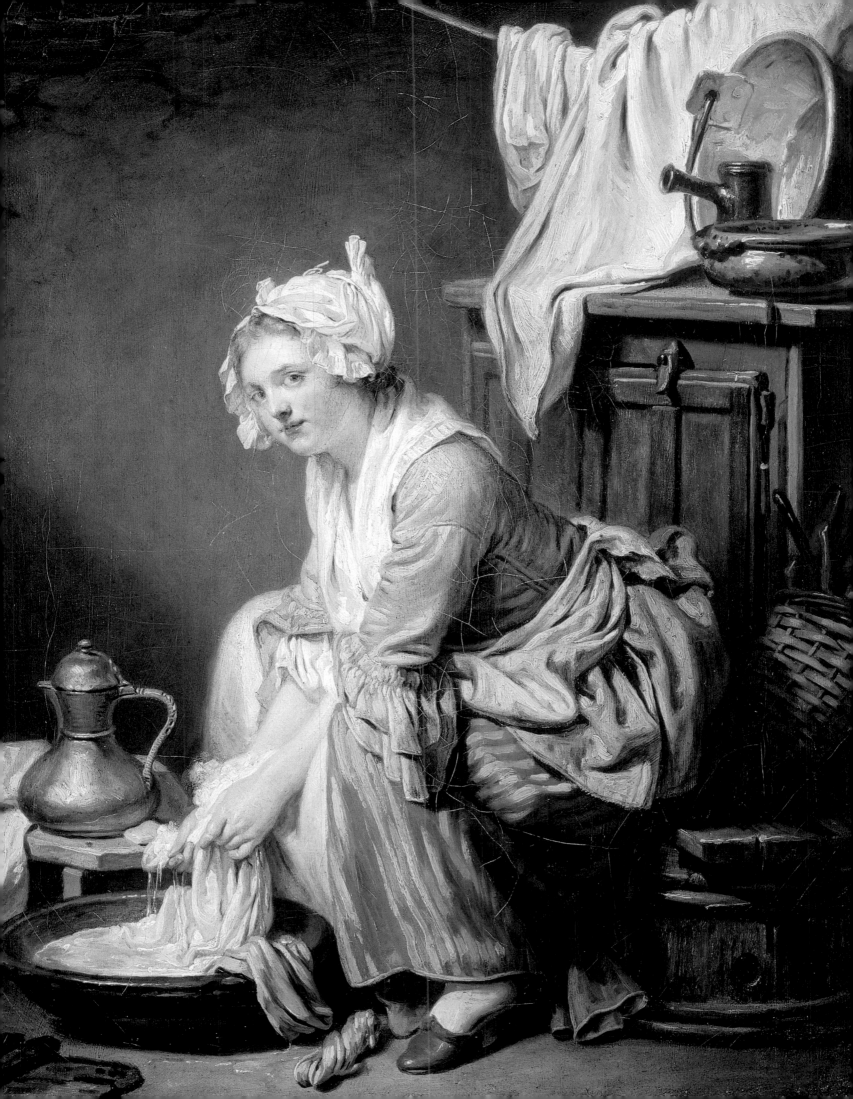

The Onions and the Spinet

A young woman sitting on her bed searches her bodice for a flea. Paintings frequently showed people hunting for insects, a theme that was trivial, picturesque, and also somewhat erotic, since the spectator was observing a woman exploring her own body.

When mattresses were stuffed with straw, they were inhabited by a diverse population of fleas, bugs, and other creepy crawlies that attacked sleepers at night. Bed vermin were a common problem until the beginning of the twentieth century. George Orwell recounted, in his 1933 book *Down and Out in Paris and London*, scattering pepper on his bed in an attempt to drive away the intolerable assailants. The price of pepper was still high in the eighteenth century, so there was no question of the young woman in the painting using the same strategy. Her room seems rather rundown. The thin mattress lies on a simple plank supported by trestles. A mat of woven fiber protects the head of the bed. The brownish gray walls contribute to the soft, sad atmosphere. The room clearly shows the deprivation of rented lodgings at this time, decorated with just a rudimentary cupboard, a small straw basket, two shelves with some earthenware dishes, and a string of onions. Even so, it has some intriguing elements here and there: a pearl necklace on a pot fixed to the wall and, hanging from a nail, a lace bonnet and a skirt hoop. A small purebred dog is perched on the pillow. Sitting on a stool by the bed are a chamber pot, a rose, and a make-up bag; on the folding stool in front of the bed is a pink corset. On the left stands a musical instrument, which is surprising in such a humble setting. But this work by Giuseppe Maria Crespi has a story behind it.

It was one of a series of paintings, all lost today, recounting the life of a singer of modest origins, from her rapid ascent in society to her deep religious devotion toward the end of her life. The spinet and the concert programs on the wall refer to her profession, while the luxuriousness of certain objects, contrasting sharply with the room's poverty, allude to the generosity of the lady's protector. With great sensitivity this painting intimately portrays the reality of poor people's lives at the time. At the back of the room sits an old man, the father of the young singer who has fallen from grace, holding a baby whom we may suppose to be his daughter's child.

Giuseppe Maria Crespi, known as lo Spagnolo

The Woman with the Flea or *The Searcher for Fleas*, ca. 1720–30

Musée du Louvre, Paris

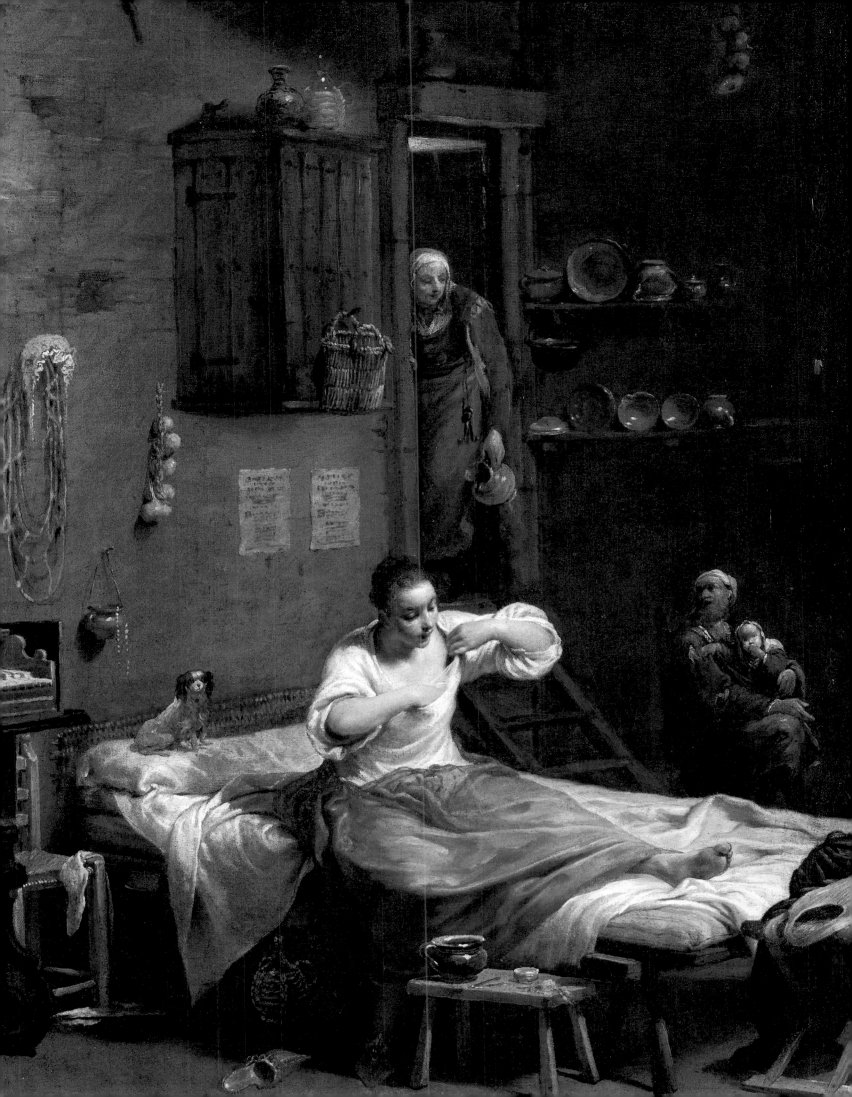

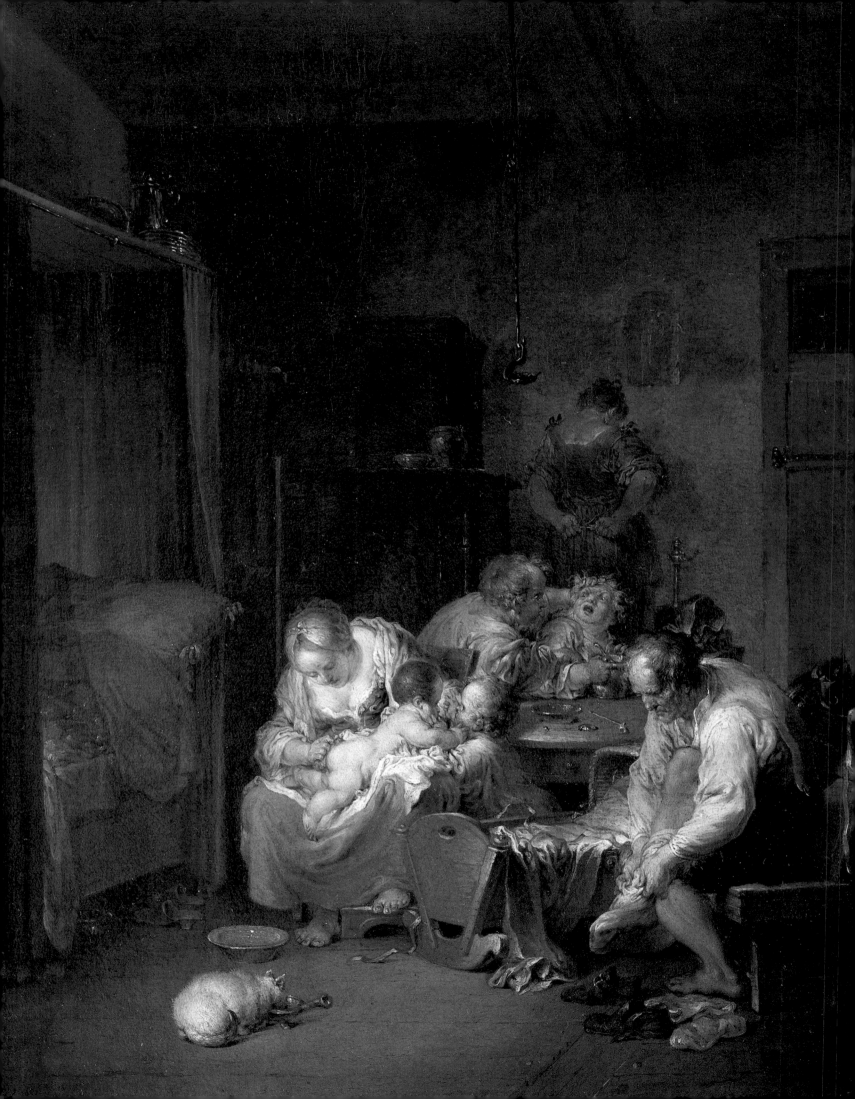

The Joy of Living in Close Quarters

Early in the morning a family gets dressed, eats breakfast, and squabbles amid a hubbub we can well imagine. One pulls on a stocking, one ties her apron, another wipes the baby's bottom, while the cat laps up the rest of the baby's food.

The furnishings comprise a table, some small, low chairs, a cradle, an oil lamp hanging from the ceiling, and a bed with curtains and sheets in sea green, a color that dirties less easily than white. Above the bed are some pewter dishes, and beneath it is the chamber pot.

In eighteenth-century cities, most domestic or commercial servants lived in one room, often in very close quarters, under the same roof as their employers. The most disadvantaged of all did not even have an area of their own and had to live in the kitchen.

Annick Pardailhé-Galabrun's 1988 book *La Naissance de l'intime*, based on a study of the posthumous inventories of more than three thousand seventeenth- and eighteenth-century Parisian homes, demonstrated that the majority of the city's population was poorly housed and explained how people adapted. It was common for families with five or six children to live together in one or two rooms.

One wonders where anyone but the baby and the parents can sleep here. Upon examination, some details of the painting draw our attention, notably the various ribbons. There are mauve ribbons tying the pillow cases on the conjugal bed, other ribbons on the baby's cradle, one of which trails on the ground, and another ribbon on the back of the father's chair. They call to mind an interior Pardailhé-Galabrun described—a room where in 1744 a modest ribbon maker died, leaving a widow and two young children. The author listed everything he owned: andirons, a shovel, tongs, a bellows, a trammel, and a trivet for the fireplace; a small bed with low pillars; kitchen utensils and tableware—a grill pan, a frying pan, a casserole, six dishes, two salad bowls, five carafes, seventeen plates, six spoons, and five forks. The furniture included a table, six chairs and an armchair, a crockery shelf, a bookshelf, and a low cabinet for linen and clothes. The room was also used as a work space, with a spinning wheel for the ribbon maker. Lighting was provided by the fire in the hearth, a window with a curtain, three candlesticks (one with a long handle), and a lantern.

The only objects related to hygiene and grooming were two mirrors. The walls were hung with eight pieces of Bergamo tapestry and decorated with twenty-one devotional prints. There was a plaster figurine of the Virgin, along with twelve devotional books.

What is striking in these inventories, and does not necessarily appear in illustrations, is the profusion of folding, portable beds, which could be used or moved as needed. Most were trestle beds. They were used by the children, the servants, or perhaps a subtenant; even in the smallest homes, a bed was sometimes rented to bring in extra money. Screens or movable partitions were used to create more private spaces. Although these interiors seem to us devoid of much comfort, the people who lived in them, as shown in paintings and engravings, appear to fit into their surroundings naturally and to feel quite at home.

Januarius Zick

Interior Scene: Morning, 1779

Musée du Louvre, Paris

The Copper Water Urn

Celebrated in numerous canvases, the most famous of which were by Chardin, the copper urn held the home's main reserve of water. Its contents were protected by a lid that could be removed when the urn needed to be refilled. It was firmly fixed to an oak base and had a tap at the bottom. Although such a storage tank might seem essential to having access to water, not every home had one—far from it, in fact, because they were expensive. Capacity varied from one model to another, generally one or two *voies* (the standard measure at the time, equal to about eight gallons) but sometimes as many as six *voies* (forty-eight gallons), or even more.

In eighteenth-century Paris about thirty percent of households were equipped to store sixteen gallons. Modest homes used stoneware urns covered in wicker, rather than copper ones. When there was no urn at all, water was stored in buckets made of copper, iron, earthenware, or wood. Water was drawn either from private wells meant to be used by one house only or from communal wells.

It was also possible to stock up on fresh water at public fountains. Most Parisians purchased their water from the carriers who transported it to their homes; in well-to-do households the servants fetched the water instead. It was used for cooking, housework, and drinking alike. It was served at table in pewter or earthenware pitchers, like the one Chardin's servant holds in her hand. The paving stones in the painting's foreground suggest that this urn has been installed in a small courtyard lean-to. Also stored here are vats, a copper cooking pot, some buckets, a broom, some cloths, a stack of wood, and, suspended by a hook, a large piece of meat whose proximity to the water supply seems unhygienic by modern standards.

Jean-Baptiste-Siméon Chardin

Woman at the Fountain, 1733

The Barnes Foundation, Merion, Pennsylvania

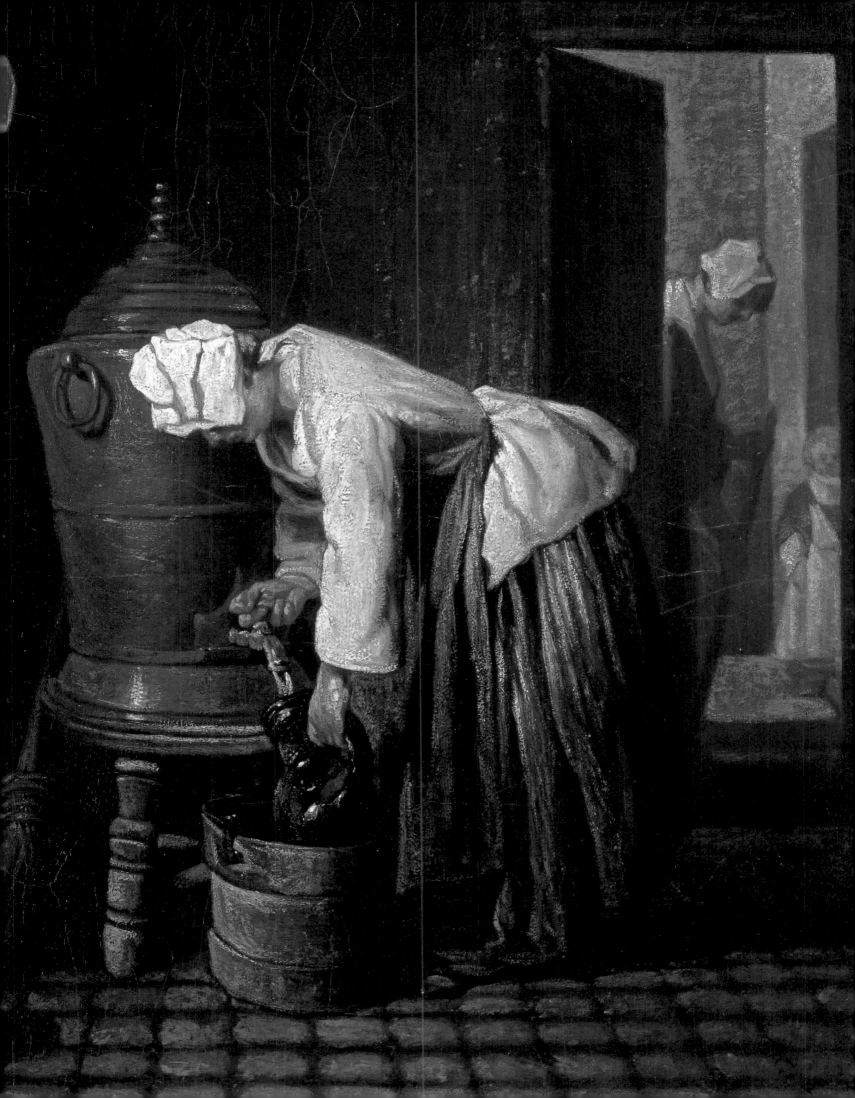

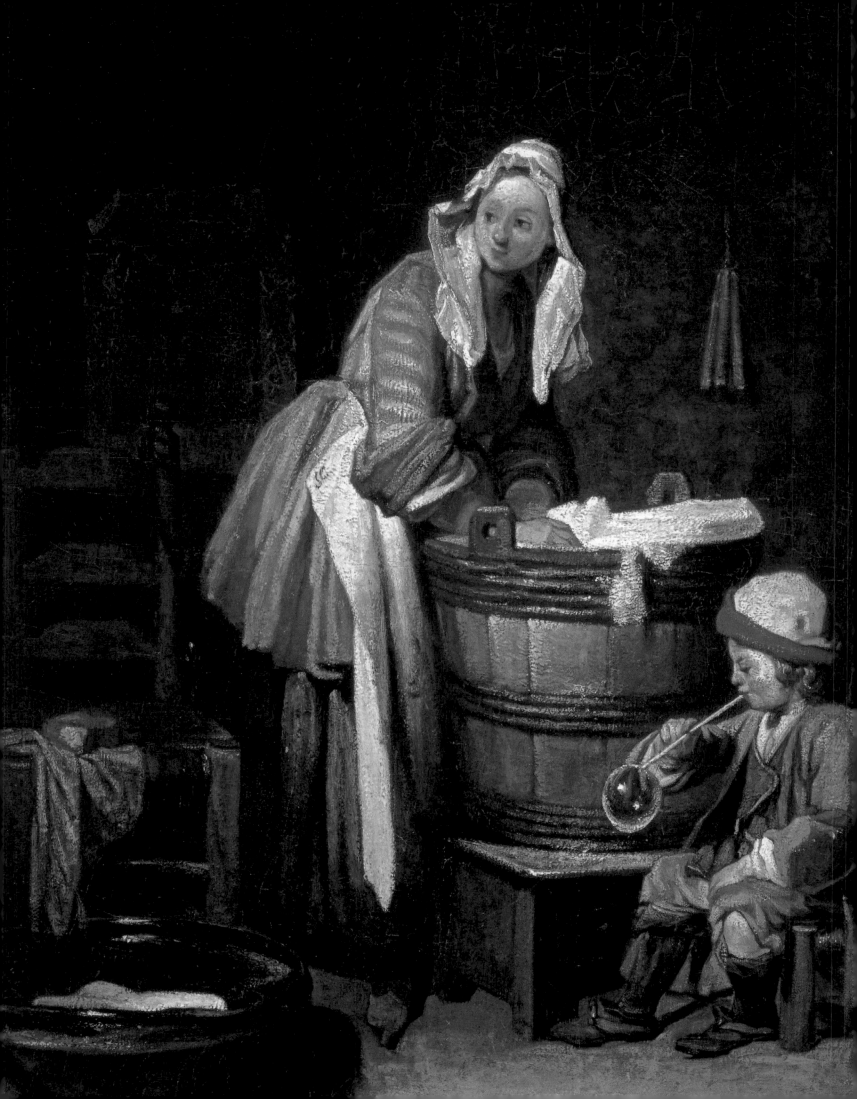

The Fatigue of Laundering

The child sitting on a small chair takes advantage of the soapy wash water to blow bubbles through a straw. In this painting by Chardin, the lightness of the soap bubbles starkly contrasts with the burdensome task facing his mother at a time when doing the laundry was a backbreaking job.

Country folk rinsed their linens in icy river water or at fountains. For washing small everyday items, people used tubs or wooden buckets. In cities, where there was a shortage of space and water, people gave most of their washing to laundresses, who usually lived near a stream or river in the suburbs. The linen was hung to dry in the courtyard on an iron rod or horsehair rope. The servant here has left the small items to soak in a large earthenware basin while she scrubs the rest in the large vat.

The soap was made from ashes and tallow, or from a mixture of plants, saponin, and clay, but effective detergents had not yet been invented. What was really required was elbow grease, as laundresses scrubbed and beat the linens. The eighteenth-century writer Louis-Sébastien Mercier complained: "There is no city where linen becomes more worn out than in Paris, or where it is more badly whitened. Each shirt belonging to a poor workman, private tutor, or clerk is subjected every two weeks to the brush and the beater; and soon the poor wretch's eight or ten shirts are threadbare, full of holes, and torn, and they disappear into the paper factories. . . . So those who have only one or two do not hand them over to the laundress's beater; they do the laundry themselves, to preserve their shirts.

"And if you doubt it, go one Sunday in summer to the Pont-Neuf at four o'clock in the morning and, on the river bank, in the corner of a boat, you will see several individuals with nothing on under their coats, washing their only shirt or their only handkerchief. Afterward they hang this shirt out on the end of a spindly stick, and wait for the sun to dry it out before they put it back on."

Jean-Baptiste-Siméon Chardin

The Laundress, 18th century

The Barnes Foundation,
Merion, Pennsylvania

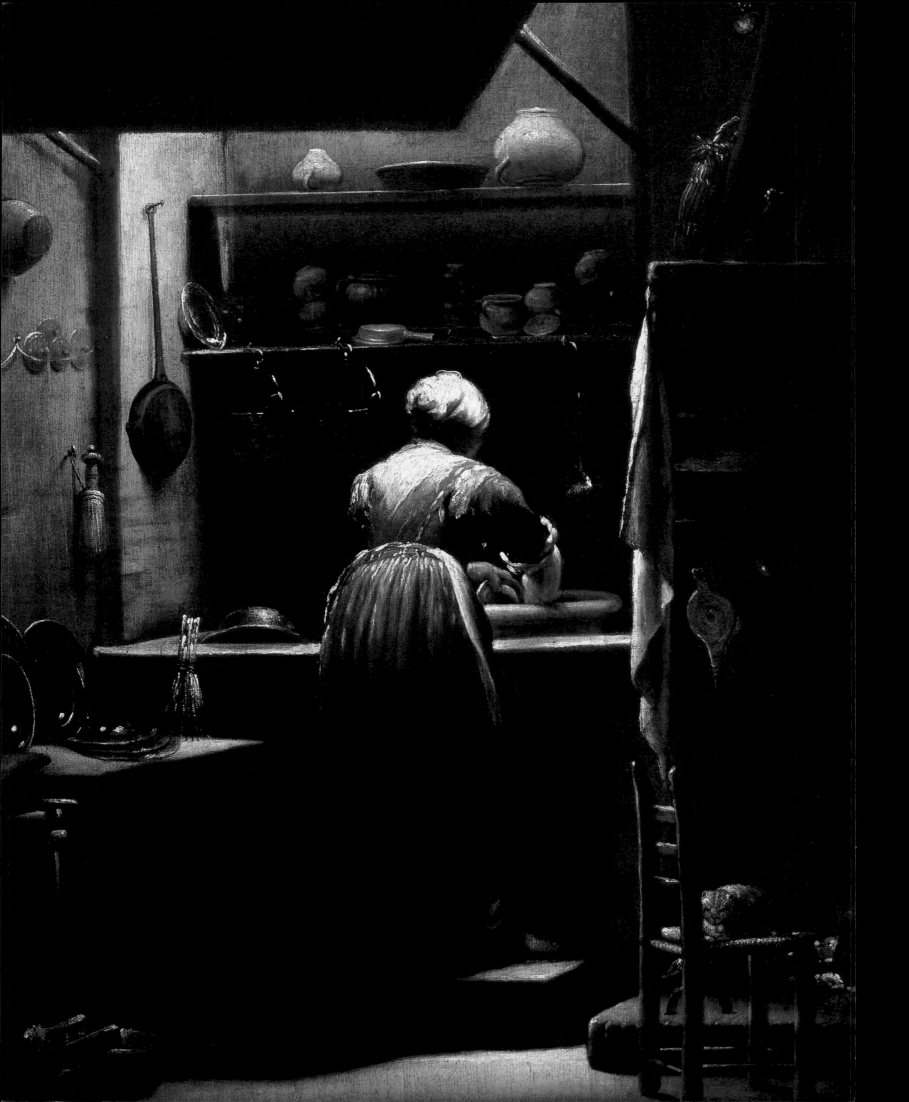

The Loneliness of Doing the Dishes

The painter Giuseppe Maria Crespi clearly empathized with the anonymous servant he showed from behind washing the dishes, who is a far cry from the mischievous figures of Fragonard or Watteau. The softness of the brown walls and earthenware pots, the copper-colored dress, the light filtering in through a sort of air shaft and making a halo of her white cap, and her strong shoulders all imbue the scene with humility and emotion. Crespi also included a wealth of scrupulously observed domestic details.

The woman is washing a pewter dish in a basin placed in the sink. From the wall hangs a saucepan whose long handle allows for cooking on the fire in the hearth without risk of burning oneself. Pots and ladles hang from nails, and household utensils are scattered here and there: a large scouring brush, a small hand brush, and a cleaning cloth. Some dishes are drying on a shelf. On the wall the lids of various containers are wedged in behind a cord. A bellows hangs just under the salt box, which is always left near the fire to keep the salt dry.

What utensils and dishes did homes have in the eighteenth century? Andirons, skewers, roasting spits, trammels, cooking pots, trivets, cauldrons, frying pans, casseroles of various shapes and sizes, and various spoons for eating, stirring stew, skimming fat, or making jam. "All sorts of objects are mentioned in these inventories of kitchen utensils," wrote Annick Pardailhé-Galabrun. "A fry basket, a skimmer, a sieve, a chopper, a grinder, a large kitchen knife, a mortar for crushing salt and spices, a pestle, a funnel, a scale, etc. In addition to this collection were less common, more specialized utensils found only in the better-equipped kitchens of well-to-do homes. Among those items were the fish kettle, the pie tin, the capon roasting tin, the waffle iron, the vessel for cooking fruit, and the beef stewpan." Poor people's utensils were made of iron, while those in wealthier homes were made of copper.

The remarkable feature of this painting is the presence of a sink. It had no running water, obviously, but could be fitted with a pipe to drain the water outdoors. This new arrangement made it possible to do the dishes standing up—no more need to crouch or bend down by a basin. The eighteenth century saw housewives increasingly doing their work in an upright position. New cooking methods accelerated that phenomenon. As portable burners came into use, food preparation was no longer limited to the fireplace. They consisted of a sort of hollow dish with one or two handles and three feet, fed with burning coals. They became very popular, as did brick stoves and slow cookers that fitted into the wall. Cooks were in less danger of scorching their skirts or their cheeks, and they no longer needed to lift heavy pots on to the trammel. They could finally watch over the simmering food without breaking their backs.

Giuseppe Maria Crespi, known as lo Spagnolo

The Scullery Maid, ca. 1720

UFFIZI GALLERY, FLORENCE, CONTINI-BONACOSSI COLLECTION

FOLLOWING PAGES

Jean-Baptiste Lallemand

The Bourgeois Kitchen, 18th century

MUSÉE DES BEAUX-ARTS, DIJON, FRANCE

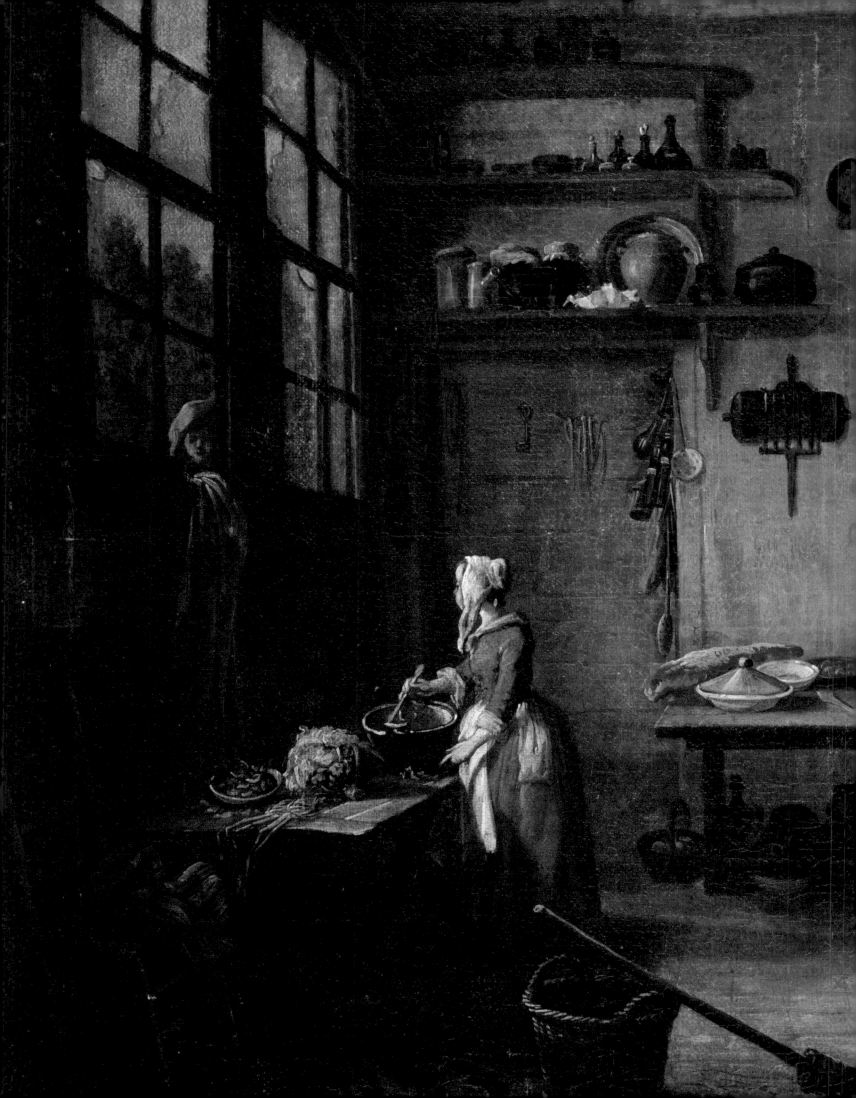

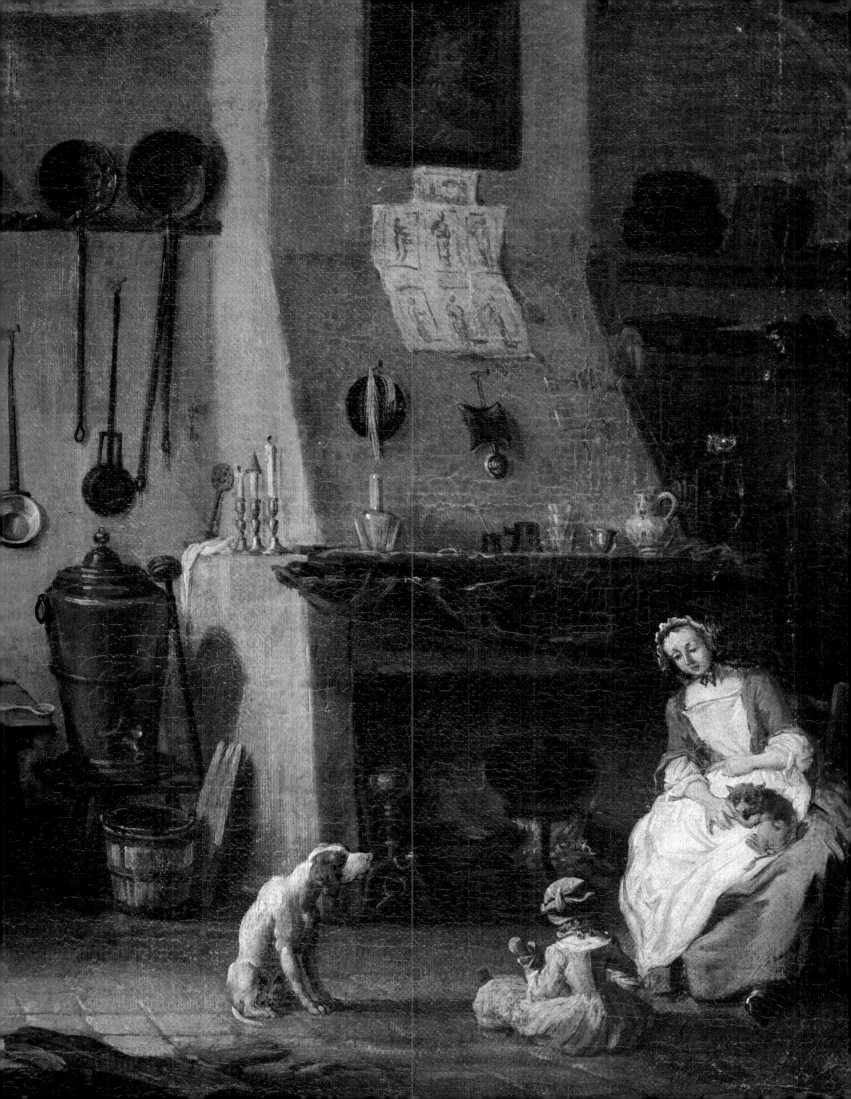

A High-Society Breakfast

Marie-Thérèse Geoffrin maintained a famous salon that was frequented in the latter half of the eighteenth century by all the fine minds of her time: writers, musicians, artists, and philosophers, including Diderot, d'Alembert, François Boucher, and Hubert Robert, who painted this picture.

We see her having a cup of tea, coffee, or chocolate—then new, fashionable drinks—while her servant, who has set down his broom for a moment, reads her a passage from a novel. Reading aloud was one of the jobs delegated to male servants. The masters of great houses preferred their menservants to be educated, which accounts for the very high levels of literacy among their staff. Here, Madame Geoffrin might be having her breakfast. At about this time the morning meal in wealthy French homes began to take the form familiar today: hot, sweet drinks with bread and jam, brioches, and croissants. In the country, where people got up earlier and needed more substantial food before working in the fields, the day began with a thick soup, sometimes washed down by wine. The first meal of the day was also hearty in England, Germany, and the Nordic countries, often including eggs and fresh and cured meats. No doubt the pace of life and the intellectual activities of a woman of letters were such that she could easily make do with a light morning refreshment. In any case, a woman in high society was duty-bound to have the appetite of a sparrow.

From the Middle Ages through the seventeenth century members of every social class ate the day's two main meals at about the same: Dinner was in the middle of the day, at noon or one o'clock, and supper was in the evening. But in the eighteenth century well-to-do people throughout Europe began taking their meals later and later, as they began frequenting theaters and concert halls and having a more active night life than before.

For the elite of France lunch became the midday meal, dinner was served in the late afternoon, and supper was eaten after the theater, just before midnight. English high society in the latter half of the eighteenth century shifted the meal that had been eaten in the late morning to two o'clock in the afternoon. Artisans and peasants, however, remained firmly tied to the rhythms of the sun and took their meals accordingly.

Hubert Robert

A Servant Reads Aloud to Madame Geoffrin, ca. 1772

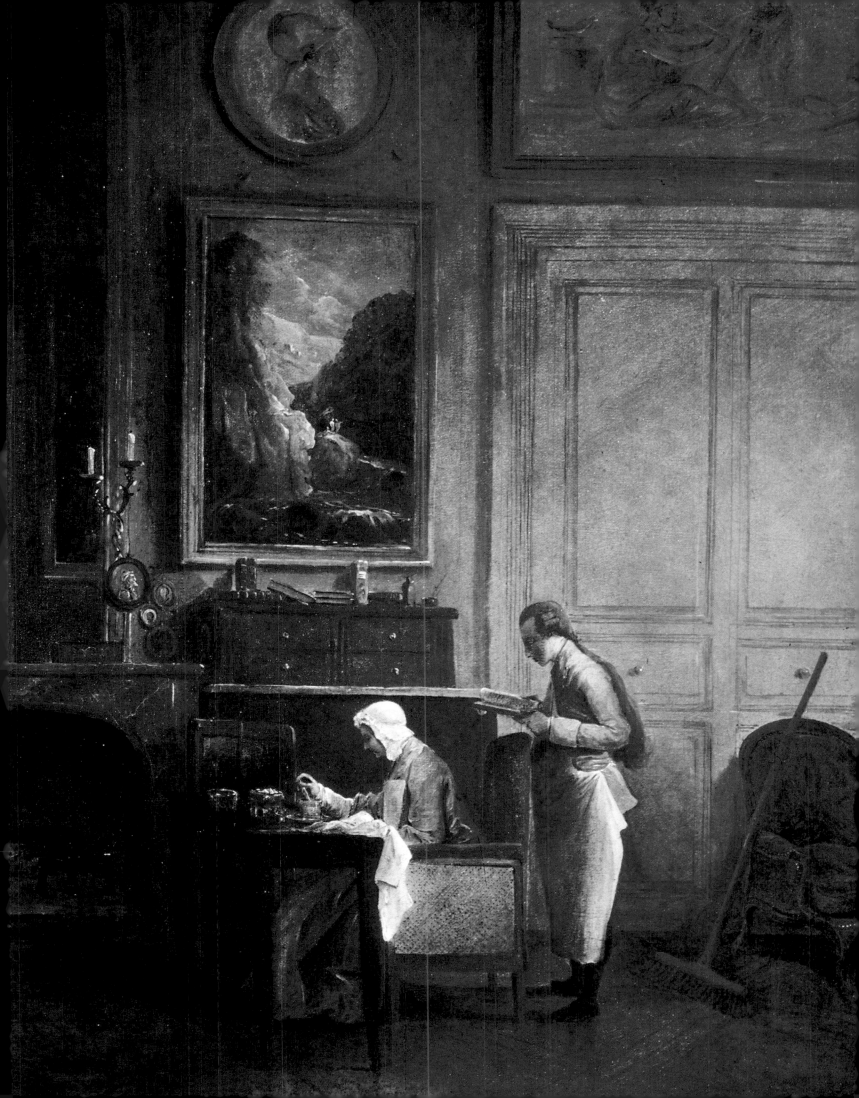

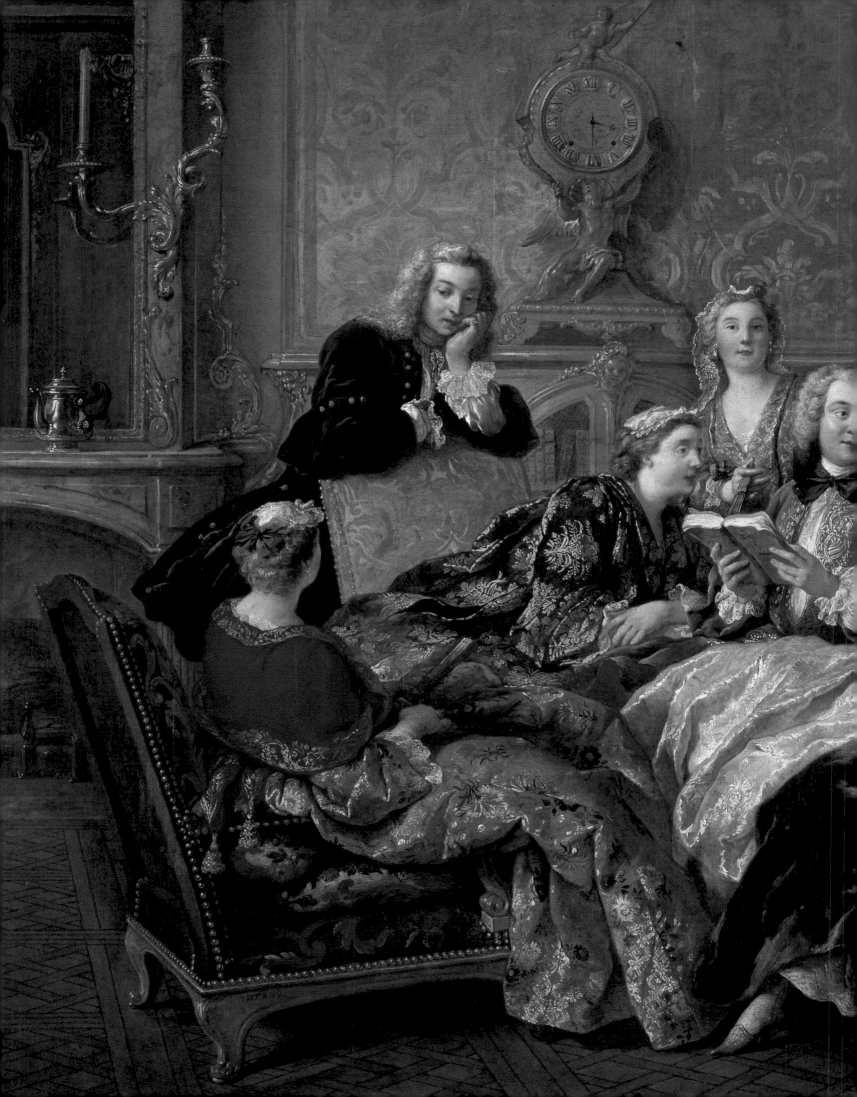

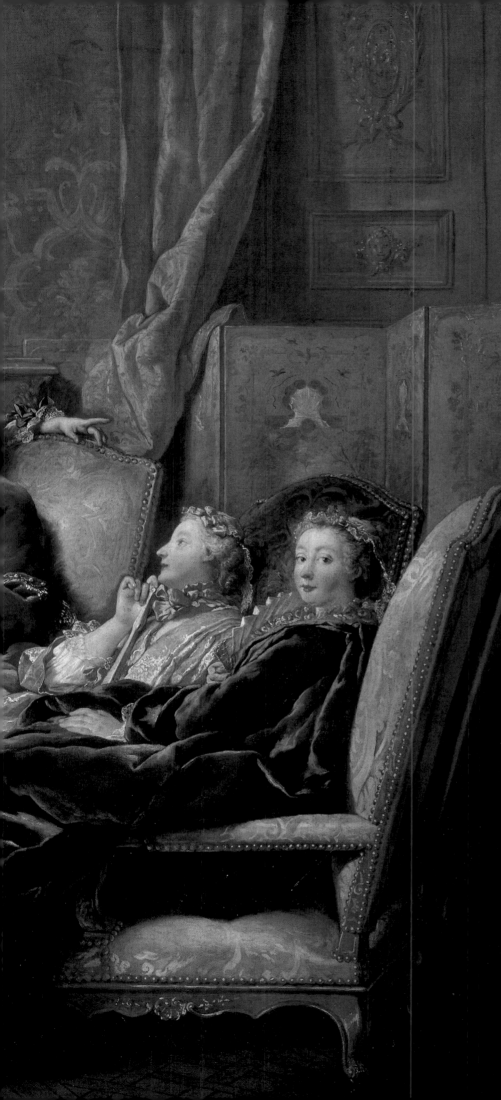

The Reading Room

The austere Louis XIV seats have disappeared. The elegant people gathered here are sitting—almost sprawling, actually—in wide armchairs that are much lower than those of previous centuries. We can see from the design, shape, and padding of this new furniture that it is intended for relaxation, comfort, and reading.

Throughout the eighteenth-century reigns of Louis XV and Louis XVI the armchair triumphed in France. No doubt this development had a great deal to do with the cultivation of the art of conversation and the craze for literary salons. Other charming types of seating also began appearing in the best houses: the davenport and its variants, the sofa, the love seat, the *veilleuse* (a reclining chair), and finally the smartest of them all, the wing chair. This new furniture was no longer lined up along the walls, as in the seventeenth century, but was now arranged more imaginatively. The design embraced a sense of freedom and rejected the idea of symmetry.

Straight lines and right angles were replaced by graceful, sinuous forms. The interior decor here is full of ripples, twirls, and coils, seen in the motifs on the rich fabrics and wall coverings, the twisting sconces, and the arabesque design on the screen. Rococo rooms like this had a living, organic air—even the legs of the chairs resembled those of gazelles—that candlelight, mirrors, and gilded moldings only intensified after dark.

At the reading in the painting, the listeners' voluminous silk brocade and embroidered velvet dresses add a sort of opulent bouquet to the scene. Behind them we see the piece of furniture that was considered essential for every cultivated man: the glass-fronted bookcase. In the eighteenth century rooms grew in number and became more specialized—a reading room, a study, a dining room. The fashion for grand, ostentatious apartments with a series of high-ceilinged rooms later shifted in favor of homes that were better arranged, better designed, and easier to heat. But even in the eighteenth century the Rococo style had its critics. No doubt it was nostalgia for the restraint and decorum of the prior century that drove the writer and engraver Charles-Nicolas Cochin jokingly to decree: "From now on, the higher a person's station in life, the smaller his apartment will be!"

Jean-François de Troy

Reading of Molière, ca. 1728

PRIVATE COLLECTION

The Taste for the Boudoir

Everything in this painting by François Boucher is curved: the lady's dainty instep; her slipper and its high heel; and the legs of the couch, velvet pouf, and small table, whose suggestively half-open drawer has a blue purse hanging from its key.

The lady with the pretty little face has been reading a letter and is lying languidly on her sofa, lost in reverie and sheltered by a screen with motifs of exotic birds and flowers. On the wall above her is a charming set of lacquered shelves displaying her fashionable trinkets and chinoiseries. In the eighteenth century aristocratic and bourgeois women sought to have an intimate, stylishly furnished room where they could take refuge. The boudoir came into being, along with a new perception of women's lives.

The journalist and critic Henry Harvard described it in L'*Illustration* magazine at the end of the nineteenth century, although by then this kind of room had rather gone out of fashion. "It is the feminine equivalent of what the study is for a man. It is here that the mistress of the house can come to seek contemplation, and on days when she is worried or has a migraine, or feels vexed or sad or in a bad mood, can make herself inaccessible to the world at large. This is where she can shut herself away to write, receive a close friend, listen to those often painful confidences that require two people to be alone, or finish a novel that she wants to read in secret.

"In cases of voluntary reclusion or a somewhat extended illness, the boudoir can provide an important and invaluable service. Its proportions can be reduced. It is its nature and its duty to be small. . . . No bulky seats and no large furniture. Everything in it must be dainty, charming, delicate, fragile. Crystal chandeliers with tinted candles, a stylish clock in marble or bisque, perfume burners."

François Boucher

Presumed Portrait of Madame Boucher, 1743

THE FRICK COLLECTION, NEW YORK

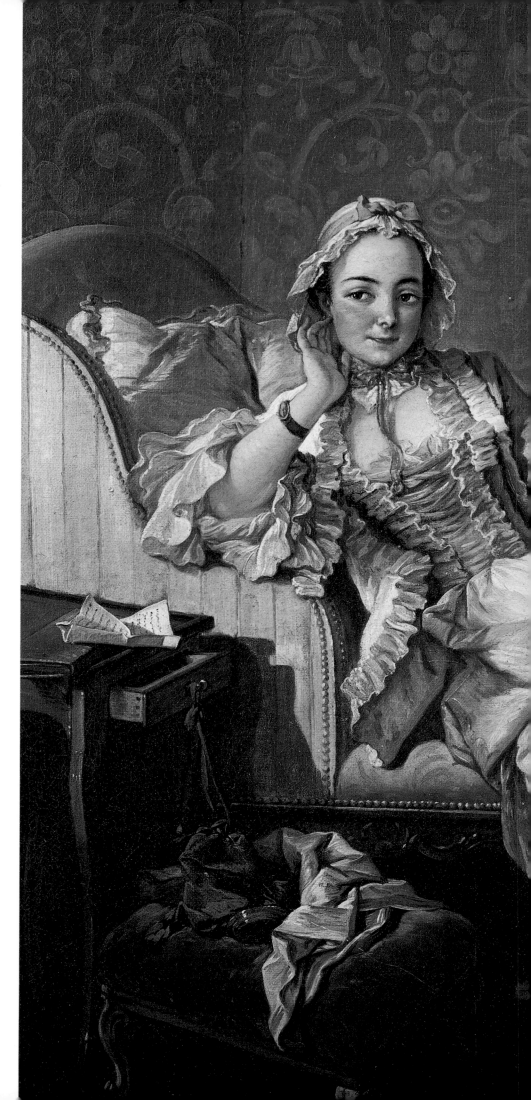

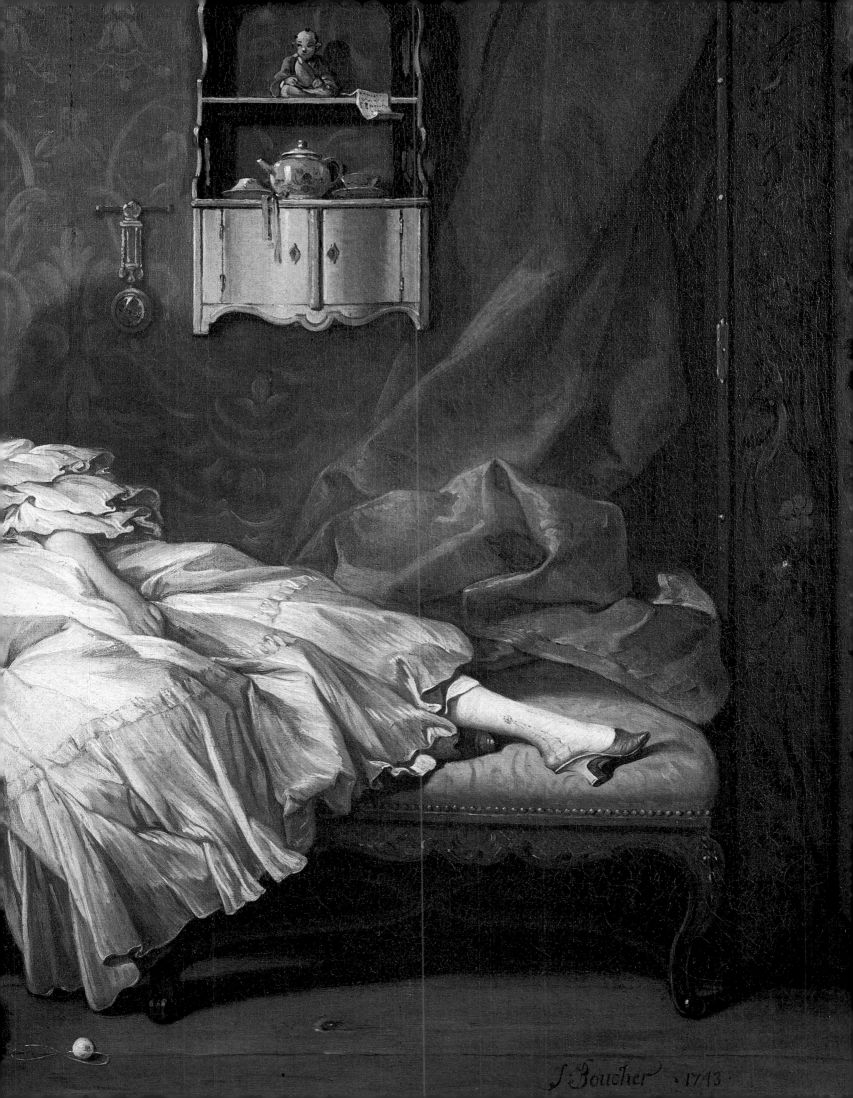

The Toilet

The Private Toilet or *The Unpetalled Rose*, by Louis-Léopold Boilly, is the type of refined yet erotic painting that made the artist's reputation after the French Revolution, when mores became more permissive. Thanks to the finesse of his technique and the delicacy of his brushstrokes the painter has achieved a tour de force: showing a young woman astride a bidet without the scene seeming smutty or vulgar. The young woman—with her nipples appearing over the top of her bodice, one hand dangling in the porcelain bowl, the other holding her petticoats up over her thighs, and her pale blue stockings and satin court shoes—remains disarmingly natural; her innocent face is almost that of a child.

The bidet—here the work of a fine cabinet-maker—appeared in France in the eighteenth century, presumably having been imported from Italy. We know of two belonging to Louis XV's celebrated mistresses. Madame du Barry had a silver one with a sponge box. The one made for Madame de Pompadour by Pierre Migeon, the creator of the pedestal desk, was a luxurious walnut piece with a lid and backrest in red morocco leather, gilded studs, and a little crystal bottle on each side at the back. In 1739 Rémy Pèverie, a Parisian turner-cabinetmaker, designed back-to-back bidets, similar to the conversation seats that could be used by two people at once, and perhaps intended for brothels.

Once we have got over our initial unease at intruding on a young woman in a very private posture, we discover much of interest in the background. The setting is one of the little multipurpose side rooms that often adjoined a bedroom; it is a charming jumble of a space serving at once as wardrobe, junk room, and toilet. Clothes are hung on pegs willy-nilly. (As yet there were no hangers or closets.) On a shelf are a hatbox, a pair of shoes, a globe, and some jewelry or ribbon boxes. On a small table to the left are a chamber pot and an enema syringe. A large earthenware water jug sits on the floor, a feather duster hangs from the shelf, and a water urn stands on an elegant console table. Leaning against one of the console's legs is the red leather lid of the bidet. On the ground lies a wilted rose, whose symbolism is not difficult to imagine.

In the second half of the eighteenth century these small side rooms began to take on a specialized function, as toilets and even bathrooms began appearing in privileged households. But the improvement in hygiene in France during the Age of Enlightenment was also due to the use, finally, of the stove, which provided more reliable, better distributed heat throughout the house. At last people could undress in winter without shuddering from the cold.

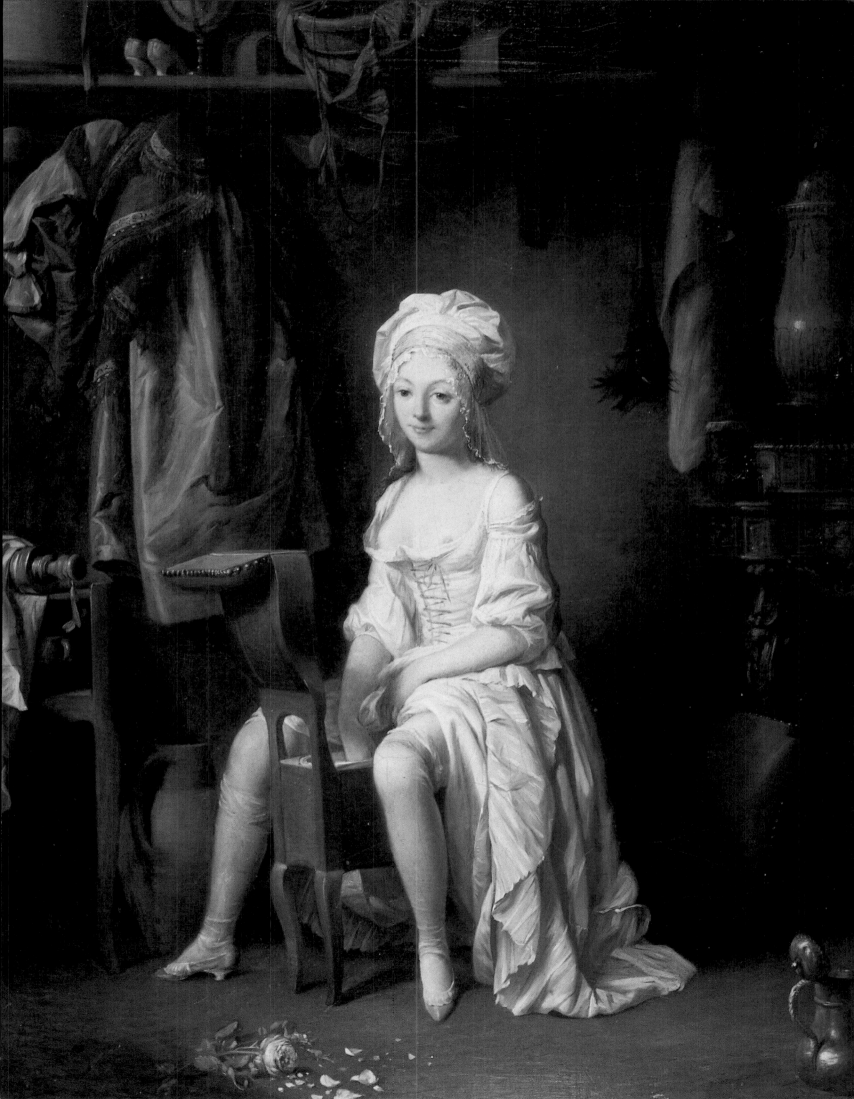

The Nineteenth Century

The Triumph of the Bourgeois Apartment

The diaphanous young woman, almost as pale as the linen she is ironing, has something of the "fine lady" about her, although the painter, Louis-Léopold Boilly, shows her as a servant at work. The flat iron, heated on the burning coals to the left, is so hot that she has to wrap a piece of cloth around its handle. A bottle of water nearby is used to dampen the linen. The innocent, sylphlike creature gazing out at us has no idea yet of how radically the home is going to change, with the proliferation of new rooms such as the dining room and bathroom, the specialization of rooms and storage space, the introduction of the corridor that will preserve everyone's privacy, and the arrival of running water, then gas, and, at the very end of the century, the magic of electricity.

Louis-Léopold Boilly
Young Woman Ironing,
ca. 1800
MUSEUM OF FINE ARTS,
BOSTON

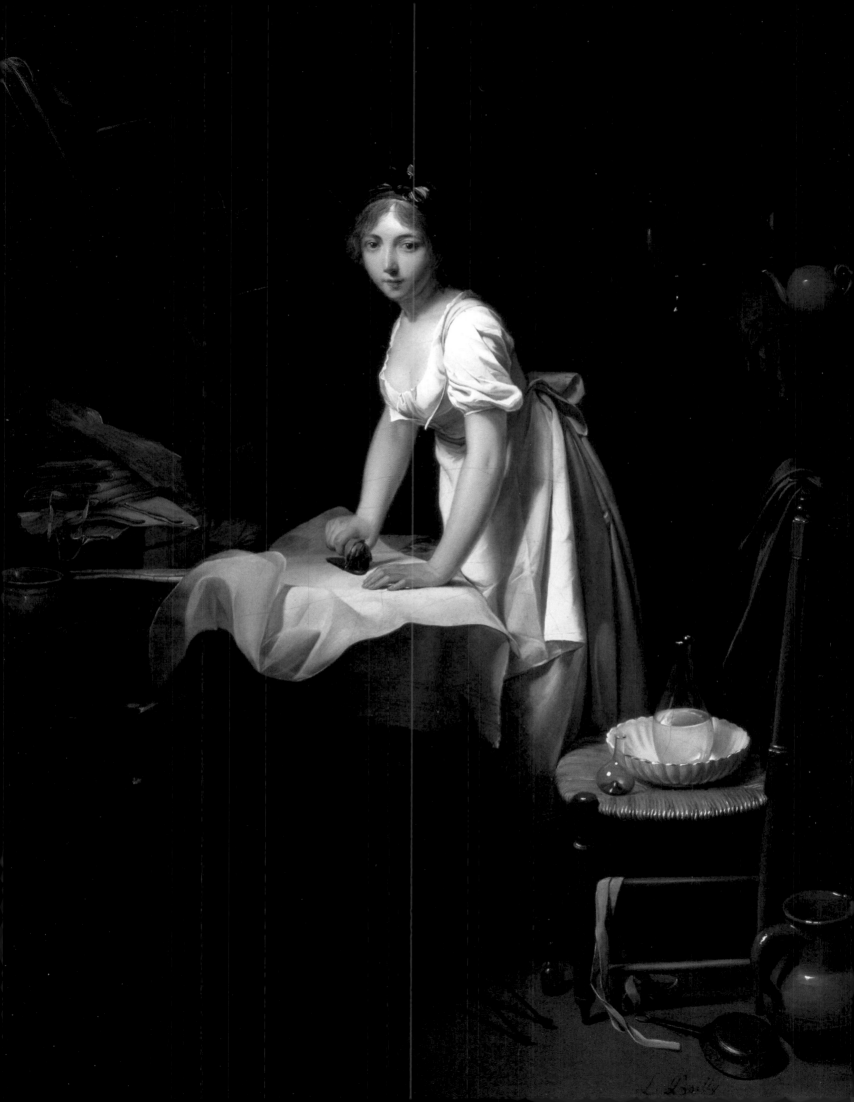

In the Kitchen

The two young women break off from their sewing for a few moments, looking as if the painter, Martin Drolling, a student of Jacques-Louis David, has just called out to them to look up for a snapshot. The room, although only simply equipped, can nevertheless be fairly called a kitchen. Multitenant dwellings in the city previously had only one kitchen, located on the ground floor and reserved for use by the owner or primary tenant, but in the nineteenth century kitchens came to be in every apartment. In the early days this specialized new room, frequented only by servants, was generally small and dark, overlooking the courtyard.

In their 1989 book *Architecture de la vie privée à Paris*, Monique Eleb-Vidal and Anne Debarre-Blanchard explained that the kitchen had low status but that, paradoxically, it was first modernized in working-class homes, under pressure by hygienists at the end of the century. Then, as middle-class families employed fewer and fewer servants, their kitchens began following the rules that governed those of more modest house-holds. The kitchen became better ventilated and more functional. When the mistress of the house had to spend more time there herself, the kitchen began undergoing continual technical and aesthetic improvements. Its transformation culminated with the arrival in the twentieth century of kitchen designers selling veritable cooking laboratories with custom-designed, endlessly adjustable units—a far cry from Drolling's kitchen, which has no cabinets or countertops, just small tables of various shapes and sizes.

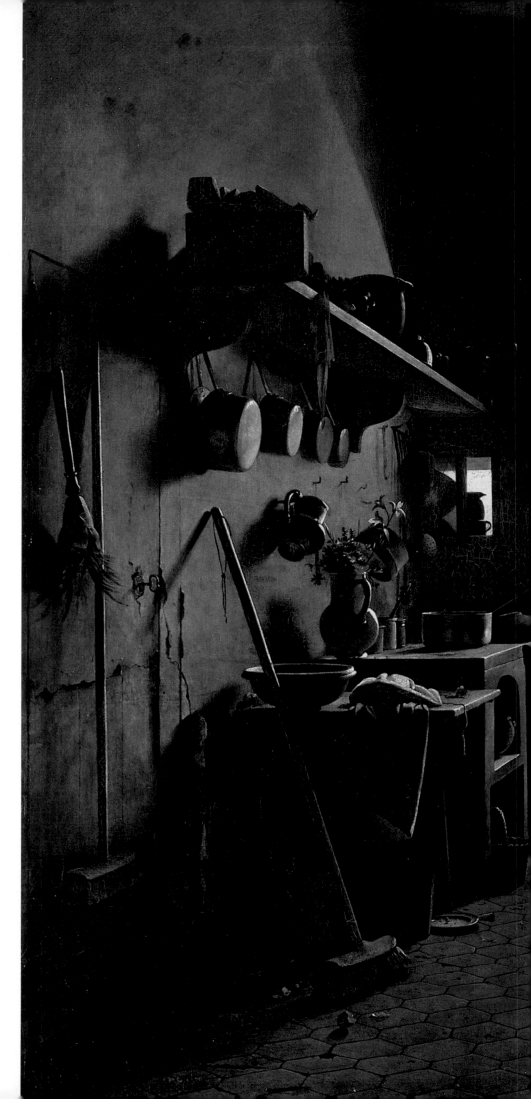

Martin Drolling

Kitchen Interior, 1815

Musée du Louvre, Paris

FOLLOWING PAGES

Martin Drolling

Dining Room Interior, 1816

Private collection

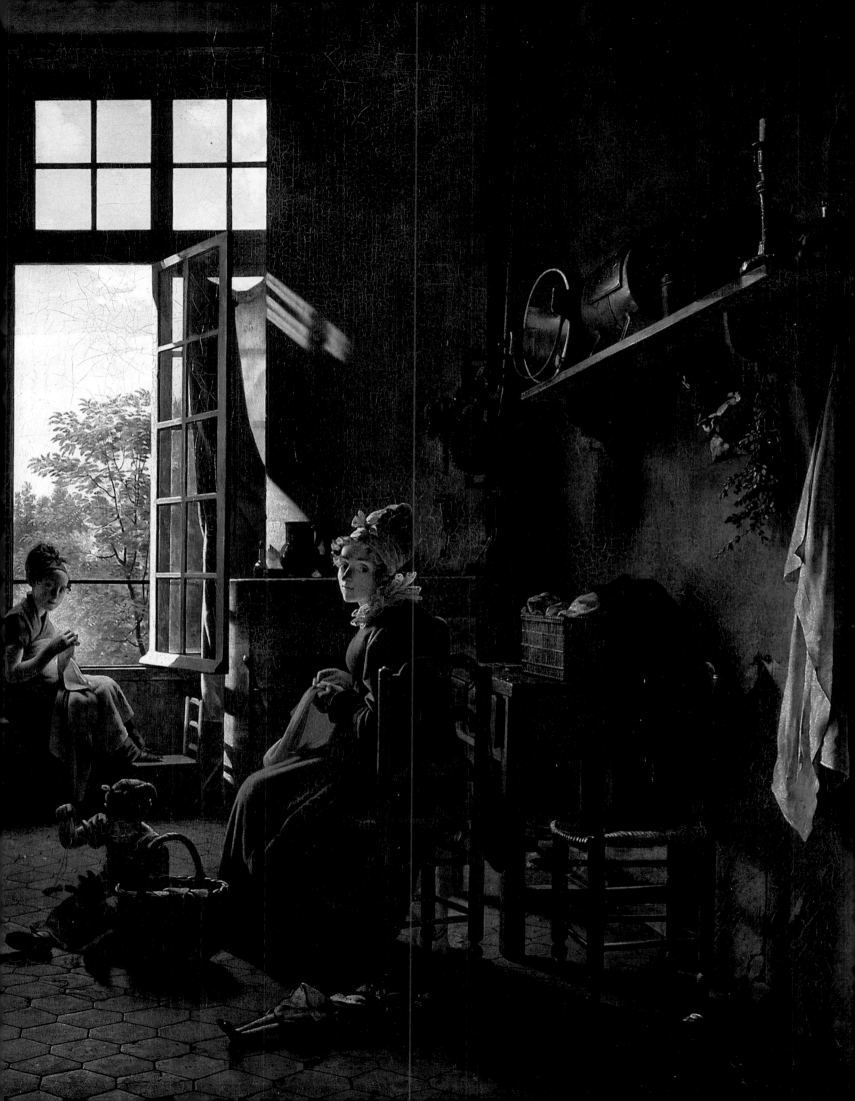

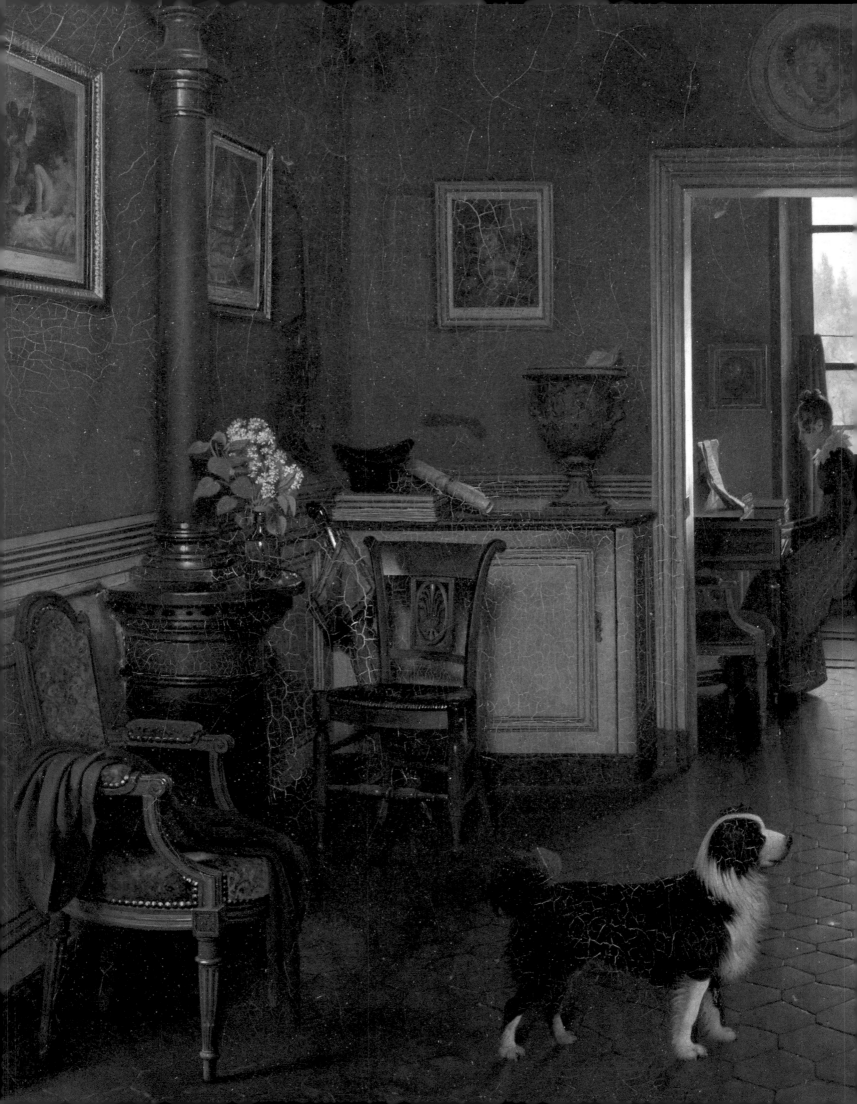

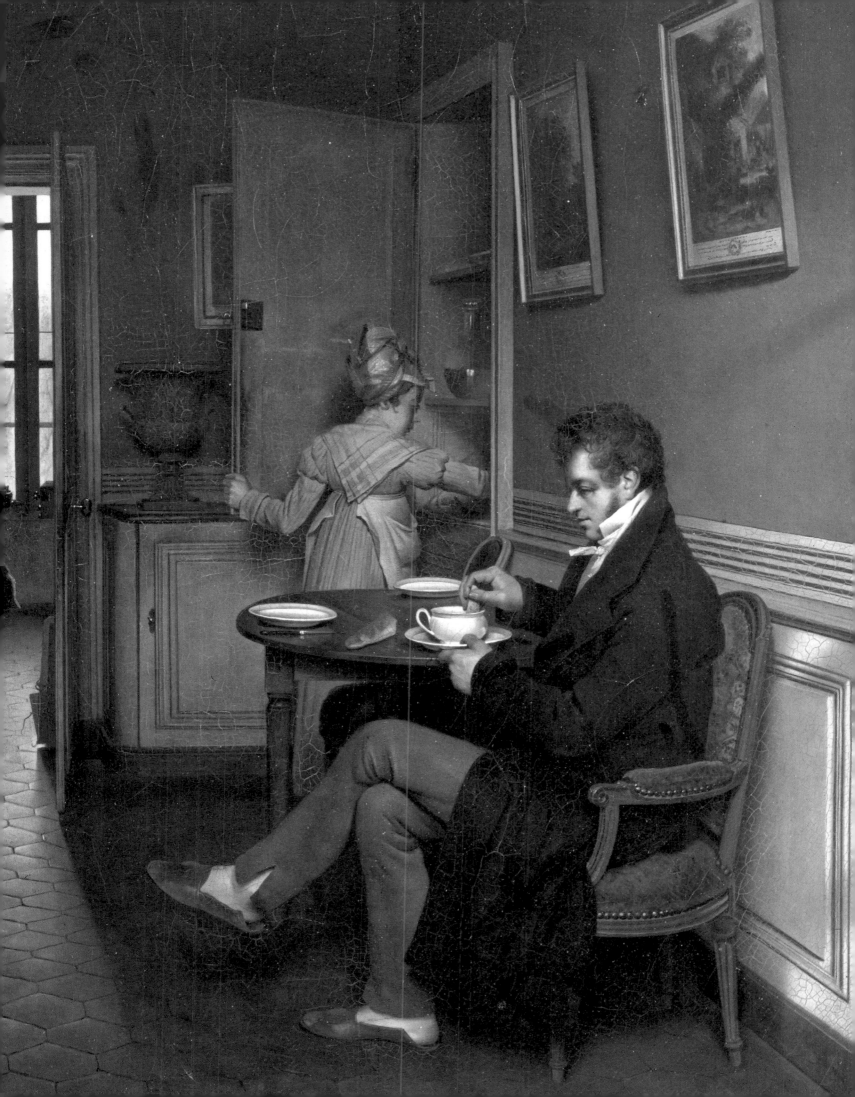

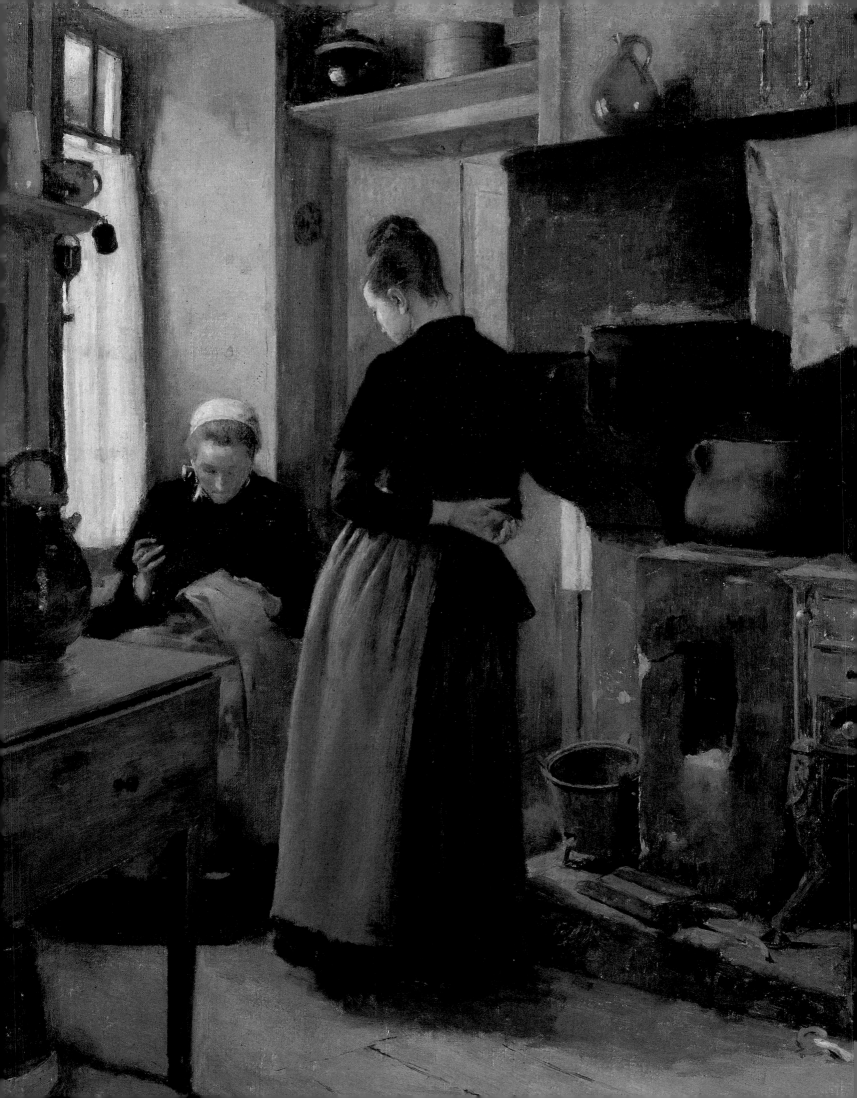

Near the Fire

As a young girl looks on, an old woman sews. She sits by the fire, to keep warm, and very close to the window, to see her sewing better. Her feet rest on a warmer, and her shoulders are protected by a black shawl. Perhaps this is a sewing lesson and the girl is learning a new stitch—or she might just be daydreaming about meeting her future husband. In any case, no serious-minded girl had much chance of standing around for long with idle hands. If the farm work was finished she would knit, embroider her linen, do the mending, darn socks, or cut up old sheets that in the course of time became cloths and then handkerchiefs. Everything was skillfully recycled and used over several generations.

A good housewife could always find something to do. Even so, she probably did not do the housework, dishes, and cooking with today's sense of perfectionism—in fact, she usually got those chores out of the way as quickly as possible. "We did not often sleep in made-up beds," admitted a woman from Minot, a village in Burgundy, whose account is included in Yvonne Verdier's 1979 book *Façons de dire, façons de faire*. "And the pot boiled away without anyone watching it—we put a log underneath it and left. For high mass we left the big stewpot on the stove. On Sundays we put the stew on before we went down to church, and by the time we got back it was cooked."

Women's most important daily work was done outside, by both farmers' wives and female laborers who were paid by the day. Until the first half of the twentieth century they helped in the fields with haymaking, harvesting, and threshing, but the mechanization of agriculture reduced the need for their outdoor labor. They found themselves driven back into the home and increasingly isolated, especially when the arrival of the washing machine brought an end to big communal wash days. One of the Minot women, la Raymonde, openly regretted the change of responsibilities: "My son-in-law says, 'Let the women do the washing up and make the soup!' The women don't go to the fields any more, they do nothing at all, so they have time to do the housework."

Joseph-Paul Meslé

In the Kitchen, 1888

Musée des Beaux-Arts,
Rennes, France

The Big Wash

"We did the washing twice a year—once in the spring, once in the autumn," recounted another Burgundian woman in Yvonne Verdier's Façons de dire, façons de faire. "This was when we had big linen chests and full closets. We called it the bui, and it took at least three days; it was a whole ceremony. When we did the bui we had to bring the vat [which was usually kept in a shed] into the stove room and put it on a tripod. It was made of wood with iron hoops, like a barrel, sort of a half cask [thirty-two inches high and fifty-nine inches in diameter]. Near the bottom, on the side, there was a hole called the pissoir to let out the lessu [the washing water], which we plugged with a straw cloth." This equipment was incredibly heavy and the procedure laborious, as Jean-François Millet's painting shows.

"On the first day we loaded up the vat. First we put in firewood, anything at all—although not too much oak, because that would stain—so that the linen would not fall down to the bottom, so that it could drain. Over that we laid a big coarse canvas sheet, and on top of that we put ashes from the fire, then we folded the sheet over the ashes. We used all the ashes we could find for the wash; we took all we had, but not too much oak. Then we arranged the linen in layers, the sheets carefully spread out, then the shirts, then the cloths [there was an order, from the biggest pieces at the bottom to the smallest at the top], and little by little we filled the vat to the top."

The next day they ran water through the wash. "We poured water on to the linen, and put a basin under the hole to catch the water. It flowed and flowed. We collected this water that had passed through the linen and ashes [the lessu] in a saucepan and poured it into a large boiler, one of those big boilers that you made a fire under in the fireplace. We heated it up, and again used the saucepan to pour water into the vat. The first time it was not too hot, lukewarm. Each time we poured the lessu back in we made it hotter—the last few times it was boiling. It had to be by the end of the day."

The following day the washerwomen came on the scene. "They arrived with their brushes and beaters. There was a group of them that did the big washes. We booked them in advance. There would be four or five of them. They came early in the morning, took the linen out of the vat, then carted it away in big baskets with two handles, on a barrow; then they went to the wash house.

"At the wash house they had to soap the linen, then scrub it, brush it, and beat it to get out the dirt. I can still see them, those washerwomen, rolling the sheets into big tubes and beating them, beating them. . . . Sometimes they spread them out to dry over the hedges around the wash house. At the springtime wash they would stretch right to the cemetery."

The big wash was a special event and, despite the exhausting work, the huge, heavy equipment, and the sheer size of the job, the last witnesses of the big washes had wonderful memories of so many women—including the washerwomen, who were never at a loss for words—coming together and the cheerful atmosphere that prevailed. The bui disappeared in the mid-twentieth century, when the washing machine arrived.

One can well imagine that in the days of the bui people did not put a slightly soiled or stained garment straight in the wash as we do now, although they were more likely to get dirty than we are today, even doing routine housework. "The pans [directly exposed to the flames in the hearth] were completely black," one woman remembered. "We got our hands black, the cloths we wiped the dishes with were black all the time—it was inevitable." For that reason people always wore aprons, a habit that has since been abandoned. "In our house," said a farmer's daughter, "we changed our aprons every Monday, but I remember . . . one little girl who was a lumberjack's daughter came to school one week with her apron on the right way out, and the next week the wrong way out. She said: 'It means my mother will have less washing to do.' "

Jean-François Millet
The Boiler, 1853–54
Musée du Louvre, Paris

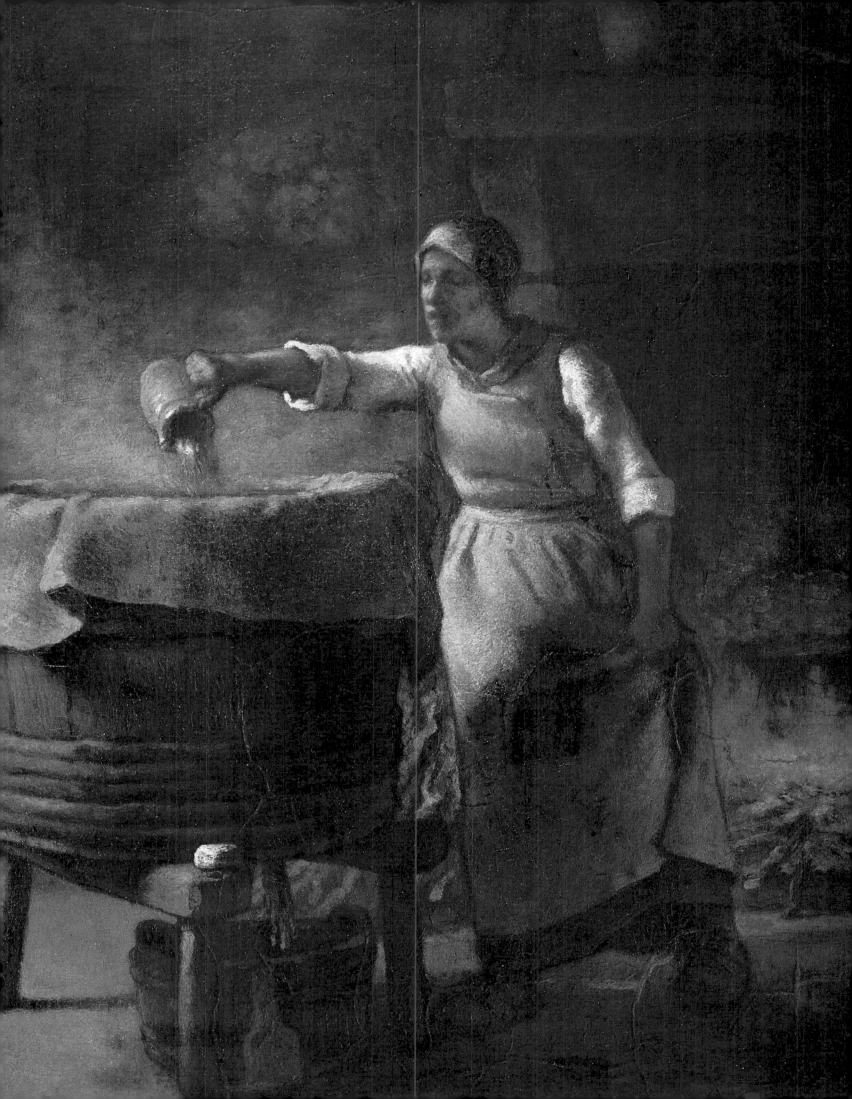

The Newborn Child in the Home

Everything radiates happiness in this Breton interior after the birth of a clearly healthy baby. The mother is resting in her high bed right next to the fireplace. It was considered absolutely essential to maintain intense heat in the room during childbirth and the days that followed. On the bedpost are a porcelain cross with a bowl of holy water, a sprig of boxwood, and a rosary, all meant to protect the mother and child, as was the engraving of a saint hanging on the wall.

To keep the baby off the ground and near its mother, the cradle has been placed on a chest alongside the bed. Well wrapped and tied in like a little mummy, he sleeps peacefully on his mattress of straw, which will be thrown away as soon as he wets it. People believed—perhaps rightly—that in their first few weeks babies would be frightened by sensing empty space around them. The blankets that restricted the baby's movements were intended to remind him of the womb and keep him calm. Also, parents were fearful for the infant's soft, shriveled body. The bands they trussed him up with were supposed to make him firmer and more "compact."

While the young woman rests, her mother (or a servant) puts some linen away in a dresser, which we can see served a variety of purposes at the time. To the left we can just make out a spinning wheel, and a pile of rags (perhaps children's clothes) lies on the floor; they are worn and full of holes and now need to be mended. Clothes were handed down among siblings and through several generations; the newborn was often dressed in clothes his parents had worn in their own infancy. People held on to old clothes not just for reasons of thrift but also because they believed a garment worn by someone who had grown up and remained more or less in good health was impregnated with a sort of vital energy from which the new wearer could benefit.

Eugène Leroux

The Newborn, Breton Interior, 1864

Musée National des Arts et Traditions Populaires, Paris

No Child's Bedroom

The mother watches over her child sleeping in a cradle made of wicker. This was a convenient material since, in the absence of waterproof diapers, the cradle was regularly soaked. It could be emptied and taken down to the river or the sea to be washed, as can be seen in some old engravings. It was light and could easily be carried around, to be placed in the room or at the edge of the field where the baby's caretaker was working. The child had no special place reserved for him alone.

The nursery, inspired by English methods of child rearing, did not appear in large bourgeois apartments in France until the second half of the nineteenth century. Until then, the side room off the parents' bedroom often was converted into a child's bedroom. Of course, for a very long time French urban families, whether well-off or not, sent their children to wet nurses in the country, then to boarding school, so the child was only intermittently at home. Household inventories show strikingly few signs of the children's presence in the home. A few objects indicate their existence: a little bed, a cradle with a straw base, a small mattress, a wicker basket, a high chair, a few feeding bottles made of earthenware or china, some plates and bowls for baby food, some baby's silverware.

Here the young mother is leaning attentively over her baby, as if she wanted to listen to its breathing. The cradle has some wicker hoops covered with a piece of material to protect the child from light, drafts, and insects. The child may be ill, or perhaps he has just gone to sleep as his mother sings him a lullaby.

Jacques-Gustave Hamelin

The Young Mother,
19th century

MUSÉE DES BEAUX-ARTS
ANDRÉ MALRAUX, LE HAVRE,
FRANCE

FOLLOWING PAGES

Walter Langley

The Orphan, 1889

TREHAYES COLLECTION,
CORNWALL, ENGLAND

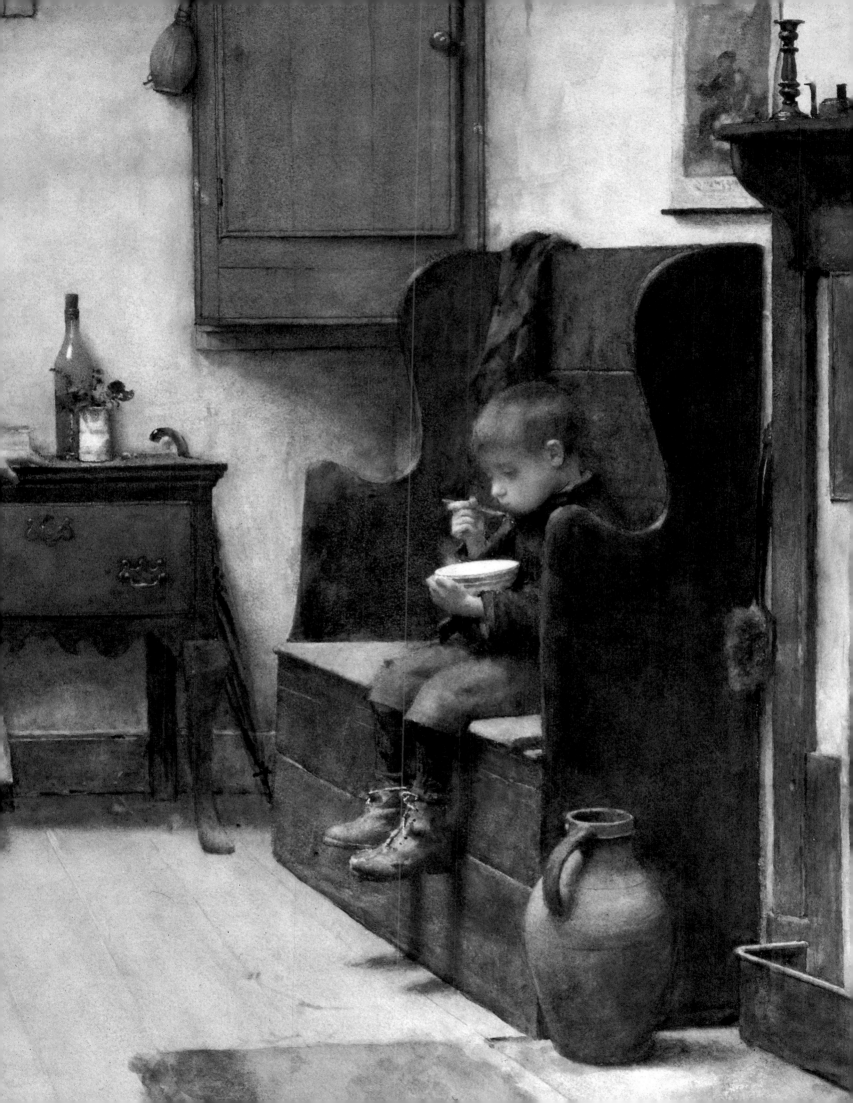

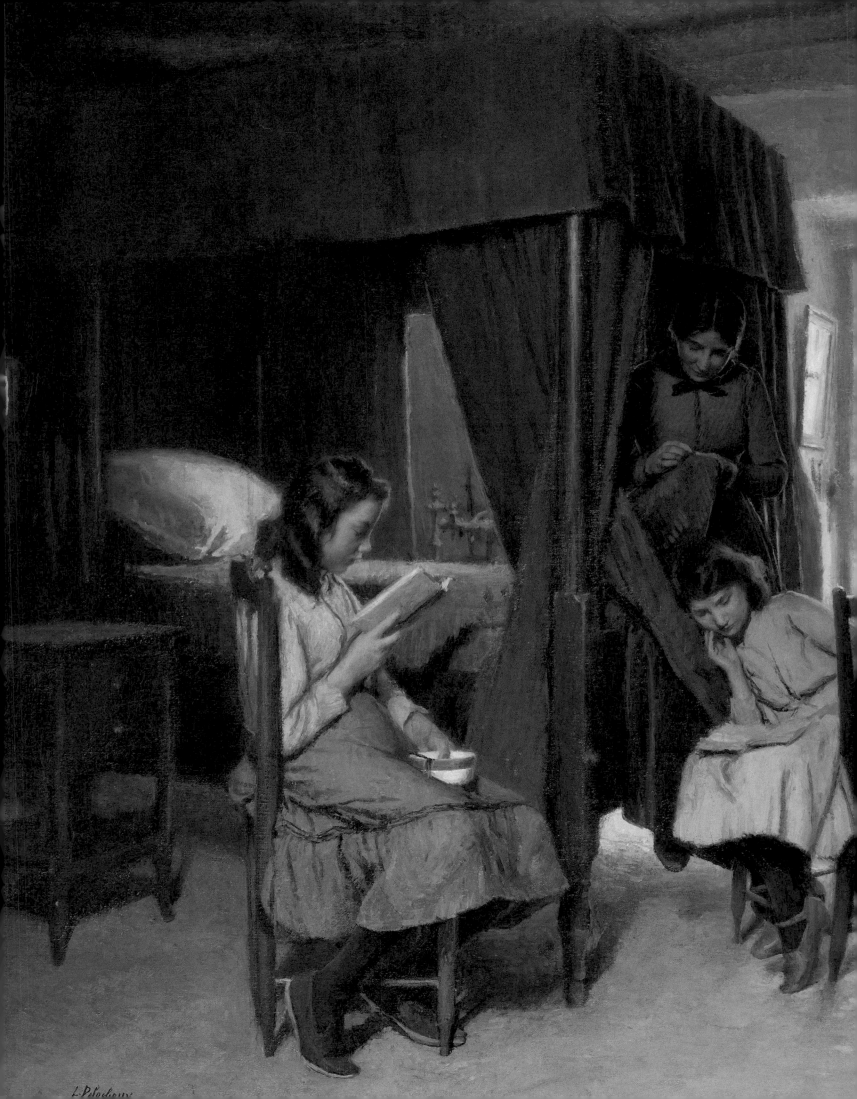

In the Silence of the Bedroom

Over time the bed had been completely separated from the communal room. People were now embarrassed to be seen in bed, or even to have their bed in a public room, which presented an uncultured, low-class image even if no one was lying in it. Having one or several private bedrooms was a sign of social status. However, bedrooms that were specifically reserved for sleeping were generally more poorly heated than the main room. In winter they were freezing cold. That is why the bed pictured here has curtains, just as in the old days; bed-curtains remained the simplest and least expensive way of protecting against the bitter chill.

The Swiss painter Léon Delachaux sets this very gentle scene in an interior of great simplicity and with a harmony of color. While the woman sews, her two daughters read. We may wonder whether the girls' books are religious tracts, cheap novels, or serious literature. We will never know but can be sure that children in the country were never allowed to be idle. They were required to perform a whole series of tasks: fetching wood, making bundles of firewood, feeding the cattle.

Girls were also dedicated to sewing. In *Façons de dire, façons de faire* Yvonne Verdier shed new light on this feminine activity. At the beginning of their adolescence, about age twelve, girls began to mark their linen with red thread to show that it was part of their trousseau. It was not by chance that this work began at about the onset of puberty, Verdier explained: "Marking" was a metaphor for menstruating. (This interpretation suggests a new reading of "Sleeping Beauty," wherein an adolescent girl pricks her finger, falls asleep, and eventually is awakened by a charming prince.) Delachaux's painting evokes all these themes: sewing, waiting, the teenage girl in the home, and the large bed, which in the future will be a married couple's refuge.

Léon Delachaux
Berry Interior, 19th century
Musée d'Orsay, Paris

The Hallway and the Anteroom

No visitor would dare walk around a bourgeois apartment in the nineteenth century without having been expressly permitted by the mistress of the house. The home had become a cloister. The muffled, even stifling atmosphere made visitors feel they mustn't disturb a thing, as if walking on tiptoe.

Rooms' layout and distribution had become more complex, and their uses more specialized. The corridor and stairs cut the rest of the house off from the bedrooms, which were now invisible to strangers. The conjugal bedroom was even off limits even to the children of the family.

Now an entrance hall, an anteroom, or a number of small waiting rooms enabled hosts to screen their visitors. One penetrated other people's houses enshrouded by a veritable spider's web of codes and rules of etiquette, and only with the greatest of respect. In her 1891 manual *Usages du Monde* Baroness Blanche Staffe instructed visitors to leave umbrellas, overcoats, galoshes, and other protections against inclement weather in the hall or anteroom. Women, however, could bring in their parasols or umbrellas, boas, and muffs—but, the baroness added, they "must take care not to damage the rugs in the drawing room where they are received with the points of their parasols."

In an 1882 issue of *L'Illustration* Henry Harvard gave many recommendations for decorating the anteroom that reveal its now antiquated function as a transitional—even a decontamination—space. He advised above all a rudimentary simplicity, which was "demanded by the uncertain quality of the visitors our waiting room must receive. Since anyone at all can have access to it, any show of luxury that smacks of ostentation would, for that reason alone, be in doubtful taste. The poor stranger who knocks at our door must not be embarrassed by an excessively marked contrast between his impoverishment and our sumptuousness. Moreover, how can one dismiss the suspect supplicant, how can one deny the dangerous beggar the help he seeks, when surrounded by the trappings of luxury?"

Frederick William Elwell

My Neighbor's House, 1929

BRISTOL CITY MUSEUM AND
ART GALLERY, ENGLAND

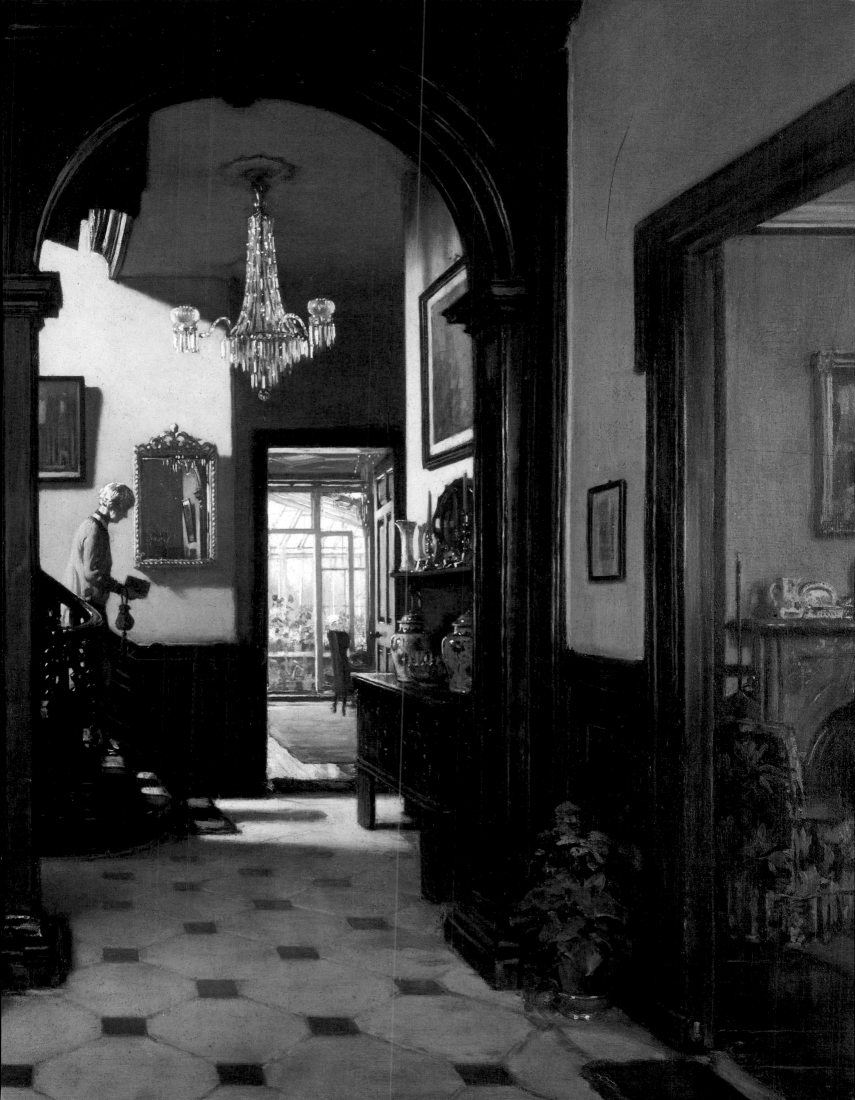

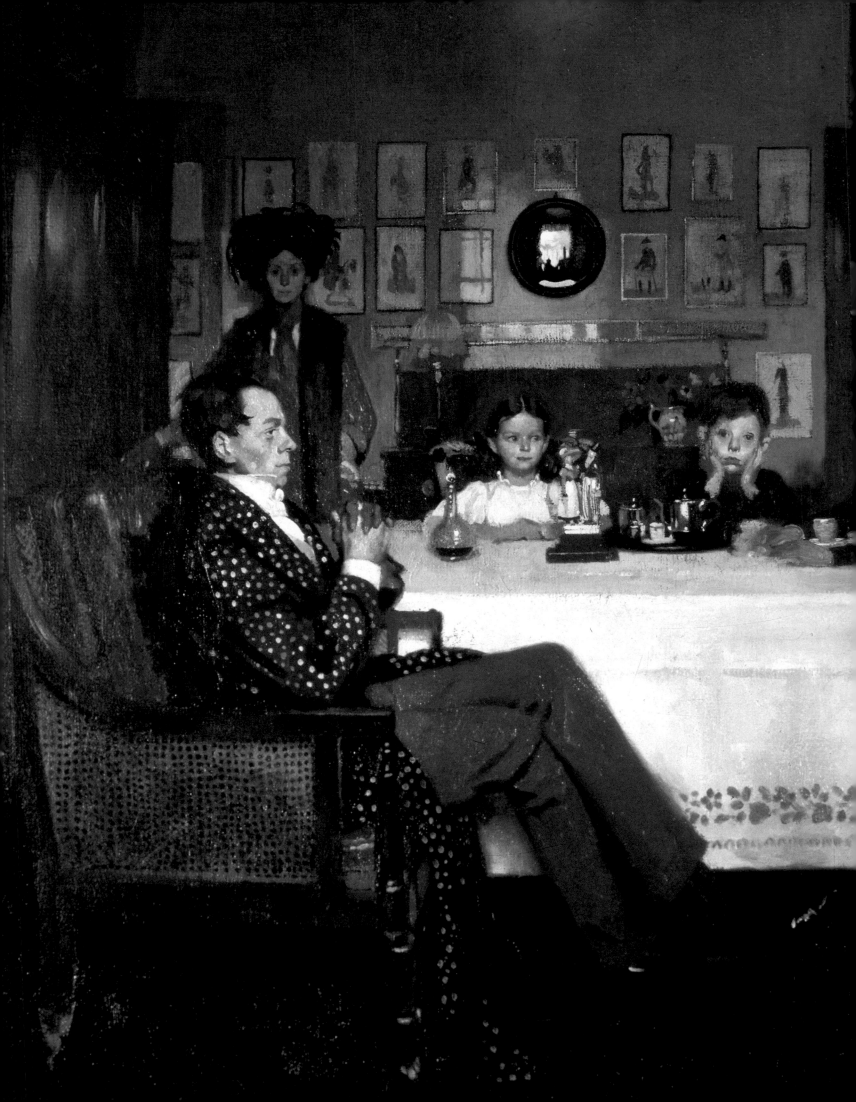

A Respectable Family at Table

Sir William Orpen, who gained recognition with his paintings of World War I, here presents an ironic portrait of the family of William Nicholson, a painter. Although they lived in Bloomsbury, London's district of artists and intellectuals, the subjects did not escape Orpen's acerbic brush. The father presides at table with a look of stiff vanity, the children seem bored to death, and the mother, pinned to a wall densely covered by a collection of small paintings, looks veritably taxidermic.

England had set the tone for interior decoration since its triumphant Victorian era, leaving no square inch of the home free of clutter. Walls were completely covered with mirrors, paintings, and layer upon layer of wallpaper. Knickknacks were piled everywhere in rooms filled with voluminous curtains and frilly upholstered furniture. By the end of the nineteenth century hygienists condemned the heavy, excessive style for squeezing out essential air, space, and light. It also came under attack by art critics, who regarded the desire to accumulate as a neurotic assault on good taste. Gradually Victorian bric-a-brac gave way to a sparer aesthetic imported from the Scandinavian countries, where light and sunshine were much valued and people preferred pale walls and light curtains. The final blow was struck, no doubt, by the disappearance of the vast army of servants who had kept all the dust at bay.

Sir William Orpen

A Bloomsbury Family, 1907

Scottish National Gallery of Modern Art, Edinburgh

Spies in the House

In their 1978 book *La Vie quotidienne des domestiques en France au XIX^e siècle* Pierre Guiral and Guy Thuillier noted that the ratio of servants to workers in France was for a very long time one to three. That striking statistic shows how common it was in the nineteenth century for even modest middle-class or farming families to engage a servant or farmhand, whose wages were very low. Day-to-day domestic life must have been very different when these domestic slaves were hard at work from dawn until late in the evening. Guiral and Thuillier explained how, right up to the 1960s, French housewives refused to buy washing machines or other household appliances because their maids took charge of the washing and other domestic chores.

Servants' labor was indispensable to running a house, but the disadvantage for the masters—sometimes a very serious one—was that these strangers in the home could learn the family's secrets and might well gossip. Rémy Cogghe's painting *Madame Is Receiving* takes a humorous view of their indiscretion. Servants were also frequently suspected of pilfering food or silver teaspoons. For such reasons the kitchen and pantry were usually banished to the far end of the apartment, with a separate entrance and backstairs, and the servants' bedrooms tended to be on the sixth or seventh floor. The apartment itself was outfitted with corridors, double doors, and bells that enabled the masters both to keep the intruders (or "enemies," as the nineteenth-century French historian Jules Michelet called them) under control and to summon them from a distance at any time.

Over the course of the nineteenth century the decline of the great aristocratic houses, which had employed a vast hierarchy of specialized servants, paved the way for the "all-in-one" housemaid. Now the urban middle classes could assert their social status at low cost by employing a servant. The servant class became proletarian and largely female. But none of the laws protecting workers applied to servants: Rules on child labor, the rights of women, who were often dismissed when they were pregnant (even if married), work-related accidents, limits on working hours, and the right to have time off every week were not extended to domestic help.

After World War I the number of servants decreased significantly. Many were killed at the front, and others were dismissed as their masters' income dropped. People who once might have been in service now preferred to work in factories, where the wages were better and they were no longer subjected to the mistress's whims. In fact, a leading reason for the decline in the number of servants was the improvement of teaching and educational standards. Once girls started to be schooled, they no longer wanted to do a job regarded as demeaning. They were attracted instead by the conditions office employees and shop assistants enjoyed.

However, the experience of the servant class was not universally negative, as Guiral and Thuillier pointed out. Some masters even looked after their servants until their death, as if they were members of their own family. Even so, one can well imagine the undemanding daily life of the lady of the house in the days when her young servant, who rose early to go to six o'clock mass, came on duty at about seven, lit the fire, prepared the breakfast, looked after the children, went to market, cooked the meals, waited at table, polished the copper and silver, was fed on leftovers, and went to bed late in the evening in a room that was not usually heated.

Rémy Cogghe

Madame Is Receiving, 1908

MUSÉE D'ART ET D'INDUSTRIE,
ROUBAIX, FRANCE

FOLLOWING PAGES

Gustave Caillebotte

Lunch, 1876

PRIVATE COLLECTION

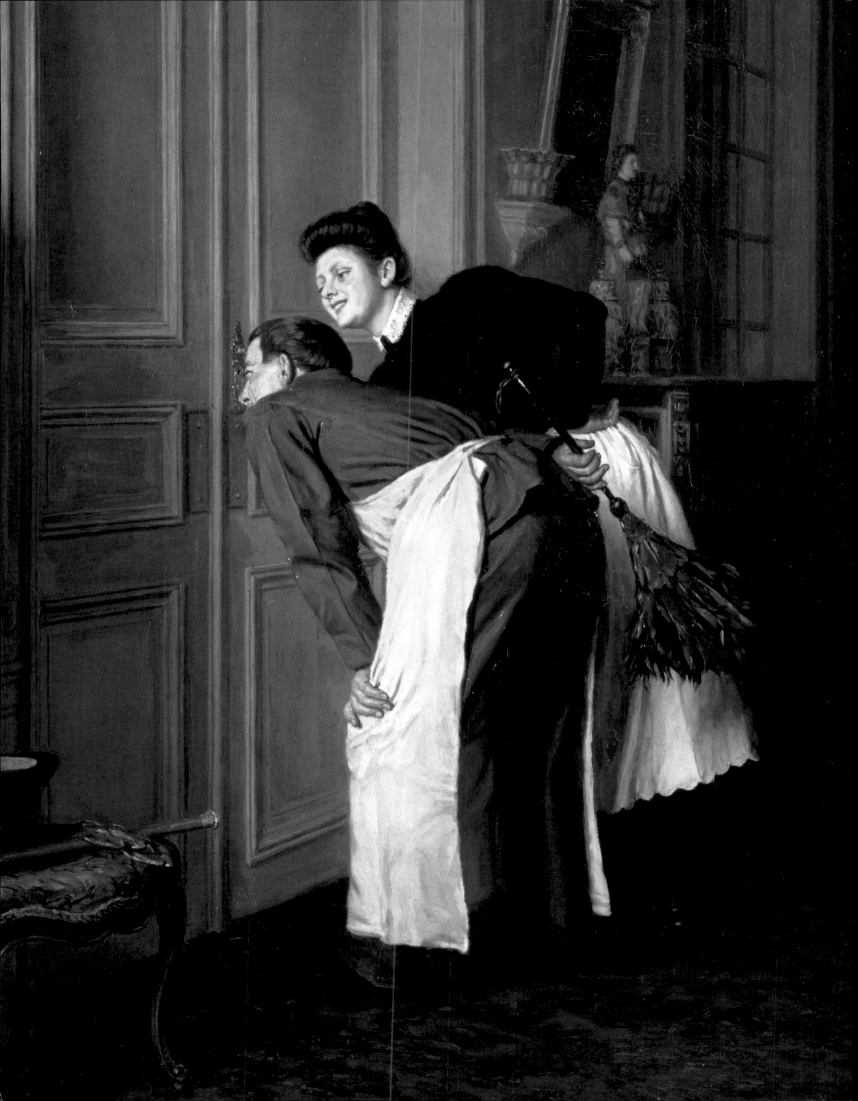

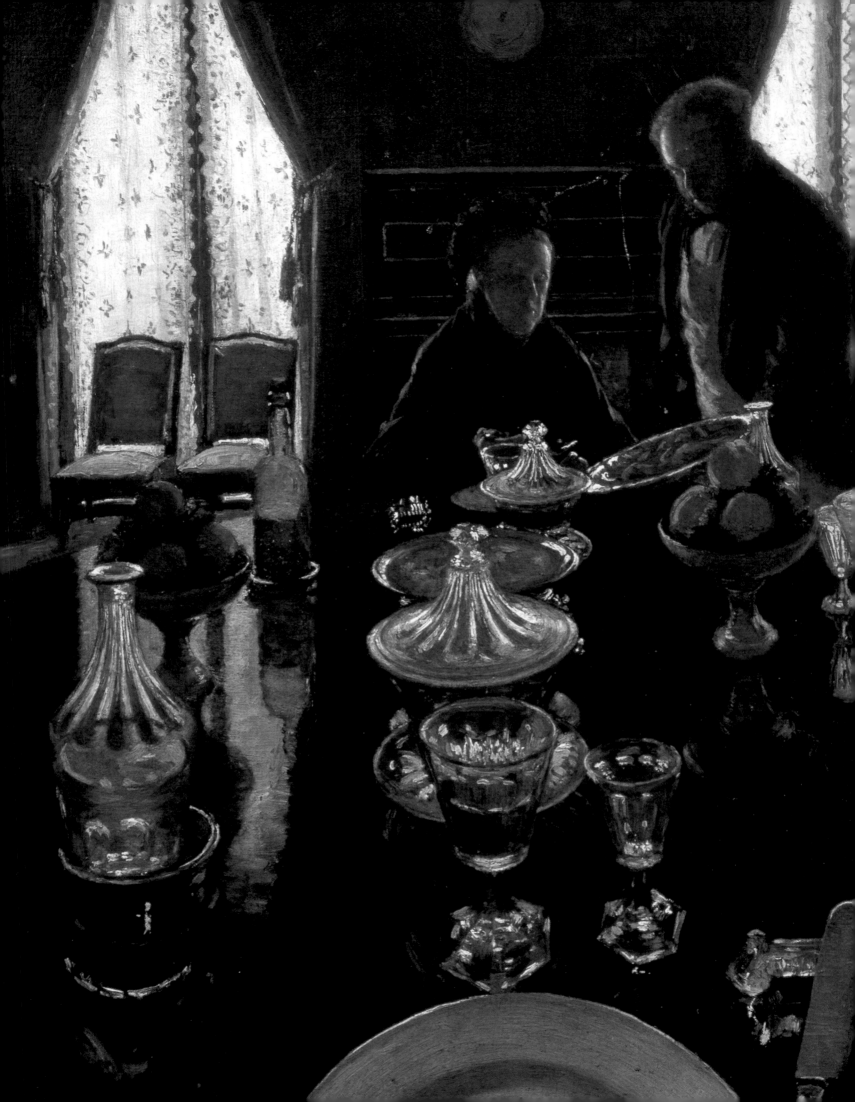

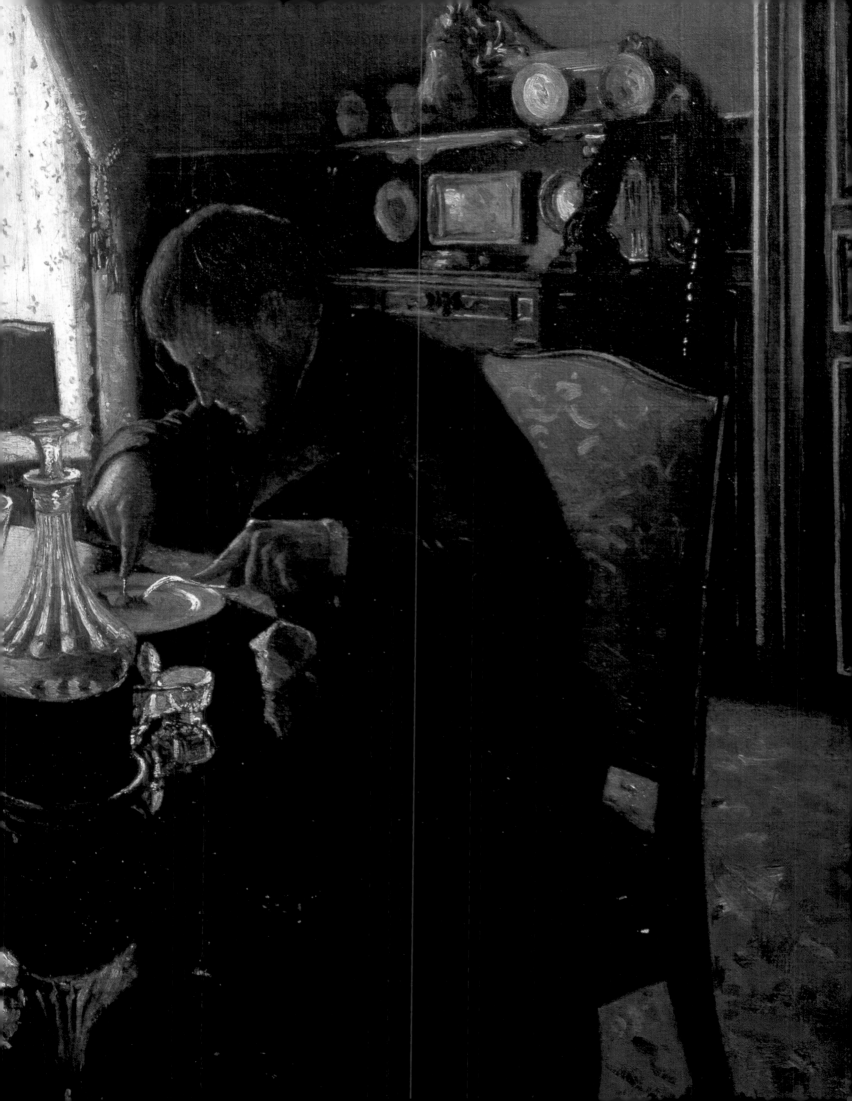

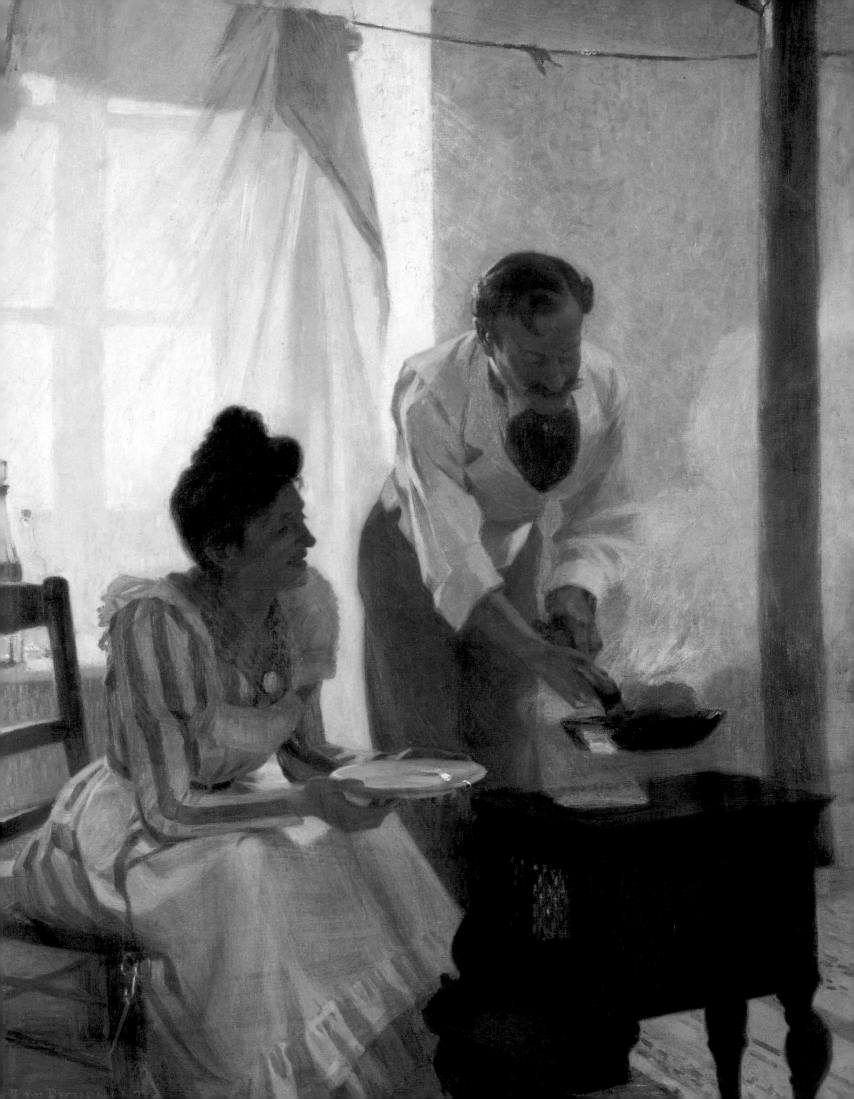

The Triumph of the Stove

For centuries people kept warm and cooked their meals at the fireplace. With its flames flickering in the open hearth, soothing crackling sound, and pleasant smell, the fire exerted a fascination that made the fireplace a sort of domestic altar. But the stove heated better, consumed less, and was cleaner.

Those considerations were less important in relatively mild climates like that of France, which could afford to waste a great deal of heat through open hearths. The ancient bond with fire allowed the fireplace to reign supreme in France through the eighteenth century, when the writer Louis-Sébastien Mercier expressed his disgust for the alternative: "What a difference there is between a stove and a fireplace The sight of a stove kills my imagination and makes me sad and melancholic, I prefer the bitterest cold to that dull, lukewarm, invisible heat."

The stove triumphed earlier in northern Europe—from Germany, Hungary, Poland, and Russia all the way to Siberia. Lands that experienced long, harsh winters required a more powerful, steady heat that lasted through the night and could be kept going most of the year. Houses that were often made of wood needed an enclosed, safer fire that could be regulated and would provide heat not by open flames but by radiation. And so the stove, which was often huge, came to occupy the center of the house.

The fireplace and the stove engendered different ways of life and different activities. People with an open fire had to stay close to it to avoid freezing. They were forced to bend over the hearth to do the cooking. The hierarchy of age and rank dictated how close each member of the family could be to the fire. Because a stove provided more uniform heating and the oven made it possible to cook standing up, people could position themselves more freely.

Despite those advantages, the French could not quite give up the fire as the focal point of the home. It was where they clustered in the evening and listened to each other's accounts of the day, and it was often their source of light. Throughout the French countryside, the fireplace, with its rituals and much-loved special instruments, long held sway. But when women realized they could cook more easily on stoves or ovens, the cast-iron or earthenware appliances did come into the home. They were sometimes installed in the middle of the hearth, with their angled pipes connected to the chimney flue: defeat at last for the fireplace.

In a scene that shows a couple's charming closeness, the painter Alfred de Richemont includes one of the Godin stoves that were extremely popular at the time. And, in what may be a sign of changing mores, it is the man who is cooking, while the comely woman in muttonchop sleeves and a white apron waits for her crêpe.

Alfred de Richemont

Making Crêpes, 19th century

Musée des Beaux-Arts, Lille, France

A Maid's Life

Having no doubt heated the water over the fire, the servant has set the heavy basin down in front of the hearth. Crouched uncomfortably, she is doing the dishes, which she will leave to drain, not very hygienically, on the floor. Mistresses were quick to reproach their maids for uncleanliness, without providing them with any facilities that would improve the condition.

The maid's bedroom was often a dark cubbyhole, perhaps with a skylight, that adjoined the corridor or the kitchen. Sometimes the maid slept anywhere at all, simply unrolling a mattress in the dining room, the kitchen, or the hall, with no privacy and no chance of a personal life. When servants were lodged on the top floor they had small bedrooms, but no heat. Usually one source of water served the whole floor.

Servants had many more chores to do than a modern housewife, especially if the staff was small. They had to carry water up to the apartment, and it was often the maid's job to collect it from the communal faucet in the courtyard. They also had to fetch wood or coal, take out the garbage, scrub the floors, and wax the parquet, which was an exhausting job. Housekeeping made no progress during the industrial age; the broom, feather duster, and cloth were still used to shift and stir up the dust among the ornaments, bronzes, wall hangings, vases, and draperies.

One of the sad stories about servants' living conditions in the nineteenth century is that of Amélie Cayrol, whose employers were charged with her death. Pierre Guiral and Guy Thuillier quote the judgment of the Seine Tribunal, whose legalese only accentuates the tragedy: "Inasmuch as in November 1904 Monsieur and Madame L . . . engaged Amélie Cayrol, aged about sixteen years, as a child's nurse, for a monthly wage of 25 francs; inasmuch as Mademoiselle Cayrol, having entered their service on 12 December in a satisfactory state of health, was obliged on the advice of a doctor to return on 21 March 1905 to her parents' home, where she died on 4 April of cerebrospinal meningitis;

inasmuch as it is established that from 8 January, when Monsieur and Madame L . . .'s child was born, Amélie Cayrol was subjected to excessive work; as it is clear from her correspondence with her parents that, with no regard for the terms of her employment, she was compelled to wash and iron all the household linen, and to rise several times in the night to attend to the mother and child; as she continually complained of the harshness of her masters, who gave her no rest by day or by night, and of her fatigue and exhaustion, which grew steadily worse; as she was clearly torn between the desire to leave in order to recover her health, which she felt to be in jeopardy, and the fear of finding herself without a position, and being a burden on her parents, when instead she wished to help them; . . . inasmuch as the young maid's state of exhaustion on her return to her parents' home has been confirmed by Doctor C . . . [there follows the content of the doctor's certificate]; inasmuch as it emerges from his findings that as a result of her exhaustion, Amélie Cayrol was particularly liable to contract the illness, and lacked the strength to resist it; that being the case, there is a direct link between her overwork and her death."

That record may answer some of our questions about how the mistress of the house used to get through all the household chores, by showing how, by whom, and at what price they were sometimes carried out.

Victor-Gabriel Gilbert

The Cook or *The Dishwasher,* 1878

MUSÉE DES BEAUX-ARTS, ROUEN, FRANCE

FOLLOWING PAGES

Edgar Degas

The Rape, 1868–69

PHILADELPHIA MUSEUM OF ART

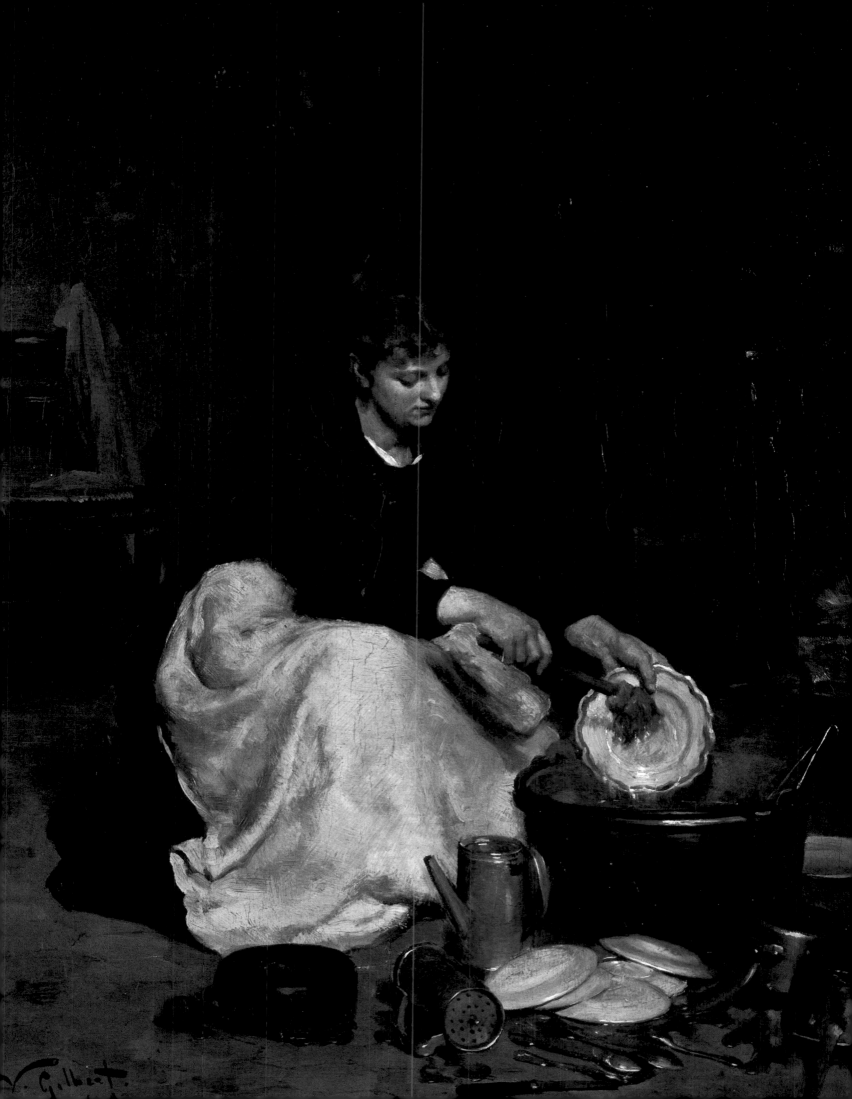

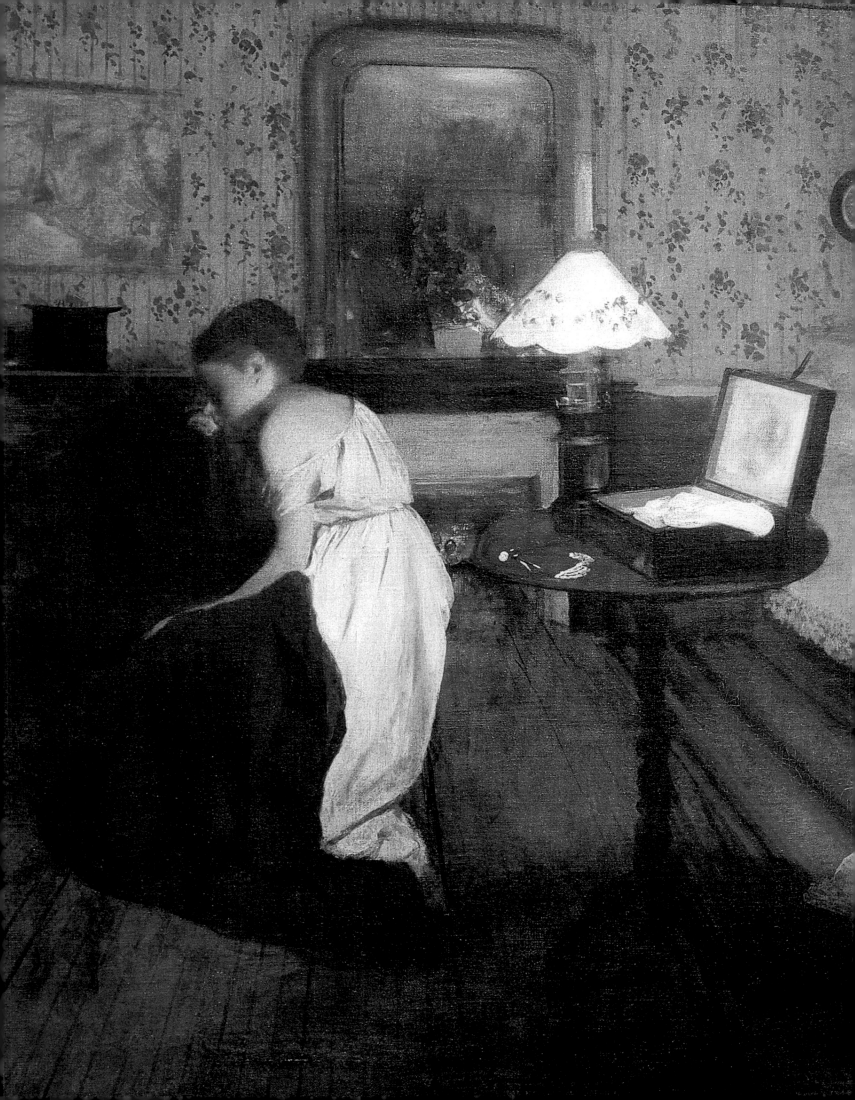

The Oil Lamp Era

After centuries of nighttime illumination by flickering candlelight, oil and kerosene lamps arrived. They provided for the first time a more intense and stable light that did not go out at the slightest draft, and the fuel they burned was more economical than candle wax.

Oil lamps had been used in Biblical times but had fallen into oblivion for several millennia. Interest in them was revived toward the end of the eighteenth century by a series of technical innovations that made oil lighting more efficient. Early oil lamps had closed containers for the oil and a wick that jutted out at the top; as the flame burned the wick down, fresh wick had to be pulled up with a sharp instrument. In 1784 the Swiss physicist Aimé Argand invented a hollow cylindrical wick that allowed air to pass through, thus providing a brighter flame. An important improvement came soon afterward, when the British physicist Count Rumford invented the lamp glass, whose chimney increased the amount of air drawn through the wick, making its flame bright yellow instead of red and smoky. In his 1987 book *Forgotten Household Crafts* John Seymour called the innovation more beneficial to humanity than the car or the airplane, as it allowed ordinary people who could not afford to light several candles at once to read during long winter evenings. In 1884 the oil lamp made one last advance with Austrian chemist Carl Auer's invention of the incandescent mantle. Its main feature was a mesh fabric impregnated with thorium, which, when lit, produced a light as bright as a hundred-watt bulb.

John Sherrin

The Valentine's Card,
19th century

PRIVATE COLLECTION

Variations in Brightness

In an opulent bedroom decorated in shades of blue, a mother, deathly pale but smiling, has just given birth. By the lamp's warm light those present gaze admiringly at the baby—its big brother eagerly trying to catch a glimpse.

The widespread use of oil lamps in homes had democratized lighting. From 1850 on even the most modest homes had several oil lamps. They were placed in bedrooms after being cleaned and filled in the pantry. Maintaining the lamps was an extremely tedious business that entailed cutting the wicks, refilling the oil containers, and cleaning the glass covers and copper parts. Otherwise dirt would quickly clog the lamp, and it would lose its brightness. In bourgeois homes one of the servants did the job, often working all day in a room reserved for the task before carrying the lamps to rooms throughout the house and lighting them.

Candles had by now been replaced by liquid fuels, but regional preferences dictated the kind of oil used: vegetal oils such as poppy seed, olive, walnut, rapeseed, and linseed; animal fats like suet, drippings, whale oil, and fish oil; and later the mineral oils, kerosene and gasoline. Kerosene was an economical lighting fuel but not entirely safe. To reduce the risk of knocking the lamp over the base was made quite wide, and to reduce the light's glare a lampshade was added. Further addressing both problems, lights began to be hung from the ceiling, raised and lowered using a pulley and counterweight. A major improvement was the introduction in 1884 of the Pigeon lamp, which eliminated the risk of fire. If it fell, the wick simply went out, so one could leave the room without fear of burning down the house. The lamp (named for its inventor, the Frenchman Charles Pigeon) was widely used until the 1920s.

The blue flame of gaslight, which had been used since the early nineteenth century to light factories and streets, was not commonly used residentially until the latter part of the century. It was soon eclipsed, however, by its great rival, electricity, which the American inventor Thomas Edison introduced in 1880. From the moment it appeared electric lighting filled the public with wonderment. The chroniclers of the time wrote lyrical odes to progress, showering endless praise on this revolutionary lighting that, unlike gas, was clean, silent, and odorless. Even so, electricity had its detractors. In 1897 two writers in an American magazine on home decoration jeered at electric light, saying its harsh white brightness removed any air of distinction from the drawing room, and that the deep-colored lampshades that usually covered the bulbs proved the light was unnecessary and its glare offensive.

But electricity had too many advantages, which spelled the end of the grease, dirt, and black smoke stains that kerosene and gas lamps billowed out on paintings and drapes, and of the gas pollution that could slowly and perniciously cause asphyxiation. Pure, odorless, and safe, electricity required neither constant supervision nor endless cleaning. It also ushered in a new generation of wonderfully simple gestures: turning a button and flicking a switch.

Victor Lecomte

The Birth, 19th century

Musée des Beaux-Arts, Nantes, France

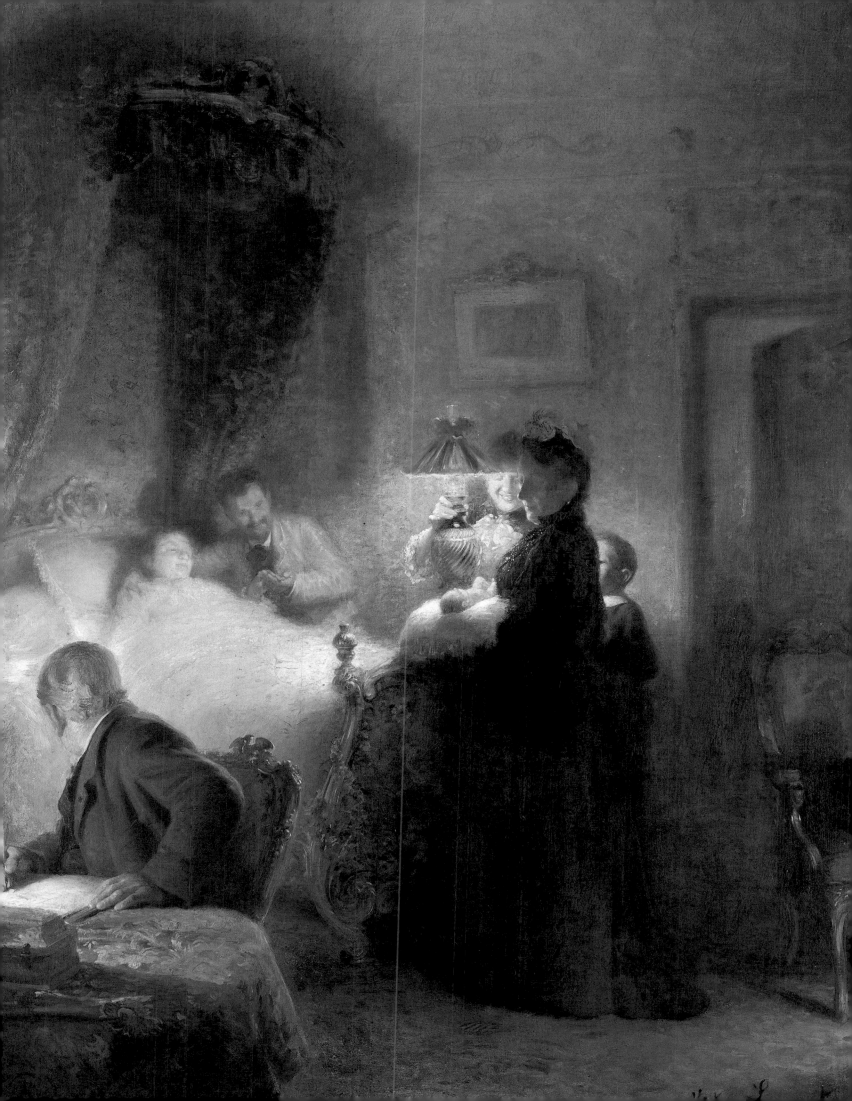

Domestic Exoticism

The young woman in her elegant dressing gown has dozed off, still holding a book in her hand. The atmosphere in this drawing room is one of Baudelairean "luxe, calme, et volupté"—luxury, calm, and pleasure. The furnishings borrow from the East and Far East. We see a Turkish couch, a Japanese lacquered closet, a Chinese pedestal table, a fan slipped into a bouquet of feathers, and the thick carpet or the floor covered with an African lion's skin.

Sometimes the taste for exoticism and love of acquisition were pushed to extremes that incurred disapproval. Drawing rooms tended to become veritable bazaars where hosts put on indiscriminate, jumbled displays of their wealth and collections of curiosities. The bourgeois apartment of the Belle Époque saw a profusion of draperies of every kind, with double or triple curtains. Even the fireplaces had decorative fringed covers. The most fashionable seats were poufs and low, satin-lined armchairs. The whole room teemed with pompoms, braid, and tassels. The furniture was copied from every style—and sometimes from several styles at a time. Each room in the home might reflect a given period: perhaps Louis XVI for the bedroom, Gothic or Renaissance for the dining room, and Louis XV in the drawing room, plus dizzying features like an Assyrian gaming room, a Moorish billiard room, and so on, in a staggering hodgepodge of eras and civilizations.

During the 1873 International Exhibition in Vienna one chronicler wrote with some irony about the French fashion for excess: "Where style is concerned, the Frenchman of today lives and sleeps in the eighteenth century, but eats his dinner in the sixteenth, and sometimes smokes his cigar or drinks his coffee in the Orient, while for his ablutions he takes his bath in Pompeii or ancient Greece."

Adolfo Belimbau

Rest (detail), 19th century

PALAZZO PITTI, FLORENCE,
GALLERIA D'ARTE MODERNA

James Tissot

Hide and Seek (detail),
1880–82

NATIONAL GALLERY OF ART,
WASHINGTON, D.C., CHESTER
DALE FUND

The Nineteenth Cen

Joseph Benwell Clark

The Bachelor's Breakfast Table, 1885

The Fad for White

Everything in this painting is the color of meringue: the tablecloth, walls, doors, and dresses. One senses liberation at last from the aesthetic excess that prevailed for much of the nineteenth century. The rooms appear airier and less cluttered with furniture. A couple stands chatting by a large window with simple drapes. There are no heavy velvets, walls cluttered with paintings, thick jungles of plants, or heaps of cushions. A young woman is placing a vase of yellow flowers on the table, where a light lunch is about to be served.

We can see the decor has become lighter and more agreeable, but the painting cannot show another development: Mealtimes in well-to-do homes throughout Europe were now considerably later. In France, for example, breakfast, eaten first thing in the morning, consisted of a cup of milk, hot chocolate, or tea and bread or toast. Lunch, served between ten o'clock and midday, included appetizers, ham and other cold cuts, and dessert. If lunch was served later, it would include roast meats. The timing of dinner had shifted the most. At the end of the eighteenth century Parisians dined no later than four o'clock, but the writer Stendhal reported in his diary that in 1805 invitations to dinner were for seven o'clock. He himself sometimes dined earlier, as on 3 May 1808: "At a quarter to four, I dined on grilled mutton, fried potatoes, and salad." By 1820 dinner in Paris was no earlier than five o'clock, and often at six. Some people could not get used to the new mealtimes. In Honoré de Balzac's 1837 novel *César Biroteau* an elderly couple begs dinner guests to arrive by five o'clock, "because these seventy-one-year-old stomachs will not bend to the new hours that are now regarded as good form."

The later hour was intended to accommodate men's activities in the business world. By the end of the century guests were invited for dinner at about half past seven. Etiquette of the time—in contrast to today's—required guests to arrive five or even fifteen minutes early. Late guests were given fifteen minutes' grace, after which the company went to table without them. With dinner so much later, French ladies began to follow the British example and served tea with an assortment of small cakes, all on fine china, at five o'clock.

Philip Connard
May Morning, 19th century
MUSÉE D'ORSAY, PARIS

The Privacy of the Home

In a light room with flowered wallpaper a woman sews, her feet resting on the crossbars of a chair and a cup of coffee on the seat in front of her. A man reads a book that is lying on the table next to a coffeepot. On the wall are a large mirror, some small canvases, and photographic portraits. The atmosphere is one of perfect peace and quiet, which suggests how important it was at the end of the nineteenth century for the home to be a nest where people could take refuge. The arrival of the industrial era had transformed people's ways of life. In France, for example, two-thirds of the population worked at home at the beginning of the century. By century's end almost all worked outside their own home, which considerably altered their attitude toward it.

Men's time was governed by public life in the outside world, with a schedule dictated by the pace of business. The private sphere became a haven where men could rest after a tiring day at the office. The home became idealized as a place of relaxation and well-being, which led in turn to the idealization of the mistress of the house, who had to know how to make harmony reign there.

The mirror on the wall shows that contemplating one's own image was no longer a privilege. The new ability to observe oneself at home, along with the increasing popularity of photographs (of oneself or one's family), encouraged the growth of individualism. The sharpening sense of self-importance had ramifications for home design, as people sought to create interiors that reflected themselves and their tastes, and where they could comfortably read, write, and think.

"We can see everything that goes on in the private space, where power strategies, interpersonal relationships, and the quest for the self are made manifest," noted the 1985 *History of Private Life*, edited by Philippe Ariès and Georges Duby. "So it is not surprising that the home plays such a part in art and literature. Monet's sunlit gardens, Matisse's half-open windows, the dark shadows around Vuillard's lamp: Painting enters the house and suggests its secrets."

Francisco Oller y Cestero

The Student, undated

Musée d'Orsay, Paris

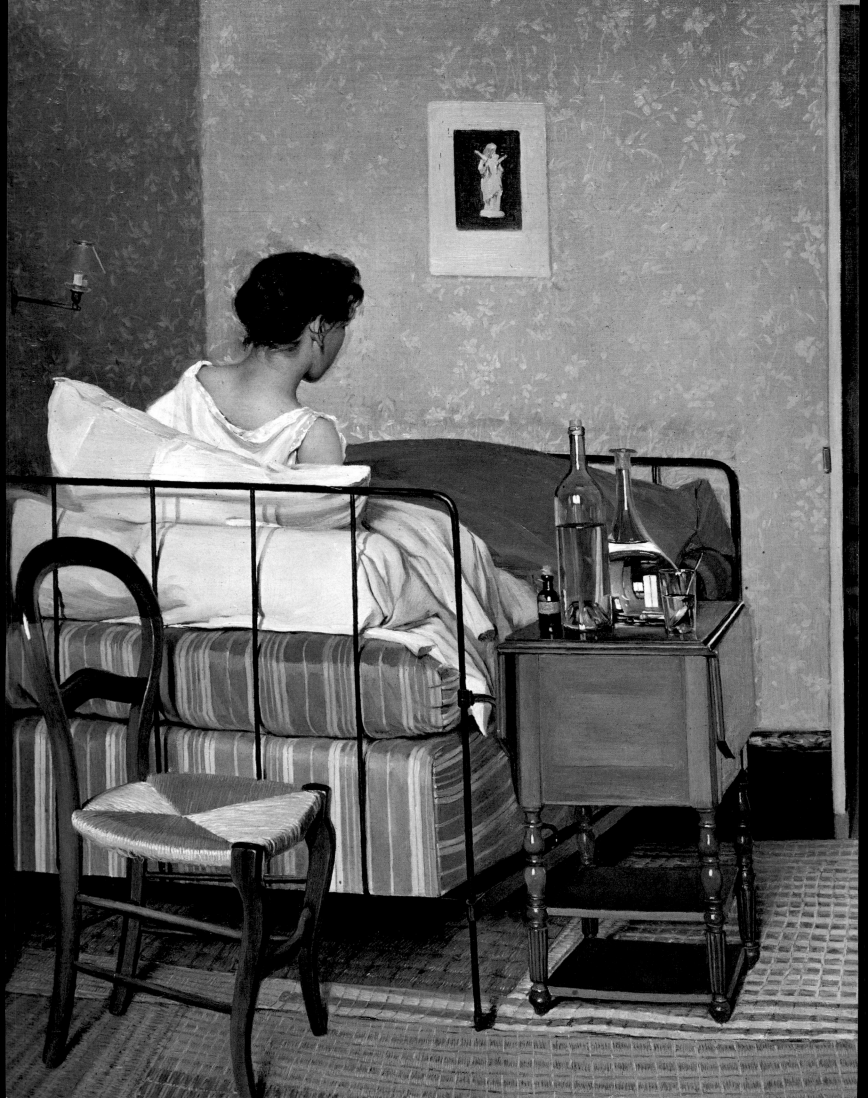

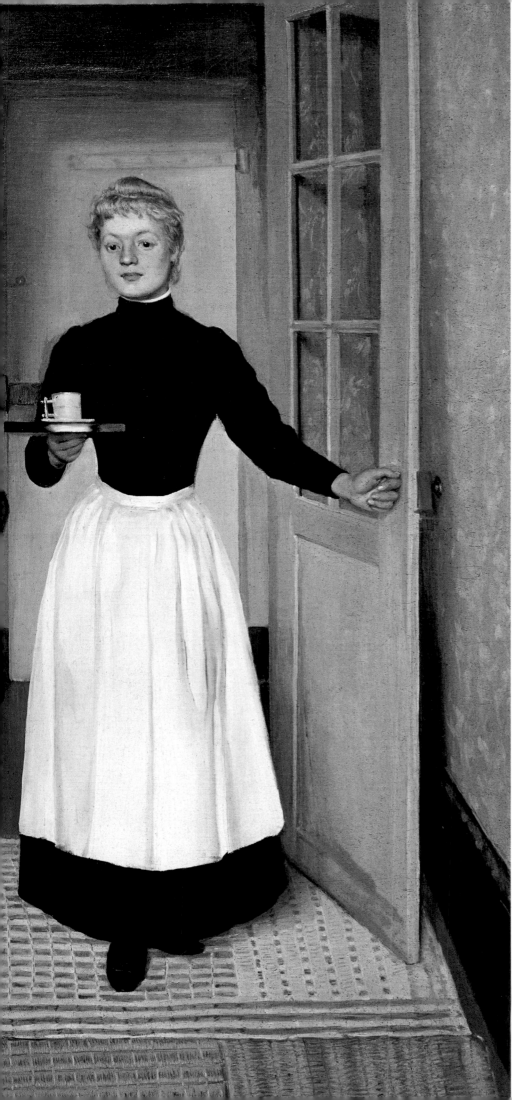

The Hygienic Iron Bed

A servant brings a hot drink to a girl who is clearly ill. A small table next to an austere iron bed is covered with bottles of various potions. A single engraving is pinned to the wall, and the floor is covered with two simple mats. Alcoves, enclosed beds, and curtains and other hangings were by now forbidden by hygienists, who in some cases developed a truly neurotic obsession with ventilation. They declared that bedrooms had to be cleared of clutter and fully aired and recommended iron beds to avoid infestation by wood-eating insects. They regarded the alcove as responsible for the spread of cholera and ordered its stagnant odor banished. They accused feather beds of emanating noxious fumes. Piles of pillows and eiderdowns were likewise anathema.

Those views might seem laughably excessive today, but at the time devastating respiratory illnesses were not uncommon. Even so, some contemporary writers, such as Henry Harvard, protested the hygienic radicalism: "In recent times, there has been a school of medical opinion that, caring only for the demands of hygiene, has pushed respect for it to the most ridiculous extremes. According to these intransigents, a bedroom must be absolutely bare, without hangings or wallpaper, with whitewashed walls and a wooden floor, oiled, varnished, and sluiced with water at least once a week. For them the bed should be small, plain, and made of metal, with no drapes and just a mesh spring base with a horsehair mattress on top. For the rest of the room they will just about allow a bowl or two—the most essential ones—a table, a chair, and that is all. Why this bareness? It is for fear of miasmas. . . . But as for the attraction that is supposed to arouse in us love of the home and make us want to stay there, what remains of it in the midst of this bleak, bare decor?"

Félix Vallotton

The Sick Girl (Hélène Chatenay), 1892

PRIVATE COLLECTION, LAUSANNE, SWITZERLAND

The Writing Desk and Its Secrets

The young woman looks anxious. She is quickly sealing a letter, looking all around to make sure no one catches her in the act. She is still holding the stick of sealing wax, which is the same color as her scarlet dress.

Women of the aristocracy and the bourgeoisie devoted several hours a day to their correspondence. Naturally they regarded the writing desk as an important piece of furniture—especially since its secret compartments could be used to hide a lover's letters. Women in polite society wrote not only letters but often kept diaries as well, sometimes with a relentless passion. If propriety forbade them to publish, the diary was the place they could freely satisfy an irrepressible need to write.

Women's activities then were regulated and restricted by extensive codes of conduct that seem outrageous nowadays. The mistress of the house had to be the first out of bed in the morning, even if she did not have much to do. She was expected to be up by half past six or seven o'clock in the summer and by half past seven or eight in the winter—essentially just to keep an eye on the servants and give her orders for the day. Bourgeois families usually had three in help: a valet-coachman, a cook, and a chambermaid. If she had enough servants the mistress of the house could spend the latter part of the morning on her own activities: letter writing, embroidery, and piano playing—or "women's hashish" as the nineteenth-century writer Edmond de Goncourt put it. There was no question of going out in the morning; a respectable woman did not set foot beyond the house before lunch. If someone encountered her in the street, politeness demanded that he not greet her. It had to be assumed she was devoting herself to philanthropic or religious activities she would not wish to discuss.

From about 1840 until 1914 the ladies of the bourgeoisie had an "at home day" for receiving guests. At the start of the season they would send out cards saying, "Madame ___ will be at home on such and such a day from ___ to ___." These gatherings were governed by a meticulous protocol that had to be respected in every detail: What to wear, where to sit, and what type of seat to choose all depended on one's status. A young girl, for instance, was never to sit on a chair with a back. As Madame Celnart wrote in 1833, a girl could be sure of maintaining a gracious, modest posture by doing needlework. Within fifty years, however, it was considered rather vulgar for a woman to work while receiving her friends. Sewing, tapestry, and all signs of correspondence disappeared from the scene. Private life was strictly separated from social life. The "at home day" persisted for several more decades, then ceased to exist at the onset of World War I.

Charles Baugniet

The Letter, 19th century

Christie's, London

FOLLOWING PAGES

Nils Gustav Wentzel

Paris Interior, 1884

Nasjonalgalleriet, Oslo

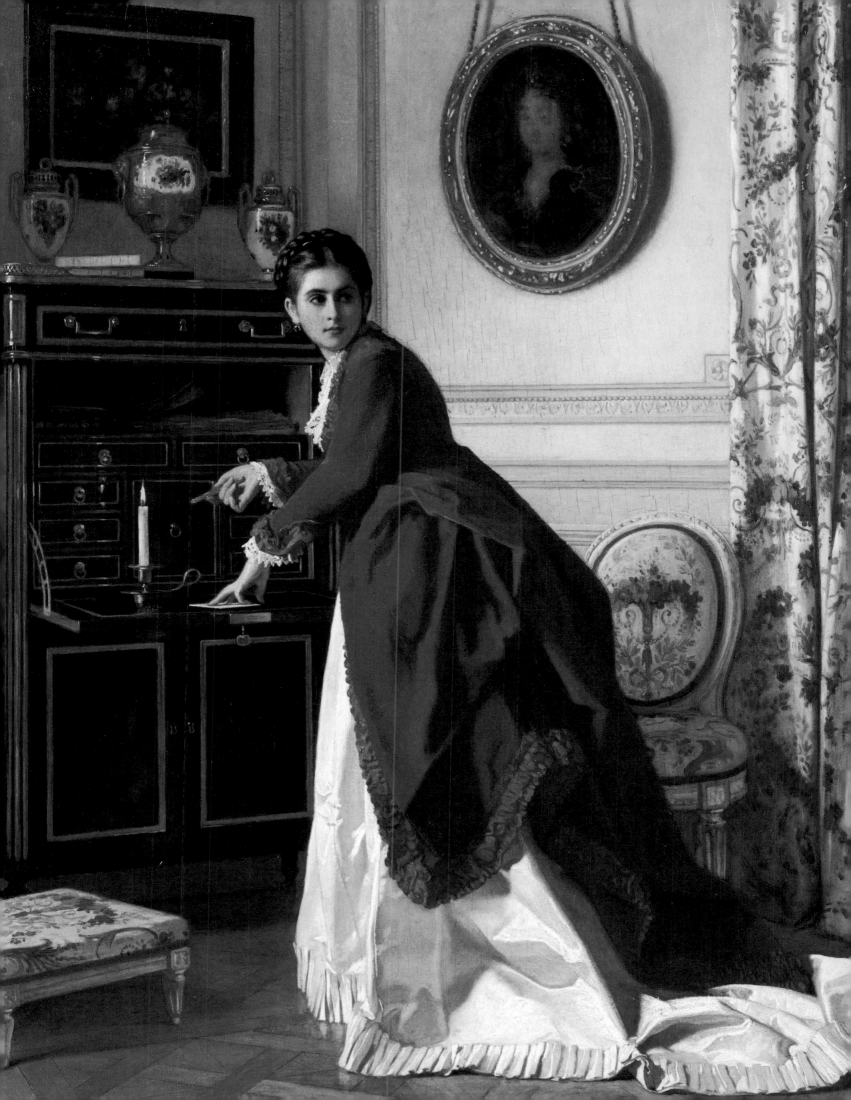

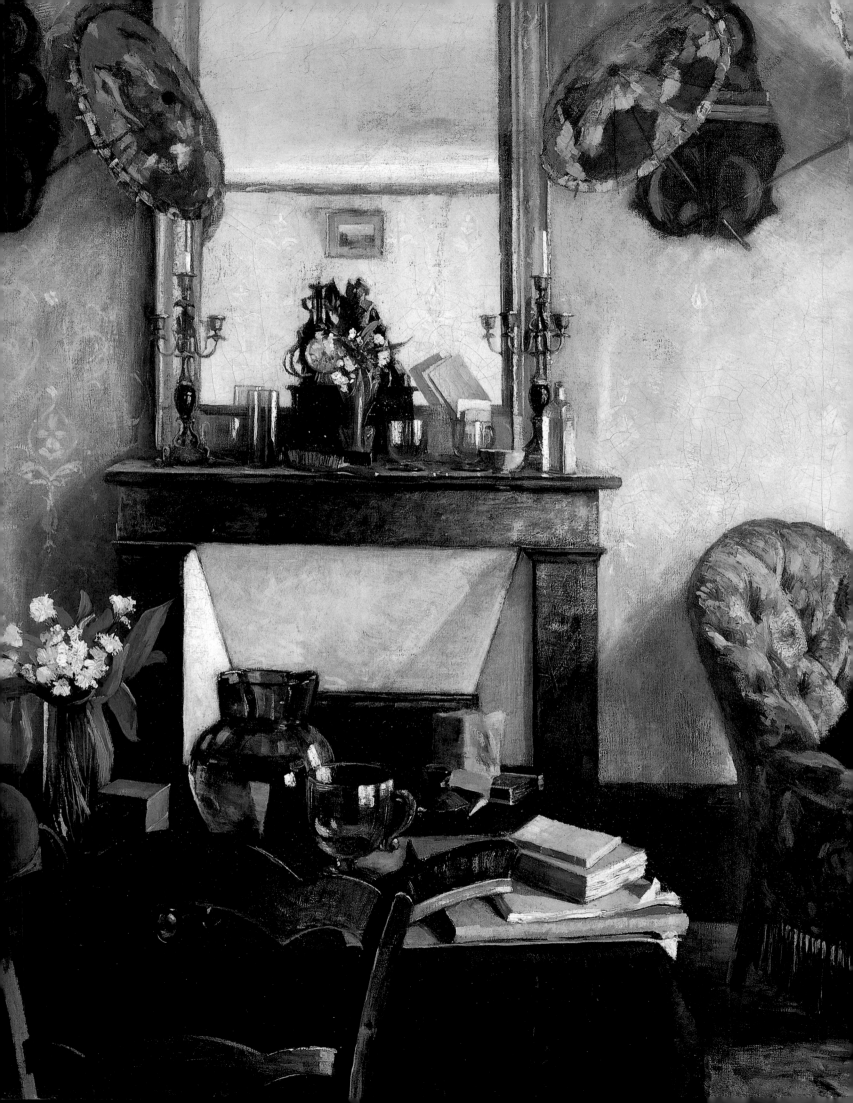

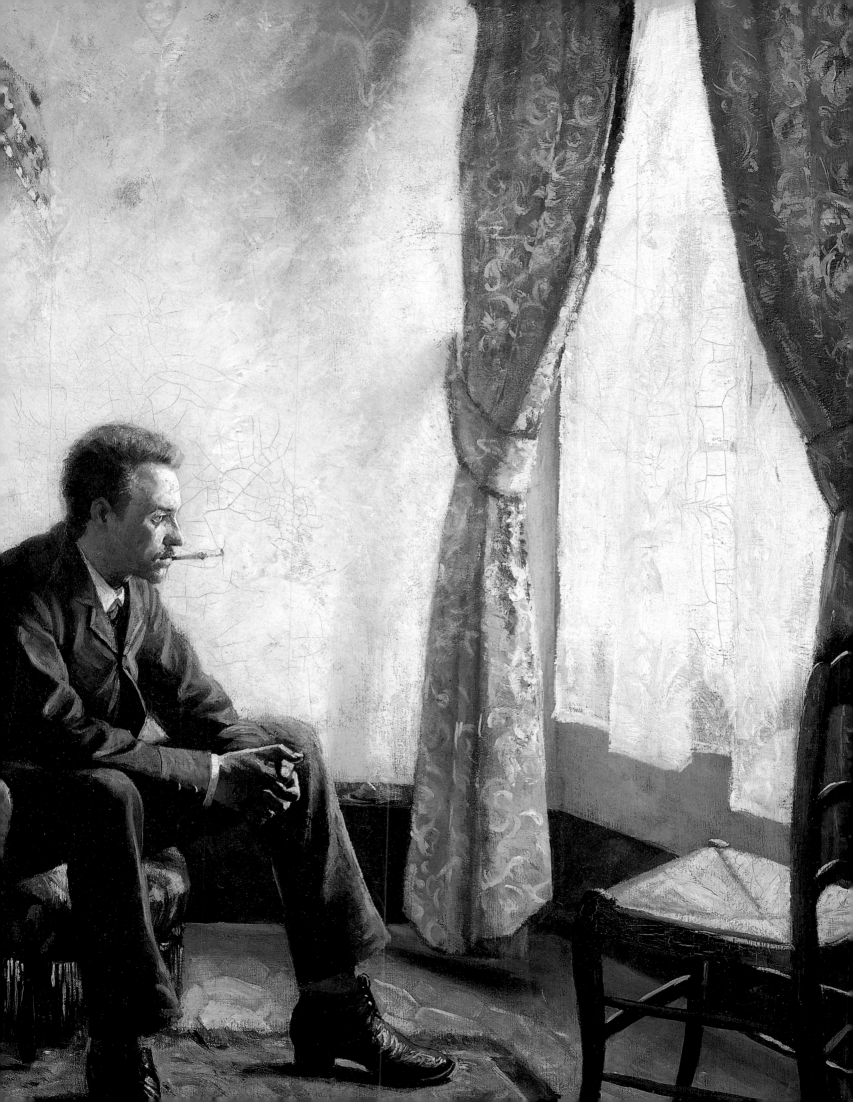

Edgar Degas

The Tub, 1886

Musée du Louvre, Paris

The Humble Home

The worker, naked from the waist up, stands washing himself in an earthenware bowl set on the table. Until the arrival of running water in city apartments in the latter part of the nineteenth century (and much later in the country), people had to make do with partial washing and little water. The ewer and washbowl were basic accessories, although the man in Maximilien Luce's painting does not seem to have them. Some better-off homes had a convertible chest of drawers whose upper part could be lifted to reveal a marble slab and a mirror, providing a small, foldaway washing area.

Bathtubs began to be made of sheet metal, which was less expensive than copper, and covered with a special paint that looked like enamel, which made them more hygienic. Tubs were made of zinc about 1840, cast iron about 1880, and porcelain or ceramic about 1900. At the dawn of the twentieth century only four percent of homes had baths. Before the arrival of running water, water heaters, and proper drainage, taking a bath was an extremely tedious business. It involved fetching buckets of water (at least thirty trips for a forty- to eighty-gallon tub), then endlessly heating it in kettles or pots and pans that cluttered up the stove. Not until homes obtained running water and new devices to heat it could one could casually run a bath simply by turning the taps.

In Paris the engineer Eugène Belgrand began developing a vast underground system of water supply and drainage in the 1850s. Water from the new mains began reaching the top of apartment blocks on the right bank in 1865, but the full system was not completed until about 1900. Even then, after centuries of rationing it was considered extremely wasteful to run gallons of hot water from a faucet. And Parisians did not yet consider it natural to strip completely and plunge into water. Consequently bathrooms were rare; until the early twentieth century, washing facilities remained in the bedroom, where a dressing table and tub were hidden behind a screen near the bed. Immortalized in Degas's paintings, the tub—a huge zinc basin imported from England—evidenced a new desire to wash the entire body while using very little water.

Like other objects associated with personal hygiene, the tub was hidden behind curtains under the dressing table or in a closet. The meager lodgings of the poor essentially ignored the existence of bathrooms. Those who did not have their own bedrooms washed in the kitchen, behind a small curtain.

Throughout the nineteenth century European philanthropists and social reformers representing the full spectrum of opinion, from conservative to anarchist, condemned the scandal of the lower classes' cramped, insalubrious living conditions. A History of Private Life quoted the official inquiry carried out after Paris's 1832 cholera epidemic, which killed 18,602 people: "Where an impoverished population was crowded into dirty, cramped lodgings, the epidemic's death toll was greatly increased."

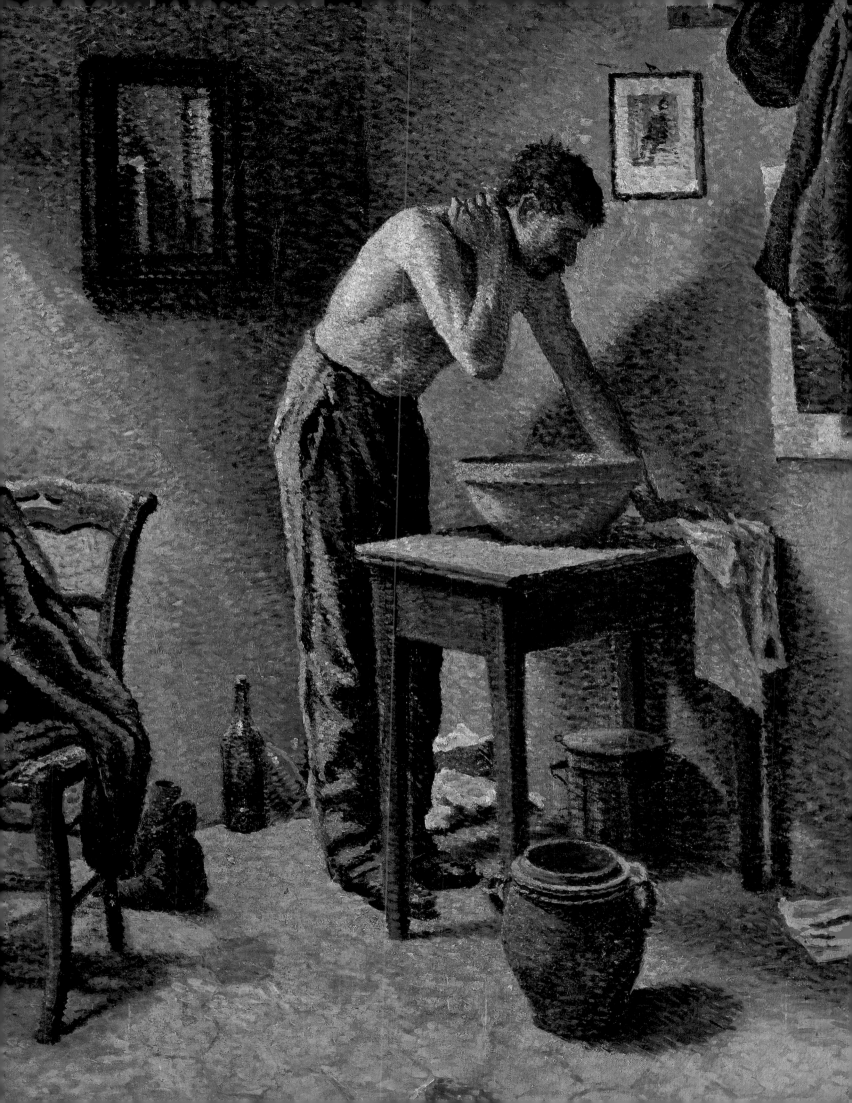

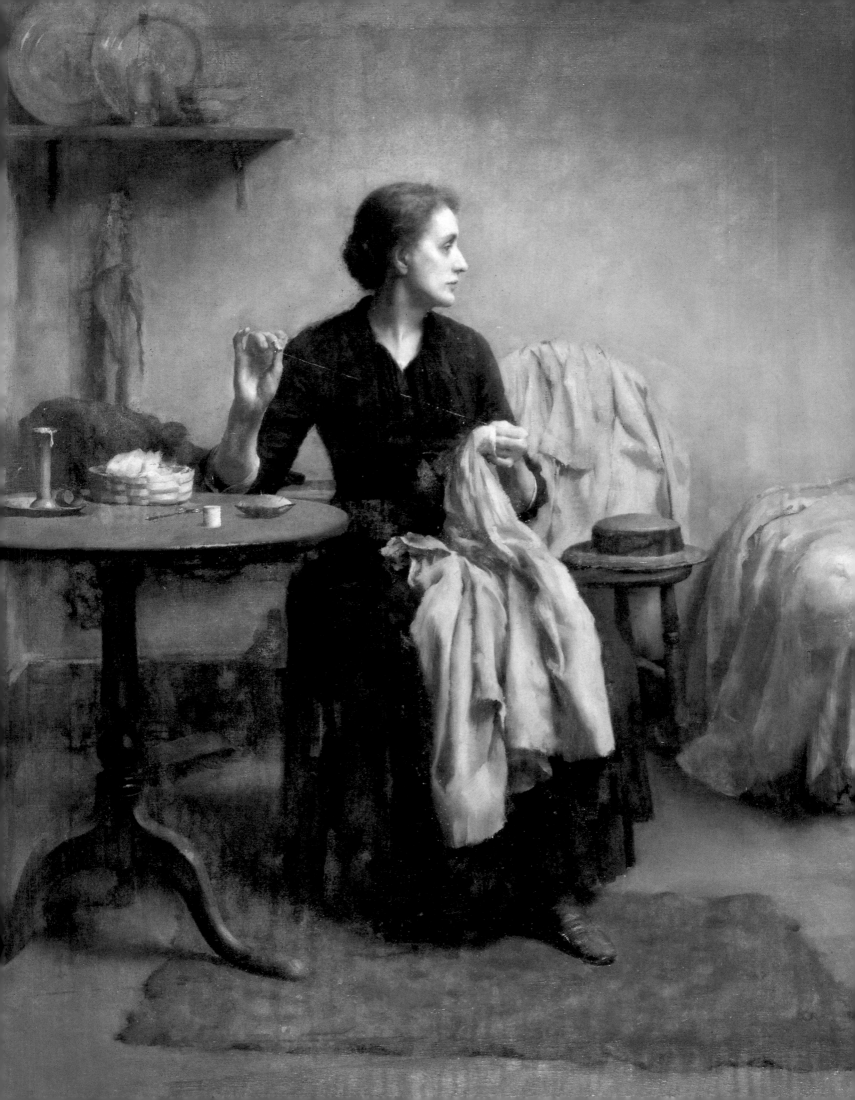

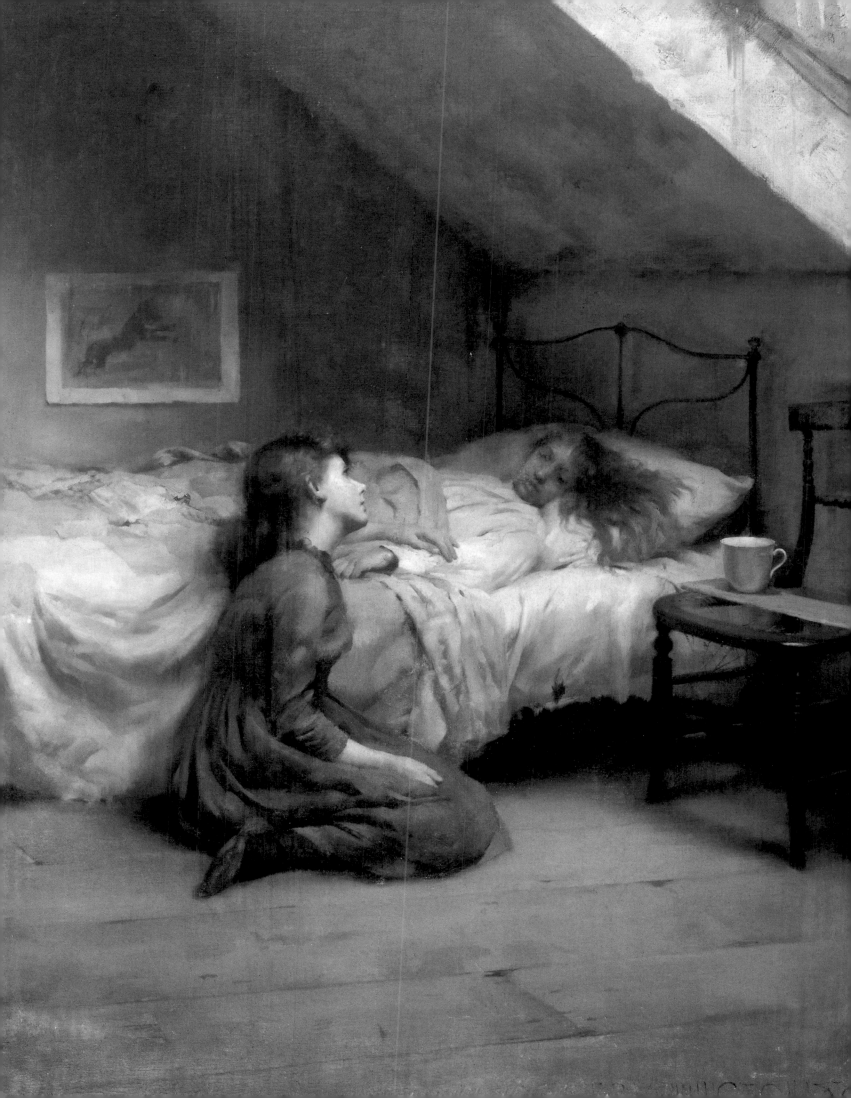

The Twentieth Century

The Decline of the Linen Closet and the Birth of Comfort

Kneeling like a priestess before the altar of the family's linen closet, a woman searches among neatly arranged piles of sheets, tablecloths, and dustcloths, perhaps trying to find something she has hidden. Vast stores of linen were once the pride and joy of the mistress of the house. It used to be that the mistress of a modest home would always find some excuse to open the linen closet when visitors arrived, and would even hide newspapers between the sheets to make the piles look bigger. But since the arrival of electricity, the washer-dryer, and easy-to-wash textiles we no longer need so much linen or so much space to store it. Today a storage unit may even be made of cloth, light as a kite, and on wheels for complete mobility—a far cry from the imposing wooden wardrobes of the past.

Félix Vallotton

Woman Searching Through a Cupboard, 1901

Private Collection, Switzerland

A Simple Decor

The woman has just slipped out. The raven black of her dress, the fireplace, and the mirror frame emphasize the whiteness of the walls and the ivory color of the door. Modern interiors opted resolutely for sobriety, the new watchword of those who wished to dissociate themselves from clutter, now déclassé. Gone were the walls covered with picture frames, the theatrical draperies, the armadas of hideous knickknacks, and the interiors so crammed with furniture they looked like cabinetmakers' shops. People now sought coherence, harmony, and decisive style.

The late-nineteenth-century horror of empty space gave way to a love of order and lack of ornamentation. The governing idea was to banish any inessential accessory and to tolerate only a limited number of decorative objects. Innovative architects also became designers, creating furniture that was in keeping with their spare new interior spaces. In smart interiors wallpaper began to give way during the 1930s to bare walls painted in light colors, and moldings disappeared. As paper was stripped from the walls people discovered an almost archaeological stratification, revealing layers of wallpapers with patterns popular in other times.

Marius Borgeaud
Interior, 1922
PRIVATE COLLECTION

Our Beloved Homes

Along with the simplicity of the decor—the few plates hanging on the wall, the small checked tablecloth, the oil lamp, and the large alarm clock—this scene is imbued with all the affection the painter Léonard Foujita feels for his home. He underscores the point with the revealing and disarming title of his canvas: *My Interior in Paris*.

Whether owner or tenant, people began forming ever closer links with the place they lived, however comfortable or uncomfortable, modest or luxurious it might be. The home became a cocoon where modern man curls up to protect himself from the rigors of life and the world of work. People like being at home, especially since central heating, insulation, and ventilation provide a temperate and agreeable atmosphere year-round. Today we spend much more time in the home than people did in centuries gone by because it is stocked with everything we need, including an arsenal of electric appliances for storing and preparing food—freezers, refrigerators, ovens. In the past the challenge of keeping food fresh forced housewives to buy supplies much more frequently.

We also have machines that enable us to educate or entertain ourselves at home. Until the end of the nineteenth century people who wanted to listen to music had to make it themselves, as a family or with friends, or go out to a concert or a show. The phonograph, radio, and record player—and then the television, videotape player, and personal computer—provided unlimited home entertainment. The telephone and Internet allow people to stay connected with the entire world without taking off their slippers. In the space of a few decades the home has changed more than it did in several thousand years.

A study published in 2005 by Guillaume Emer, a sociologist at the Institut d'Études Politiques in Paris, described the twenty-first-century dream home. The once-disdained kitchen has become the most important room: Spacious and attractive, it is where family and even guests gather. Not only does the ideal home have multiple bathrooms (though the days of the ewer in the bedroom and the wooden hut out back are not long past), but the master bath often has two sinks so a couple needn't take turns washing. The parents' bedroom is quite far from the children's rooms. The house is a refuge, designed to respect the privacy of each individual within it.

Of course, the gap is widening between this ideal home and reality, especially in large cities and other areas where housing is in short supply. There, a thriving market for sofa beds and other space savers reflects the exorbitant cost of every square inch.

Léonard Foujita

My Interior in Paris, attributed title *Still Life with Alarm Clock*, 1921

Musée National d'Art Moderne, Paris

FOLLOWING PAGES

Carl Larsson

Bathroom Scene—Lisbeth, 1909

Bibliothèque des Arts Décoratifs, Paris

The Wardrobe as a Tabernacle

The mistress of the house, wearing a dressing gown, observes her servant repairing an evening dress. The opulent bedroom exudes a sense of privacy and comfort, with flowered curtains, a soft bed with a Japanese-style cover, and patterned carpeting on the floor. The effect is elegant and mysterious.

Wall-to-wall carpeting was a high-status novelty at the beginning of the twentieth century. Gradually replacing the jigsaw puzzles of thick rugs that had to be vigorously beaten, it signified modernity and social success. Wall-to-wall carpeting became widespread with the proliferation of vacuum cleaners, which were invented early in the century. Carpeting also changed people's perception of the floor; they could now walk on it barefoot, or even sit on it quite comfortably.

In this scene, on which we seem to be spying, our attention is drawn by the massive, mirrored wardrobe that could almost betray our indiscretion by reflecting us. Long before wall-to-wall carpeting this imposing piece of furniture was a sign of its owners' respectability and wealth. In its inner depths the lady kept her embroidered, perfumed linen.

The large mirror made it possible to gaze at one's own image from head to toe. The mistress of the house would check her appearance before going out and would catch a glimpse of her naked body when she came home and undressed—ordinary to us today, but almost revolutionary then.

Félix Vallotton

Interior, 1903–4

THE STATE HERMITAGE
MUSEUM, SAINT PETERSBURG,
RUSSIA

FOLLOWING PAGES

Edward Le Bas

Interior, 1951

TATE GALLERY, LONDON

Félix Vallotton

*Intimacy: Couple in an
Interior with Screen*, 1898

SAMUEL JOSEFOWITZ
COLLECTION, LAUSANNE,
SWITZERLAND

A Warm Interior

This painting by the American artist Eric Fischl catches the woman coming out of the bathroom. As if in a surreptitious snapshot, the figure is blurred and cut off. With the terry-cloth bathrobe, the thick towel on her head, and the white bed, the whole scene is a "sensationist ode," to use the Portuguese poet Fernando Pessoa's beautiful neologism. It is bathed in softness, warmth, and dampness, but not destined to remain so for long. A pleasant home should be dry and light, with a few selected places where subdued light creates shady recesses.

In today's climate-controlled house people can walk around in underclothes—or even naked—in complete comfort. The physical ease homes now guarantee has given rise to behavior far different than that of our forebears. We no longer need to station ourselves by the only sources of light and heat. Instead of moving about to stay warm, we can stay still for a long time, sprawled in an armchair or stretched out between soft cotton sheets or under a light quilt—scarcely recognizing anymore the tactile pleasure we enjoy. A feeling of well-being is available in every room and throughout the year.

Deodorized or even perfumed, heated, cooled, and well insulated (despite ever-larger windows), abundantly lit, and with hot and cold water available at will, the home has undergone a rapid transformation that has greatly influenced our perceptions of our bodies and emancipated our physical postures.

Eric Fischl

The Bed, the Chair, Crossing, 2000

Private collection

Following pages

Eric Fischl

Bathroom Scene 2, 2003

Private collection

Eric Fischl

Sunroom Scene 1, 2002

Private collection

Bibliography

Ariès, Philippe, Georges Duby (eds.). *Histoire de la vie privée*. Paris: Seuil, 1985. English trans. A *History of Private Life*. Cambridge, Mass.: Belknap Press of Harvard University Press, 1987–91.

Babelon, Jean-Pierre. *Demeures parisiennes sous Henri IV et Louis XIII* [Parisian homes under Henri IV and Louis XIII]. Paris: Le Temps, 1965; Hazan, 1991.

Bluche, François. *La Vie quotidienne au temps de Louis XIV* [Daily life at the time of Louis XIV]. Paris: Hachette, 1980.

Bonnin, Philippe (ed.). "Manières d'habiter" [Ways of living]. *Communications* 73, 2002.

Bonnin, Philippe, Martyne Perrot, Martin de la Soudière. *L'Ostal en Margeride*. Paris: CNRS, 1983.

Burnand, Robert. *La Vie quotidienne en France en 1830* [Daily life in France in 1830]. Paris: Hachette, 1943.

Claverie, Élisabeth, Pierre Lamaison. *L'Impossible mariage, Violence et parenté en Gévaudan XVIIᵉ, XVIIIᵉ, XIXᵉ siècle* [The impossible marriage: violence and kinship in Gévaudan in the 17th, 18th, and 19th centuries]. Paris: Hachette, 1982.

Csergo, Julia. *Liberté, Égalité, Propreté, la morale de l'hygiène au XIXᵉ siècle* [Liberty, equality, cleanliness, and the morality of hygiene in the 19th century]. Paris: Albin Michel, 1988.

Dibie, Pascal. *Ethnologie de la chambre à coucher* [The ethnology of the bedroom]. Paris: Grasset, 1987.

Eleb-Vidal, Monique, Anne Debarre-Blanchard. *Architecture de la vie privée à Paris: 1880–1914* [The architecture of private life in Paris: 1880–1914]. Brussels: Archives d'Architecture Moderne, 1989.

Febvre, Lucien. "La sensibilité et l'histoire: Comment reconstituer la vie affective d'autrefois." *Annales d'histoire sociale* 3, 1941. English trans. "Sensibility and History: How to Reconstitute the Emotional Life of the Past," in A *New Kind of History: From the Writings of Febvre*. New York: Harper & Row, 1973.

Fillipetti, Hervé, Janine Trotereau. *Symboles et pratiques rituelles dans la maison paysanne traditionnelle* [Symbols and rituals in the traditional peasant home]. Paris: Berger-Levrault, 1978.

Flandrin, Jean-Louis. *Familles: parenté, maison, sexualité dans l'ancienne société*. Paris: Hachette, 1976; Seuil Points Histoire, 1995. English trans. *Families in Former Times: Kinship, Household, and Sexuality*. Cambridge, England, and New York: Cambridge University Press, 1979.

Foisil, Madeleine. *La Vie quotidienne au temps de Louis XIII* [Daily life in the time of Louis XIII]. Paris: Hachette Littératures, 1992.

Fourastié, Jean. *Histoire du confort* [The history of comfort]. Paris: PUF, 1950.

Franklin, Alfred. *La Vie privée d'autrefois* [Private life in the past]. Paris: Plon-Nourrit, 1897–1902; Perrin, 1973.

Goubert, Jean-Pierre. *La Conquête de l'eau*. Paris: Robert Laffont, 1986. English trans. *The Conquest of Water*. Princeton, N.J.: Princeton University Press, 1989.

———. *Du luxe au confort* [From luxury to comfort]. Paris: Belin, 1988.

Goubert, Pierre. *Les Paysans français au XVIIᵉ siècle*. Paris: Hachette, 1982. English trans. *French Peasantry in the 17th Century*. Cambridge, England, and New York: Cambridge University Press, 1986.

Guerrand, Roger-Henri, *Les Lieux: histoire des commodités* [The lavatory: a history of the toilet]. Paris: La Découverte, 1985.

Guiral, Pierre, Guy Thuillier. *La Vie quotidienne des domestiques en France au XIXᵉ siècle* [The daily life of servants in France in the 19th century]. Paris: Hachette, 1978.

Lucie-Smith, Edward. *Furniture: A Concise History*. London: Thames and Hudson, 1979.

Mercier, Louis-Sébastien. *Tableaux de Paris*. Paris: 1781–88; Mercure de France, 1994. English trans. *Panorama of Paris: Selections from Le Tableau de Paris*. University Park, Pa.: Pennsylvania State University Press, 1999.

Montaigne, Michel de. *Montaigne's Travel Journal*. San Francisco: North Point Press, 1983.

Pardailhé-Galabrun, Annick. *La Naissance de l'intime* [The birth of privacy]. Paris: PUF, 1988.

Perrot, Philippe. *Le Luxe: une richesse entre faste et confort, XVIIIᵉ-XIXᵉ siècle* [Luxury: a wealth between pomp and comfort]. Paris: Seuil, 1995.

Poche, Daniel. *Histoires des choses banales* [Stories of everyday things]. Paris: Fayard, 1997.

Praz, Mario. *An Illustrated History of Interior Decoration*. London: Thames and Hudson, 1964.

Roux, Simone. *La Maison dans l'histoire* [The house in history]. Paris: Albin Michel, 1976.

Sansot, Pierre. *Les Gens de peu* [The people of modest means]. Paris: PUF, 1992.

Schama, Simon. *The Embarrassment of Riches: An Interpretation of Dutch Culture in the Golden Age*. New York: Knopf, 1987.

Schweitz, Arlette. *La Maison tourangelle au quotidien* [Everyday life in homes in the Touraine]. Paris: Publications de la Sorbonne, 1997.

Seymour, John. *Forgotten Household Crafts*. New York: Knopf, 1987.

Staffe, Baroness Blanche. *Usages du Monde* [Customs of the World]. Paris: Victor-Harvard, 1892.

Thornton, Peter. *The Italian Renaissance Interior, 1400–1600*. New York: Harry N. Abrams, 1991.

———. *Authentic Decor: The Domestic Interior, 1620–1920*. New York: Penguin, 1984.

Todorov, Tzvetan. *Éloge du quotidien, essai sur la peinture hollandaise du XVIIᵉ siècle* [In praise of daily life: an essay on Dutch painting in the 17th century]. Paris: Seuil, 1997.

Verdier, Yvonne. *Façons de dire, façons de faire: la laveuse, la couturière, la cuisinière* [Ways of saying, ways of doing: the washerwoman, the seamstress, the cook]. Paris: Gallimard, 1979.

Photographic credits

AKG Images, Paris: 10–11, 34–35, 36–37, 83,
150–51, 186–87 / Erich Lessing: 113, 164, 175 /
Rabatti-Domingie: 108 / Sotheby's: 62–63

Artothek, Weilheim, Germany / Blauel-Gnamm: back
cover, 30–31, 84–85 / Christie's: 119 / Ursula
Edelmann: 77 / WLMKUK: 70–71

Bibliothèque Nationale de France, Paris: 9, 14,
18–19, 20

Bibliothèque Sainte-Geneviève, Paris: 16–17

The Bridgeman Art Library, Paris: front cover, 32–33
44–45, 47, 48–49, 52–53, 60, 68, 72, 88, 96–97,
104–5, 106–7, 114–15, 121, 124–25, 129, 134–35,
138–39, 140–41, 143, 144–45, 155, 158–59,
166–67, 176–77, 190–91 / Alinari: 40–41, 156 /
Archives Charmet: 184–85 / Lauros: 90–91, 92–93,
149, 163 / The Fine Art Society, London: 152–53

Christie's Images Ltd., London: 169

Courtesy Johnny Van Haeften Gallery, London: 66–67

École Nationale Supérieure des Beaux-Arts, Paris: 50

Eric Fischl, New York / Time Lee: 194–95 / Ellen Page
Wilson: 196–97 / Zindman-Fremont: 192–93

Fondation Félix Vallotton, Lausanne, Switzerland: 179

Fondazione Torino Musei, Museo Civico d'Arte Antica
e Palazzo Madama, Turin, Italy: 29

The Frick Collection, New York: 116–17

Germanisches Nationalmuseum, Nuremberg, Germany:
74–75

The J. Paul Getty Museum, Los Angeles: 99

Musée d'art Thomas-Henry, Cherbourg-Octeville,
France / Artistic Photo: 64–65

Musée de Picardie, Amiens, France / Marc Jeanneteau:
58–59

Musée des Beaux-Arts, Dijon, France: 110–11

Musée Malraux, Le Havre, France: 133

Musée Municipal d'Art et d'Archéologie, Laon, France /
Studio Alex: 56–57

Museum Boijmans Van Beuningen, Rotterdam: 86–87

Nasjonalgalleriet, Oslo / J. Lathion: 170–71

National Gallery, London: 55

National Museums and Galleries of Wales, Cardiff:
160–61

Österreichische Nationalbibliothek, Vienna: 13

The Pierpont Morgan Library, New York: 23

Réunion des Musées Nationaux, Paris / Adélaïde
Beaudoin: 126 / Jean-Gilles Berizzi: 122–23 / Gérard
Blot: 4, 78, 102 / Jacques Faujour: 183 / Jacques
Quecq d'Henripret: 42–43 / Hervé Lewandowski:
136–37, 146 / René-Gabriel Ojeda: 94 / A. Pelle:
130–31 / Franck Raux: 101 / Jean Schormans:
172–73

Rijksmuseum, Amsterdam: 80–81

Roger-Viollet, Paris: 24

Scala, Florence: 26

Tate Picture Library, London: 188–89

The Walters Art Museum, Baltimore: 39

© Adagp, Paris, 2005 for the works by Léonard Foujita
and Maximilien Luce

Rights reserved for the works of Adolfo Belimbau and
Marius Borgeaud

© Sanderson Archive for the Windrush wallpaper,
reproduced on the cover, from an original design by
Morris & Company. Created in 1883, this wallpaper
owes its name to the Windrush River near Oxford,
England, where William Morris spent his childhood.

Project Manager, English-language edition: Céline Moulard

Editor, English-language edition: Nancy E. Cohen

Design Manager, English-language edition: Eric J. Diloné

Designer, English-language edition: Shawn Dahl

Jacket design, English-language edition: E.Y. Lee

Production Coordinator, English-language edition: Colin Hough-Trapp

Picture Research: Khadiga Aglan

Library of Congress Cataloging-in-Publication Data

Fontanel, Beatrice.
 [Vie quotidienne en peinture. English]
 Daily life in art / Beatrice Fontanel ; translated from the French by Liz Nash.
 p. cm.
 Includes bibliographical references and index.
 ISBN 0-8109-5537-7 (hardcover : alk. paper)
 1. Genre painting. 2. Manners and customs in art. 3. Interior decoration in
art. I. Title.
 ND1450.F6613 2006
 754—dc22

 2005027503

Copyright © 2005 Éditions de La Martinière, Paris

English translation copyright © 2006 Abrams, New York

Published in 2006 by Abrams, an imprint of Harry N. Abrams, Inc.

Printed and bound in France

10 9 8 7 6 5 4 3 2 1

harry n. abrams, inc.

a subsidiary of La Martinière Groupe

115 West 18th Street
New York, NY 10011
www.hnabooks.com

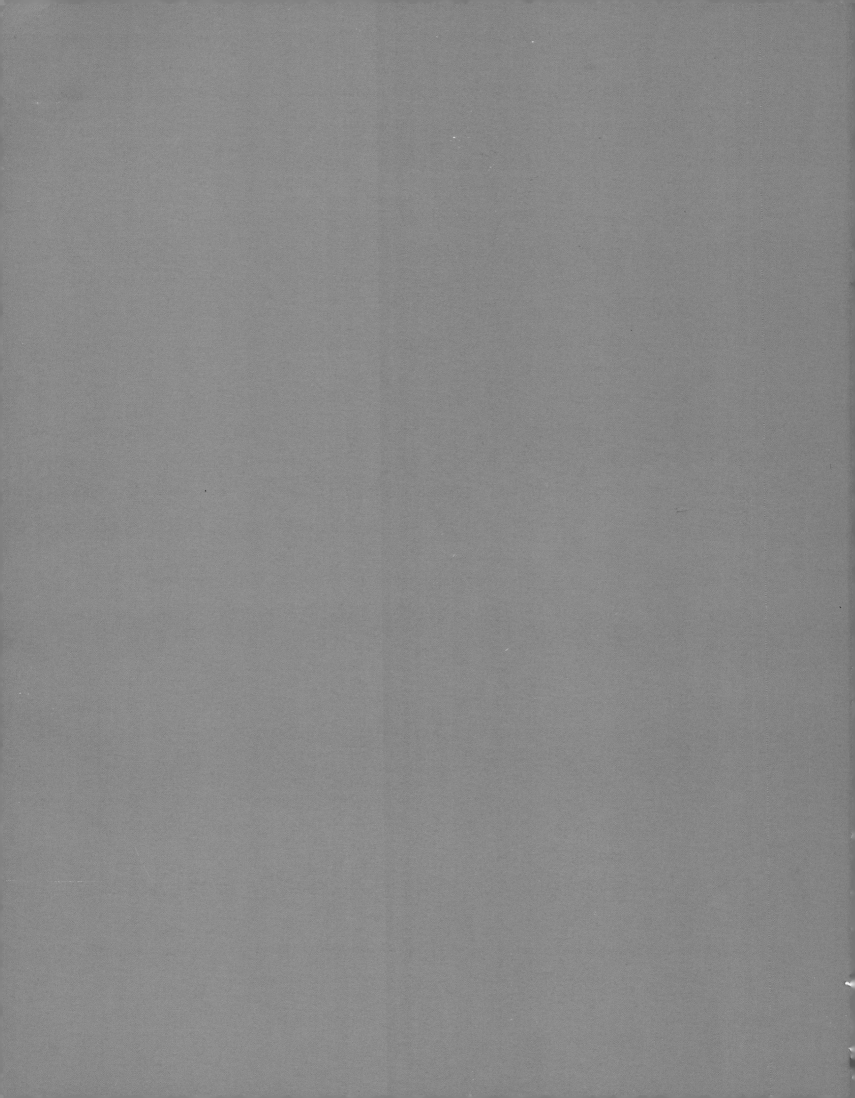